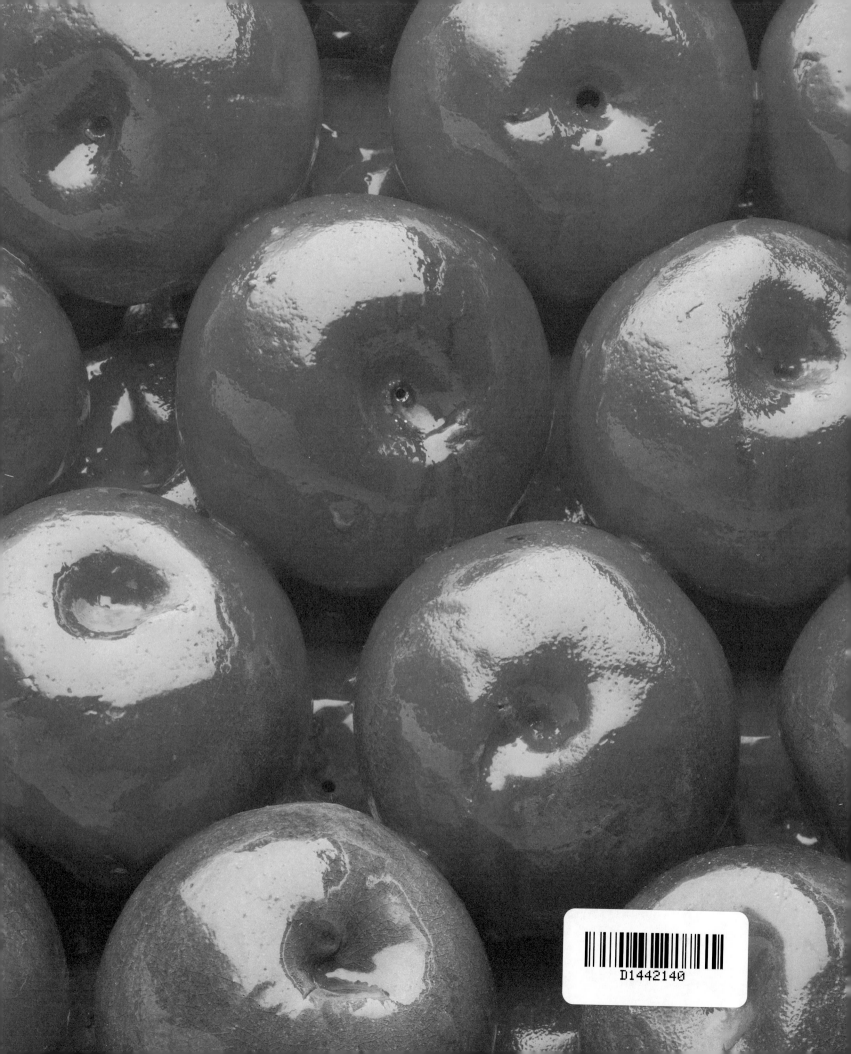

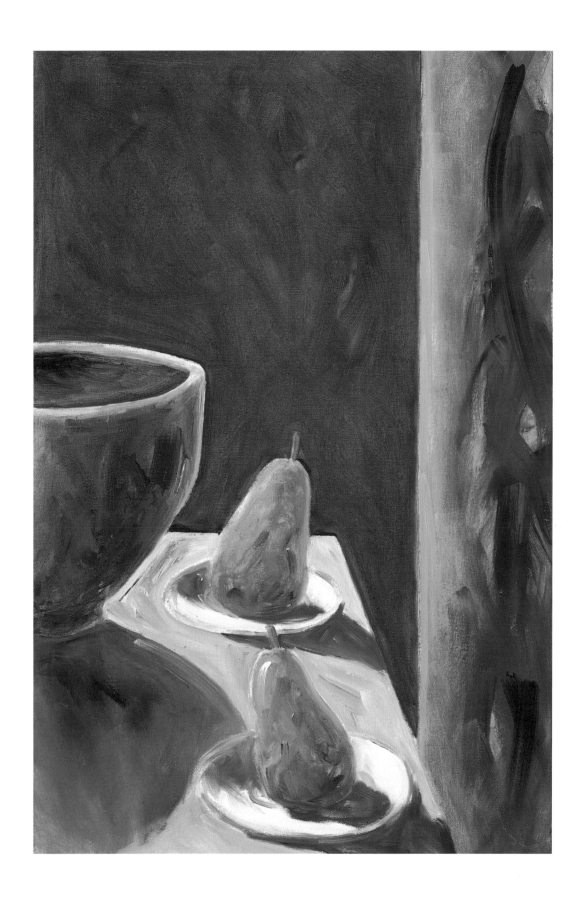

Robin Laurence, Bruce Grenville,

Ian M. Thom, Mayo Graham, Sarah Milroy

Douglas & McIntyre *Vancouver / Toronto*

Vancouver Art Gallery

gathie falk

Douglas & McIntyre Ltd.
2323 Quebec Street, Suite 201
Vancouver, British Columbia V5T 4S7

Canadian Cataloguing in Publication Data

Falk, Gathie, 1928–
Gathie Falk

Published in conjunction with an exhibition held at the Vancouver Art
Gallery and the National Gallery. Copublished by: Vancouver Art Gal-
lery. Includes bibliographical references.

ISBN 1-55054-745-3

1. Falk, Gathie, 1928– —Exhibitions. 1. Laurence, Robin, 1950–
II. Vancouver Art Gallery. III. National Gallery of Canada.

N6549.F34A4 2000 7093.2 C99-911086-1

Editing by Saeko Usukawa
Design by Mark Timmings, Timmings & Debay
Printed and bound in Canada by Hemlock Printers Ltd.
Printed on Luna Matte 100 lb. text from E.B. Eddy Paper, Vancouver,
manufacturer of high quality printing papers
Printed on acid-free paper

The publisher gratefully acknowledges the support of the Canada Coun-
cil for the Arts and of the British Columbia Ministry of Tourism,
Small Business and Culture. The publisher also acknowledges the finan-
cial support of the Government of Canada through the Book Publish-
ing Industry Development Program (BPIDP) for its publishing activities.

Endpapers: *196 Apples* (detail), 1969–70 (see page 49). Page 1: *Nice
Table with Bowl of Pears and Details* (detail), 1993 (see page 117).
Page 6: Gathie Falk in her studio, Vancouver, 1983. Photo by Tom
Graff. Page 9: *Theatre in B/W and Colour: The Kitchen Chairs*, 1984, oil on
canvas, 198.1 x 167.6 cm, collection of John and Elizabeth Nichol. Photo
by Teresa Healy, Vancouver Art Gallery. Page 16: *Beautiful British
Columbia Multiple Purpose Thermal Blanket* (detail), 1979–80 (see page 74)

National Gallery Musée des beaux-arts
of Canada du Canada

To Elizabeth Klassen, whose nimble wits have seen things through from spectral and obscure intentions to solid live manifestations. I thank her for her cheers from the bleachers and her unstinted help when it was needed.

Gathie Falk

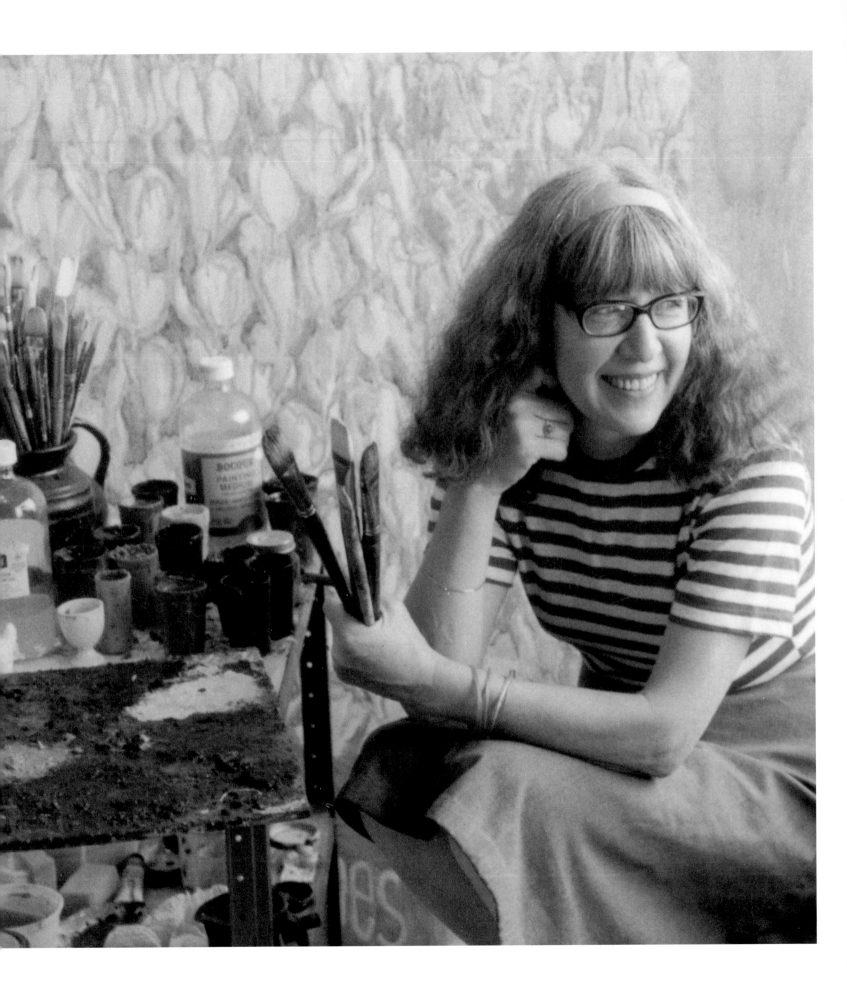

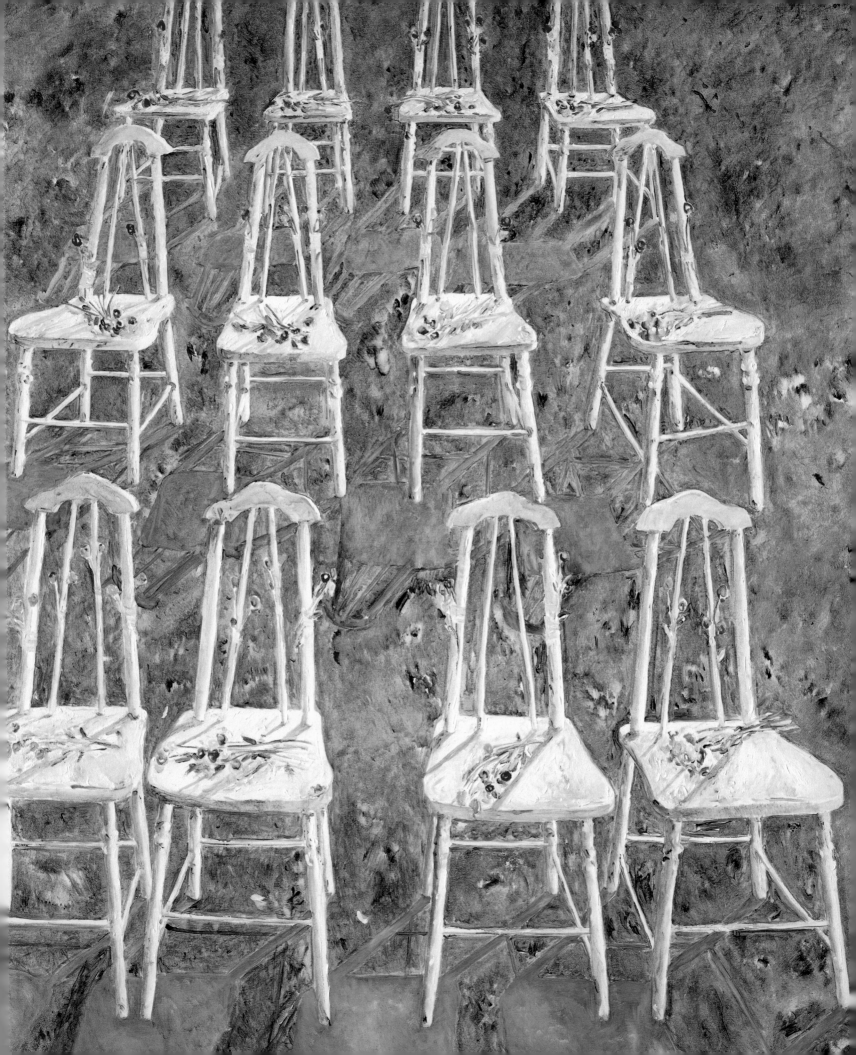

Foreword

For more than thirty years, Gathie Falk has been producing a memorable and provocative body of art from her studio in Vancouver. Nurtured by a fiercely loyal community of friends, artists, curators, critics, dealers and collectors, she has created an extraordinary variety of works that feed the imagination of those who have had the pleasure of encountering her art. This exhibition is both a celebration of that achievement and a critical insight into the art and ideas of this influential artist.

The Vancouver Art Gallery has had a long and lasting relationship with Gathie Falk, providing an important venue for her performances of the late 1960s, producing solo and group exhibitions of her work, and building the largest public collection of her art in Canada. With more than thirty works by Falk in its collection, the Vancouver Art Gallery is able to accurately document the breadth and complexity of her art. The Vancouver Art Gallery staff are honoured to have this opportunity to work with Gathie Falk in the preparation of the exhibition and to celebrate her contribution to the life of this community.

This exhibition and national tour were achieved through an innovative collaboration between the Vancouver Art Gallery and the National Gallery of Canada. Pierre Théberge, Director of the National Gallery of Canada, and Mayo Graham, Director, National Outreach and International Relations, have been longtime supporters of Gathie Falk and her work. Pierre Théberge was responsible for bringing the first works by Falk into the National Gallery collection, and Mayo Graham included her work in the ground-breaking 1975 exhibition, *Some Canadian Women Artists*. Both have continued to recognize the significance of Falk's work to the history of contemporary Canadian art. We are grateful to the National Gallery for their valuable collaboration and contributions to this exhibition and tour.

This project has been underwritten by a number of sponsors, notably The Canada Council for the Arts and Hemlock Printers Ltd. We are grateful for their assistance, which has enabled us to offer this tribute to the art of Gathie Falk.

Alf Bogusky, Director, Vancouver Art Gallery

It is with sincere pleasure that the National Gallery of Canada takes part in this exhibition of the work of Gathie Falk, organized by the Vancouver Art Gallery. Responding to the initiative of the Vancouver Art Gallery, in a spirit of outreach and partnership, our offer to collaborate in the exhibition's tour, including a presentation in Ottawa, was warmly accepted.

Gathie Falk's wondrous viewpoint and deft hands have conjured paintings and sculptures for over three decades. Her works have touched our spirits and put a smile on our lips. Given her immense talent and originality, it comes as no surprise that the two museums began acquiring her work very early on. By the end of 1970, the Vancouver Art Gallery owned five major sculptures, including three fruit piles, while the National Gallery purchased the first bootcase for a public collection in 1974. Vancouver's *30 Grapefruit* (1970), and Ottawa's *Eight Red Boots* (1973), take pride of place in this exhibition. We are also proud of our recent acquisitions, *Apples 19* (1996), and *Dress with Candles*, bringing to twelve the number of works by Gathie Falk in our collection.

The National Gallery is gratified that its collaboration in this significant project will provide opportunities for many viewers across Canada to share in the marvellous vision of Gathie Falk.

C'est avec un immense plaisir que le Musée des beaux-arts du Canada s'associe à l'exposition Gathie Falk organisée par la Vancouver Art Gallery. En réponse à la demande de la Vancouver Art Gallery, et dans une optique de rayonnement et de partenariat, notre proposition de collaborer à la tournée de l'exposition et de la présenter à Ottawa, a été chaleureusement acceptée.

Depuis plus de trente ans, peintures et sculptures naissent sous les mains habiles de Gathie Falk, inspirées par une vision tout à fait unique. Ces œuvres nous touchent et nous réjouissent. Étant donné l'immense talent et la grande originalité de l'artiste, il ne faut pas s'étonner que nos deux institutions aient commencé très tôt à collectionner ses œuvres. À la fin de 1970, la Vancouver Art Gallery comptait déjà cinq importantes sculptures, dont trois amoncellements de fruits; quant au Musée des beaux-arts, il fut la première institution publique à acheter un présentoir à bottes, en 1974. Par ailleurs, les œuvres suivantes occupent une place enviable dans cette exposition : *30 pamplemousses* (VAG, 1970) et *Huit bottes rouges* (MBAC, 1973). Nous sommes également fier de deux acquisitions récentes, *Pommes 19* (1996) et *Robe avec chandelles*, qui portent à douze les œuvres de Gathie Falk dans notre collection.

Le Musée des beaux-arts est très heureux que sa participation à cet important projet permette à de nombreux Canadiens de découvrir la vision merveilleuse de Gathie Falk.

Pierre Théberge, C.Q., Director / directeur,
National Gallery of Canada / Musée des beaux-arts du Canada

Preface

Gathie Falk is one of a handful of Canadian artists whose work has become deeply embedded in the psyche of its audience. When asked, most people can summon up a vivid image or an object that has claimed a place in their imagination. Falk's ceramic works seem to provoke the most visceral response, eliciting elaborate recollections that focus on idiosyncratic details or graphic descriptions of colour and texture. The paintings attract a fierce loyalty, with strong proclamations for or against specific bodies of work. Invariably, the performance works are spoken of with respect and admiration for their prescience and invention. And Falk's installations are often described in terms similar to those used to characterize a force of nature — overwhelming, unwieldy, enigmatic.

With such a memorable body of work, one might expect a highly charged subject matter originating in extraordinary events or intense emotional states. Instead, Falk's work finds its source in the events and objects of everyday life. The paintings and sculptures that she produces have a deeply personal presence that is grounded in an intense scrutiny of her daily environment. Falk has often commented on the sources for her art, citing her home, garden, neighbourhood and friends as the genesis and inspiration for her work. Significantly, this focussed examination of the world around her not only provides the source for much of her work but also ensures the methodology that gives meaning to her art. Falk believes that meaning and understanding are established through a process of rigorous observation:

I feel that unless you know your own sidewalk really intimately, you're never going to look at the pyramids and find out what they're about. You're never going to be able to see things in detail unless you can look at your kitchen table, see it and find significance in it — or the shadow that is cast by a cup or your toothbrush. Seeing the detail around you makes you able to see large things better. (Gathie Falk, "Statements" in Jo-Anne Birnie Danzker et al., *Gathie Falk Retrospective*, 17)

Sometimes, Falk's paintings and sculptures allow the viewer to see the world from a new perspective, casting a different light on an otherwise familiar object or event, while at other times the commonplace object is cast into a dark and emotive space, and thereby given new meaning and significance. Her sustained commitment to the everyday is remarkable for its continuity and breadth across more than thirty years of production in diverse and complex mediums.

The opportunity to review more than thirty years of art produced by Gathie Falk is a significant and pleasurable experience. In developing this exhibition, we explored several possible models but decided to focus on specific bodies of work dating from the early ceramic sculptures of the late 1960s to the complex mixed-media pieces of the present. In acknowledgement of Falk's lifelong working methodology based on the production of extended series grouped around specific subjects, the exhibition presents notable bodies of work in depth.

The exhibition includes documentation of Falk's performances of the early 1970s; the ceramic projects, including the Fruit Piles (1967–70), Single Right Men's Shoes (1972–73) and Picnics (1976–77) series; representation of the painting series, including Night Skies (1979–80), Pieces of Water (1981–82), Theatres in B/W and Colour (1983), Soft Chairs (1986), Hedge and Clouds (1989–91), Development of the Plot (1991–92) and Nice Tables (1993–94); and the mixed-media installations including *Home Environment* (1968), *My Dog's Bones* (1985) and *Traces* (1998).

This publication presents a complementary vision of Falk's art. In her extended essay, Robin Laurence offers a broad overview of the artist's art and life, linking Falk's paintings and sculptures to the larger rhythms and events of her life. It is an engaging and significant contribution to the wealth of thoughtful writing on Falk's art. This essay is interspersed with shorter essays by Mayo Graham, Sarah Milroy, Ian Thom and myself that offer analyses of individual works from throughout Falk's career. They not only provide a unique insight into the work but reveal the diverse meanings and approaches that her art encourages.

Together, the exhibition and publication describe the trajectory of Falk's art from its early roots in Funk and Pop–inspired sculpture and performances, through to the emergence of a mature style of painting and object-making distilled from an intense observation of the everyday world. Falk is remarkable for her ability to seize the ordinary and turn it into a powerful, revelatory force. Amplified by their repetition (with subtle variation), Falk's subjects invite us to consider the significant meanings of commonplace events and objects: apples, oranges, watermelons, shoes, boots, flowers, gardens, stars, water, sidewalks, chairs, dresses, bones, shadows, dogs, tables, clouds, hedges. They are as meaningful or meaningless as we allow them to be. Meaning, for Falk, comes through a repetition that is both drudgery and epiphany. All too often, especially in the world of art, the literal reading of a subject is cast aside in favour of a symbolic reading, a transcendent meaning, an abdication to a higher authority. With surprising swiftness, meaning is removed from a specific context, made abstract, and assigned a universal value.

For Gathie Falk, meaning is closely tied to responsibility—responsibility for everyday objects and actions, responsibilities to friends, colleagues and acquaintances, responsibility for the subjects and meanings that we create in the world. While it is tempting to assign a litany of transcendent values and interpretations to her work, to do so is to ignore its self-evident meaning. This exhibition and publication are an affirmation and a celebration of the power and the significance of the everyday as manifest in the art and life of Gathie Falk.

Bruce Grenville, Senior Curator, Vancouver Art Gallery

Acknowledgements

One of the great pleasures of curatorial life is the opportunity to enter into a focussed exchange with an artist. In a career filled with many agreeable exchanges, the opportunity to work with Gathie Falk has proven to be one of the most engaging and fruitful. We are grateful to Gathie for her kindness, hospitality and willingness to open up her life, studio and home to the relentless demands of preparing an exhibition.

Gathie is surrounded by a faithful circle of friends, artists, curators, critics, collectors and dealers, who generously provided thoughtful conversation and stimulating writings. The diversity of their thoughts and comments on her work has provided the core of meaning for this project. We thank them for their valuable contributions to the exhibition and publication.

We are particularly grateful to the collectors and institutions who have agreed to lend their work for the exhibition and national tour. While the thought of separation from these much-loved paintings and sculptures caused many to hesitate, all of the lenders recognized the significance of the exhibition and the importance of their work to building public knowledge of Gathie's art and ideas. We thank Cynthia Baxter, R.G. Charles, Daniel Donovan, Mr. and Mrs. Gordon Gibson, Mr. and Mrs. Howard Isman, John and Sherry Keith-King, Mr. and Mrs. John C. Kerr, Ron and Jacqueline Longstaffe, Mr. and Mrs. Gordon MacDougall, Barbara and Glenn McInnes, Susan Mendelson, Elizabeth and John Nichol, Bonnie Sheldon, Credit Union Central of British Columbia, Canada Council Art Bank, Equinox Gallery, Glenbow Museum, Kamloops Art Gallery, National Gallery of Canada, Mackenzie Art Gallery, Memorial University Gallery, Musée d'art contemporain de Montréal, Trans Mountain Pipe Line Co. Ltd., and those lenders who wish to remain anonymous.

We are especially indebted to Andy Sylvester, Director of the Equinox Gallery, for the considerable efforts he devoted to tracking down works, securing loans and offering thoughtful comment. Throughout this endeavour he maintained a sense of humour and graciousness that made this project a satifsying collaboration.

At the Vancouver Art Gallery, all members of the staff contributed to the project, and many of them made exceptional efforts to ensure its success. We are grateful for their hard work, thoughtful ideas and collegial enthusiasm. Photographer Teresa Healy took up the challenge of documenting these subtle works and provided the splendid images that form this book. Conservator Monica Smith supervised the laborious preparation of the works for photography and exhibition. Registrars Helle Viirlaid and Bill Jeffries ably handled the to-and-fro movement of works and guaranteed their safety. Jacqueline Chiang produced the backbone of files, forms and paperwork that kept this project on track and on time. Deanna Ferguson had a valuable role in the preparation of this book and made a substantial contribution to the development of the Selected Chronology. Rose Emery lent her remarkable memories of more than twenty-five years of gallery

activities, including numerous exhibitions of Gathie Falk's work, and her refined ability to track down errant information. Finally, Lead Preparator Bruce Wiedrick and the preparation staff skillfully resolved the challenging range of demands necessary to install these complex works. Special thanks are due to Director Alf Bogusky, Chief Curator and Associate Director Daina Augaitis, Ian Thom, Grant Arnold, Angela Mah, Linda Worrow, Lynne Kelman, Cheryl Meszaros, Brian Foreman, Nancy Kirkpatrick, Allister Brown, Jennifer Brash, Lenore Swenerton, Natacha Dobrovolsky and Tom Collins.

Robin Laurence's essay is an important contribution to the corpus of writing on Gathie Falk's art; her devotion to the project and her willingness to work within the allotted timelines and other constraints have made this collaboration a great pleasure. Mayo Graham, Sarah Milroy and Ian Thom eagerly seized the opportunity to focus on specific works and to share their insights and special knowledge. We are grateful for their contributions to the book and the exhibition as a whole.

Douglas & McIntyre's respect for Gathie Falk's art and commitment to its documentation have made this book a reality. We thank publisher Scott McIntyre, editor Saeko Usukawa and designer Mark Timmings for bringing their considerable skills to this book and ensuring its success.

The national tour of this exhibition was achieved by a unique collaboration with the National Gallery of Canada. We are very grateful to Pierre Théberge, Director of the National Gallery of Canada; Mayo Graham, Director, National Outreach and International Relations; Martha King, Head of the Travelling Exhibitions program, and Diana Nemiroff, Curator of Contemporary Art, for their part in the success of this project. Their skills and knowledge have substantially enhanced this exhibition, publication and tour.

This project would not have been possible without the backing of a number of sponsors, notably the generous support of The Canada Council for the Arts, which has ensured the exhibition's success. Our supporting sponsor Hemlock Pinters Ltd., and our media sponsors The Vancouver Sun, CBC British Columbia Radio-Television and Maclean's, have made substantial contributions. We are most grateful to all of them for their assistance.

Bruce Grenville, Senior Curator, Vancouver Art Gallery

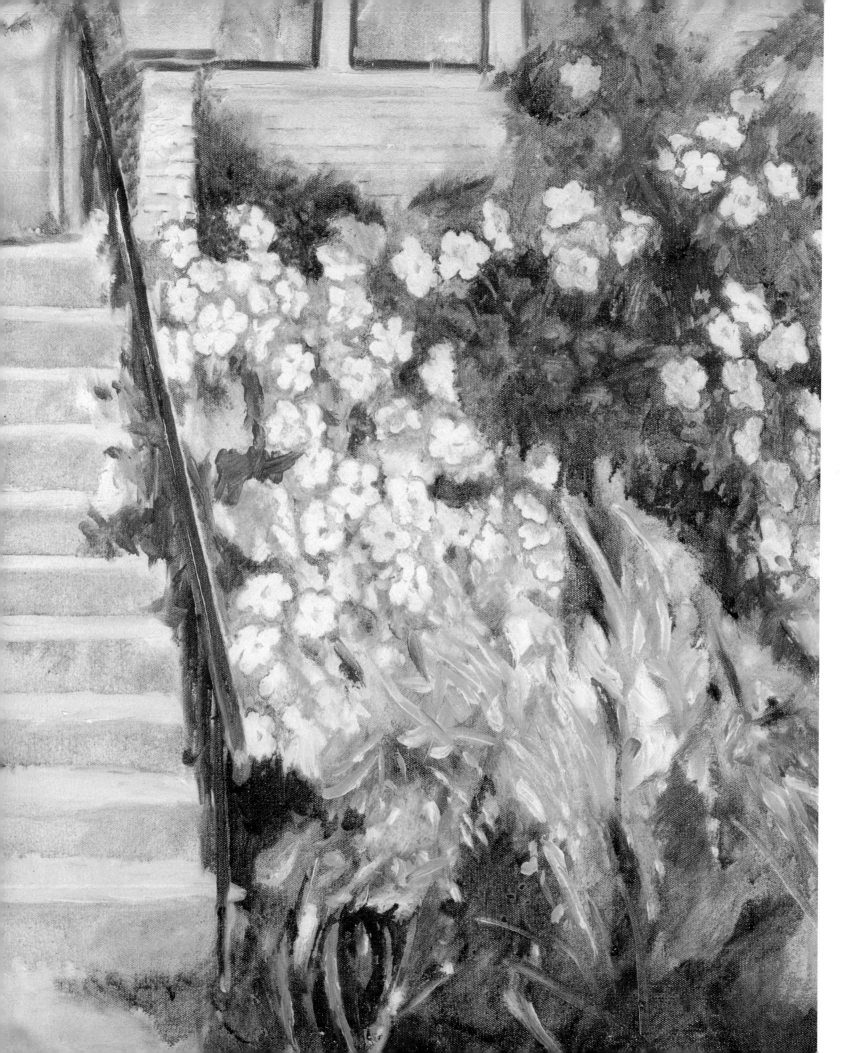

To Be a Pilgrim

by Robin Laurence

From the bus stop, you turn onto a street of half-hearted enterprise and partial dereliction. At one end of the block stands a first-aid training centre, dummies strewn like hurricane victims across its carpeted floor. At the other end stands a corner market, the slumped and fading signs in its windows advertising chewing gum and chocolate chip cookies to non-existent customers. Between these shabby ports, the businesses range from null to marginal: two defunct restaurants, a series of unpeopled storefront offices, a small millwork, a kitchen-counter factory, a fluorescent-lighting shop and an autobody shop emitting toxic-smelling fumes. Opposite the autobody is a row of hard-luck apartments, one of them with an antique wooden shoe last sitting on its windowsill.

At the far end of the block, you turn again — into another landscape, another notion of what a city should look like. It's a well-groomed residential neighbourhood, a neighbourhood from which industry and dereliction have been banished. Spreading cherry trees line the street, their rounded forms seeming to float like cumulus clouds just above the horizon. You walk another block, crest the hill, and look out onto a neighbourhood that was once a still arm of the ocean.

Partway down the hill, a row of elderly cedar trees, twined round with pale-blossomed clematis, marks the eastern edge of Gathie Falk's property. Garden growth surges over the pebbled terraces and retaining walls and along either edge of the sidewalk. Poppies, geraniums, rhododendrons and azaleas clamour and bloom in lusty and extravagant colours: crimson, magenta, cadmium red, fuchsia. Bluebells, cinquefoil and sweet woodruff chime their more modest notes and hues. Other chords of colour and texture are struck by the Irish moss, English lavender and Persian forget-me-nots, by the daisies, lupines and wallflowers, by soapwort, spiderwort and dusty miller.

Roses range through shapes, seasons and degrees of cultivation: some are as big and complex as cabbages, some are small and simple, one step removed from the wild. Some are rare, some are common, some are new, some are old; some are in full bloom on this late-spring day, and some are saving their flower faces for the religious festivals after which they have been named.

Also planted in the front yard are young cypress, fir, and Alberta spruce trees. The latter are compact and shapely, like miniature Christmas trees; they've been a recurring motif in Falk's art since 1968. Rose trees have recurred in her work, too, and their forms are reiterated here by the topiary holly bushes on either side of her front door. Above that door, across the pale-yellow face of the house, is a frieze of bas-relief tiles designed by Falk, each bearing the image of a large leaf and small tendril. The house itself, the garden that surrounds it, and the courtyard and studio behind, were also designed by Falk.

Inside the house, you sit on a blue-striped sofa and talk over tea and homemade scones. French-paned windows run floor to high ceiling; a piano with sheet

17

music and a hymnal stands near the door; paintings, sculptures and big vases of cut flowers abound. A slipper chair covered in green velour sits by the central stairway, opposite a still-life painting of the same green velour chair. A black dog snores on a cushion beside the sofa; an orange cat, its eyes the colour of celadon glaze, hops into your lap and purrs. In the painting behind you, a rabbit-dog hybrid leaps over a sink in an ecstatic arc of light. Somewhere in the house, a mechanical cuckoo calls out the hours and a still-life watercolour — you know this, having toured past it — quotes words from a hymn based on a passage in John Bunyan's *Pilgrim's Progress*:

> Who would true valour see,
> Let him come hither;
> One here will constant be,
> Come wind, come weather.
> There's no discouragement
> Shall make him once relent
> His first avow'd intent
> To be a pilgrim.

You absorb all the details of the artist's environment and reflect on how they accord with the imagery in her art. And you argue with her. Falk could not be more generous, more forthcoming, more agreeable, but nevertheless, you argue with her. You insist on imposing meanings and intentions, making symbols out of her images and signs out of her humble motifs. Falk responds that she is first of all a colourist. She says she would like — but does not expect — a formalist critique of her work, an appreciation of the way she has constructed a painting, for instance, its colour and mass, balance and dynamism, whether it is "strong, weak, fresh, tired," because these are the things that preoccupy her as she works.[1] She also says that her art operates on an emotional plane; its meanings cannot necessarily be translated into words. The subject matter signifies, of course, but it sorts itself out at an unconscious level. You contend that her art is rich with metaphor and that its iconography and iconology must be deciphered.[2] Because you are a critic, you think you have a right to say this. You eat another scone. Delicious.

Gathie Falk has created extraordinary art out of the most ordinary objects and activities. Through a range of mediums and disciplines — most notably sculpture, performance art, installation art and painting — she has laid unshakable claim to the realm of the everyday. A phrase attached to her work in the 1970s (Falk recalls that she composed it herself and fed it to the media) is "the veneration of the ordinary." It's a phrase that critics and curators continue to invoke. As a function of that veneration, she has often treated her everyday, ordinary or even banal subjects as if they were precious artifacts or religious icons, placing them in shrine-like cabinets or vitrine-like cases or upon tall pedestals. The shrines themselves, whether drawn, painted, sculpted or found, have also been derived from the ordinary; they might be tool cabinets, hotel-room sinks, shoeboxes or the wooden seats of kitchen chairs.

During the course of her career, Falk has evolved a distinctive visual vocabulary, a lexicon of images that have engaged her creative interest again and again. These images encompass the natural, domesticated and manufactured worlds, and include apples, eggs, watermelons, fish, fire, light bulbs, tulips, roses, rose trees, spruce trees, garden stakes, birds, shoes, clothes, chairs, tables, clouds and shadows. Compelling as these images are to Falk, however, and as frequently as they recur in her work, she is reluctant to pin them with any fixed meaning or to assign them any overtly symbolic intent. With very few exceptions, her art is neither didactic nor consciously political; it doesn't illustrate cultural theory, critique modernism or deconstruct history. It doesn't seek to employ archetypes, either. In fact, Falk doesn't like the notion of universal symbols or archetypes; she finds the pre-assignment of cultural meaning too limiting, too constraining, too unstimulating. She believes in "personal symbols" shaped by the particular conditions and individ-

ual circumstances of each artist's life. She also reads those conditions and circumstances in a different way from others; something that might look morbid to you would look beautiful to Falk. For years, whenever she found a dead bird, she would put it in her freezer, planning to have it stuffed and mounted. She thought it too lovely to lose.

Images come to Falk "unbidden," she says. They "go boing" in her head and wordlessly demand formal and material resolution in her work. Often these images go boing as she is taking a walk around her neighbourhood. The seed of an image or idea will press upon her mind until she can fully develop it, fully realize it in clay or paint or performance or papier-mâché. She may repeat images or motifs within the same work or series of works, and sometimes through many series over the course of years, even decades. Her practice of repetition and serialism, together with her often-surreal juxtapositions — a fish tied with a yellow ribbon to the back of a kitchen chair, a maple leaf nailed to the side of a case, festive streamers dangling over rows of ghostly cabbages — suggest that her images are loaded with significance, loaded with the raw materials of iconographers and iconologists.

Still, as often occurs with images that emerge from the unconscious, rational intention cannot necessarily be assigned to a practice which intuitively converts fragmented or singular visions into complete and complex artworks. Falk says that she does not set out to put messages into her art, but through the process of working out an image, will often derive a message from it. Viewers, too, derive messages from her art, some relevant to the artist's own understanding of what she does, some not, although she is usually tolerant of differing opinions. "I always agree that a critic or historian has her own interpretation and can use that," she says. "I've never thought that my way of looking at things is the only way."

Falk is a devout Christian who prays often and fervently, sings hymns every day, regularly attends church services, undertakes generous and unadvertised acts of charity, has a powerful sense of community and is deeply committed to pacifism. On a couple of occasions during the past fifteen years, attempts have been made to read her art in the light of the tenets and ceremonies of the Mennonite Church in which she was raised and baptised.[3] But although Falk says that life without her faith is unthinkable, she resists a close religious interpretation of her imagery. She also resists being characterized as a "Christian artist."[4] Her art, she reasons, is not Christian art because it does not depict "scenes from the Bible or people praying."[5] Still, despite her protests, and despite all the postmodern, anti-reductivist arguments lined up against biographical readings of contemporary art, it is difficult to disentangle what Falk does from who she is. It's especially difficult given the way everyday life informs her practice. Her house, her garden, her friends, her family, her pets, her furniture, her cloverleaf tea cups, her communion-like rituals of food and drink: all these things speak to her artmaking — and her artmaking to them.

And so you continue to argue with her — but amiably. You see men's suits as symbols of corporate power while Falk sees them as portraits of ordinary humanity. You sip your tea while Falk sips her coffee, and eventually you find a place of agreement. You concur that her art embraces a number of opposites: life and death, light and shadow, surface and substance, loveliness and ugliness, celebration and lamentation. Between the poles of these oppositions, any number of readings is possible. When Falk shines the enquiring light of her art upon an ordinary object or act, she transforms it. Its ordinariness becomes beautiful. Or terrible. Or both.

Sometimes family photos compress significant histories into their monotone moments, sometimes they portend the future. Both past and future, history and portent, are compressed within a single Falk family photograph taken in Oxbow, Saskatchewan, in November 1928. A plainly dressed woman in her early thirties, a baby girl in her arms and two little boys at her side, stands between an unadorned plank house and a

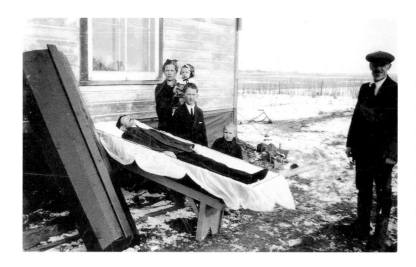

The death of Gathie Falk's father: Cornelius Falk in coffin, Agatha Falk with Gathie in her arms, Jack in front of them, then Gordon, unknown man at right, at Oxbow, Saskatchewan, 1928.

The story Gathie Falk recounts is that the family had warning of an impending arrest and fled immediately, packing only a few possessions including the family Bible in a small trunk and leaving the breakfast dishes still on the table. They were forced to abandon their land, their business and all their assets, and it's an indication of Cornelius Falk's character that, enterprising as he was, he chose not to acquire property in his new homeland. He interpreted the great losses he had sustained as an opportunity to live a more spiritual and less material existence. A gifted violinist, singer and choral director, he refused an opportunity to teach music at a college in the northern United States. He was enacting, it seems, some form of atonement, and that is why, when he died of pneumonia at the age of thirty-one just before the start of the Great Depression, his family was left homeless and penniless.

Poverty and hard work conditioned Gathie Falk's childhood, teens and early adult life, but she has said many times that she did not feel deprived.[6] She remembers having good food, clean and pleasant surroundings and bountiful gardens — all the work of her mother's hand. She remembers, too, her mother's innate creativity and resourcefulness: Agatha sewed beautiful clothes without using patterns; made cloth shoes with braided hemp soles; appliquéd floral patterns on rugs she'd patched together from old woollen coats; decorated her gardens with painted rocks. Still, Gathie was acutely aware that she had no father. "There was definitely an 'absent father' in my childhood, and I always thought if he were there, things would be better," she says. "I prayed for my father to return." Stories of Cornelius Falk's character and accomplishments were told and retold within the family, and Gathie was likened to him, to this man of whom she had no conscious memory but considerable admiration. "I felt very close to [my father] and missed him dreadfully," she has said. "Dreadfully."[7]

After Cornelius's death, the family moved frequently, dependent upon the charity of friends and relatives. Falk's earliest memories were formed in Hochfeld, a Men-

rough wooden coffin. Laid out in the coffin is the corpse of a dark-haired man; he is the woman's husband, the father of her three young children. The white sheet he's lying on and the angle of the camera conspire to make his body look as flat and featureless as his clothing — as if he weren't actually wearing his suit, as if his corporeal being had already departed along with his soul. An unidentified man, a friend perhaps or possibly the coffin maker, stands apart from the others. Behind the family group, the prairie landscape is as desolate as their transformed lives. Winter stretches to the far horizon.

Two years earlier, Cornelius and Agatha Falk, together with their sons Jack and Gordon, had emigrated to Canada from Orenburg in the Ural Mountains of southern Russia. Their daughter, Gathie (a pet name for Agatha), was born in Alexander, Manitoba, on January 31, 1928, a Canadian citizen. The Falks were just a few of the twenty-one thousand Mennonites who arrived in Canada during the 1920s. Many settled on the prairies, where they homesteaded and established close-knit farming communities. Most were escaping the political and religious persecution directed toward Russia's German-speaking Mennonite communities following the Bolshevik revolution.

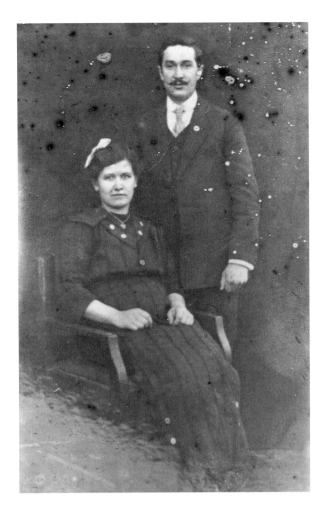

Gathie Falk's parents, Agatha and Cornelius Falk, Russia, c. 1914.

Other early memories and early sensations also reach into the future to her art: breaking watermelons over her knee in hot summer fields, disliking the stickiness on her leg but loving the flavour and colour; receiving a gift of ripe, red cherries — more delicious flavour and colour; "wailing and yelling" in protest at being put to bed for an afternoon nap, then waking up and being given an egg — a precious thing, perfect in form — to take to the grocery shop to exchange for candy; playing games with her brothers in which chairs were rearranged or upturned and used as props; visiting friends in another village and seeing their pond and garden as something splendid — a kind of paradise. There were the requisite childhood horrors, too, anecdotes of the prairie-gothic variety, including the trapping of gophers by her brother (a two-cent bounty was paid on each tail), and the spring migrations of thousands and thousands of garter snakes through the community. Falk attributes her lifelong fear of snakes to those yearly migrations; the village boys would pick up the harmless creatures and throw them at the little girls.

When Gathie was five, her mother remarried and the family moved to Resor, another Mennonite community, near Timmins in northern Ontario. Although Gathie has spoken about her stepfather in the past, his bad temper, his drinking and his beatings of her brothers, she now is reluctant to name or describe him or to recount what finally drove her mother to leave him. Given Agatha Falk's religious, cultural and economic circumstances, abandoning her marriage was an unthinkable act, but Gathie sees it as resolute and courageous.[8] Gathie's own memories of the two years spent in Resor are mixed. She had acquired five stepsiblings, three sisters and two brothers, and recalls games with them in the woods, playing school and fashioning sofas and chairs out of deep moss (another artmaking portent, given the recurrence of furniture in Falk's adult paintings, performances and installations). And there was the opening of a wondrous doorway into literature: Gathie learned to read in Resor's one-room schoolhouse.

nonite farming village near Winkler in southern Manitoba, where the family settled when she was two. Her first memory is of moving day, of very carefully carrying a square blue box into the house and as carefully placing it on the floor beside a whitewashed Russian stove. This is a remembrance that she has often repeated in interviews, and it's easy to see the nascent formalist in the vivid impression of colour, shape and spatial relationship. It's also possible to divine Falk's future performance art in her early mindfulness of the objects and tasks of the everyday. Her second memory, also from the age of two, is of sitting on a window ledge and saying "scissors." Associated with this memory is one of cutting a hole in a piece of cloth and fashioning a dress out of it, a harbinger of the recurring motifs of clothing in her art. "I was a maker from the earliest days," Falk says.

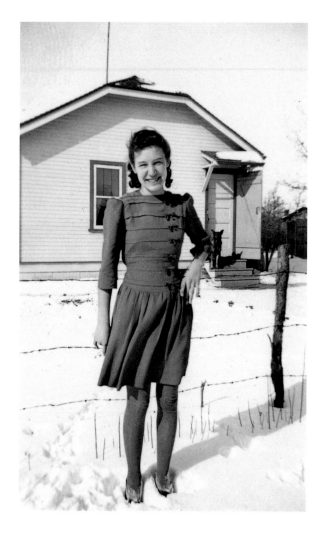

Gathie Falk in a dress of her own design sewn by her mother, Winnipeg, c. 1940.

After two years of marriage, Agatha moved with her children to Winnipeg, where the family patched together a small income with some meagre government assistance. They settled in a little red house in North Kildonan, a rural municipality of Mennonite origin on the city's outskirts. Throughout public school, Falk was a top student and a prodigious reader. Books, especially fiction, became more and more important to her, more and more of a delight and an escape. Drawing was a means of escape, too, and she remembers her fifth-grade teacher penalizing her for drawing during a geography lesson by forcing her to stand at the front of the classroom along with her delinquent artworks. (At that point in her life, she drew the same images over and over: dolls with elaborate curls, carriages and accessories, and glamorous women in fur coats and evening gowns. Later, she would make faithful drawings of movie stars, copied from newspaper or magazine photographs.) Falk's reaction was one of mixed embarrassment and pride, since her intended punishment was also "a mark of distinction." The teacher's feelings must have been mixed, too; although she seemed hostile at the time, she later recommended that Falk attend Saturday-morning art classes at the Winnipeg Art Gallery.

Earlier, unsanctioned trips to the gallery had taken place with her brother Gordon, as part of their long treks from the suburbs to downtown, often on hooky-playing days. These treks included trailing through the Bay and Eaton's, running around the provincial legislature building and exploring the civic auditorium, site then of Winnipeg's small museum and art gallery. Gathie and Gordie would make their way past the ground-floor exhibits of stuffed animals to the upstairs gallery, never officially open when they visited, at least not in her memory. The two sat on the floor in the dark, waiting for the pictures to resolve themselves out of the gloom. What resolved were large, old, brown oil paintings, undistinguished examples of European art.

The Saturday-morning art classes that Falk began attending at the age of thirteen, classes which were supposed to be a privilege, were an alien and unhappy experience. The young art students were directed to paint the animals in the museum exhibits, "a very fearful exercise" for Falk, who previously had drawn from her imagination or from magazine photos but who had no idea how to render a three-dimensional object from life (or death) on a two-dimensional surface. The class was assigned other subjects, too, and she remembers painting an image of a Thanksgiving table and refusing an instructor's suggestion to make the tablecloth red. "I was pretty stubborn in my mind as to what you did and what you didn't do," she says. Stubborn, yes, but she was also intimidated by how well the other students drew. What finally killed this first art-education experience for Falk, however, was the red dog.

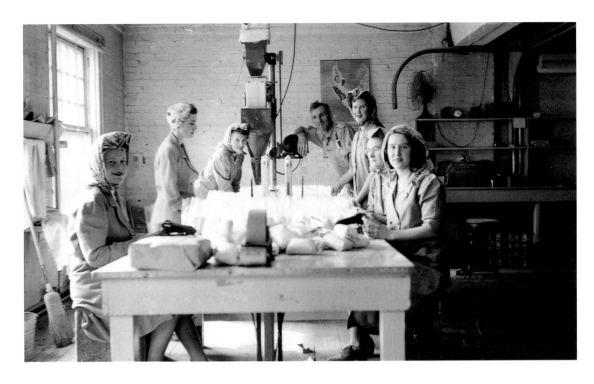

Gathie Falk (far right) and coworkers at packing plant, Winnipeg, c. 1945.

During a session of art appreciation, the class was shown a reproduction of a Paul Gauguin painting, a symbol-laden Polynesian scene with a vivid red dog in the foreground. She disliked the flat way the work was painted, and her adolescent sense of reality was so offended by the red dog that she never returned to the art class.

Falk continued to draw at home, working in pastels, and also collected images that appealed to her — photographs and art reproductions from newspapers and magazines — and mounted them in scrapbooks. For the next ten years, however, most of her creative energies and aspirations were focussed on music. She achieved distinction in her community as a choral singer and, at fifteen, began to exchange babysitting duties for voice lessons. Falk also took music-theory lessons, paid for by an anonymous benefactor. Although she had a fierce determination to be a musician, this determination was often undermined by extreme nervousness during performance, a nervousness she never learned to control. "Sometimes I sang well," she recalls, "sometimes I sang dreadfully."

The singing lessons occurred during the latter years of the Second World War, at a time when the family's financial situation had eased a little; Falk's brother Gordon had enlisted in the army and was sending home some of his modest pay. But the family's period of financial respite was short-lived. Gathie's other brother, Jack, moved away and married, Gordon left the army, and Canadian Pacific tracked down Falk's mother to demand payment for the family's passage to Canada from Europe eighteen years earlier. Gathie was forced to quit school at sixteen and work to pay off the debt. She spent two years packaging raisins, dates, peas, beans, brown sugar and chocolate rosebuds in a warehouse, but it was not the menial work so much as leaving school that upset her. She adored learning, and to have her education cut off after grade nine was "very, very distressing." Fortunately, a chance conversation with an acquaintance alerted her to the possibility of finishing her high-school education by correspondence. She studied nights and weekends, and finished grade ten with honours, one of the top students in the province, despite her full-time job. Music lessons, however, had to be relinquished. Still, Falk had an active choral and social life through the church and attended a Mennonite girls' club led by Mia de Fehr, a proto-feminist and an important mentor.

Mennonite Girls Club, with Gathie Falk (seated, far right) and Mrs. Mia de Fehr (centre), Winnipeg, 1944.

De Fehr was a woman of extraordinary character (fleeing persecution, she had walked across Russia to China) and education, who urged the young women to "accomplish something" before marriage. Her advice struck a sympathetic chord with Falk, who even as a young girl had chafed against the social constraints imposed upon her sex. "I couldn't see why girls couldn't do things that boys could."

In 1944, Gathie had been baptized a Christian (adult baptism is a central article of faith among Mennonites) and had become a member of the Mennonite Brethren Church. She earlier had experienced a few troubling doubts, but overcame them and decided that her faith was more important than what she saw as her too-worldly preoccupations, her interest in movie stars, for instance. By sixteen, the movie stars had been fully banished, and Gathie's baptism was an occasion of great joy for her.

In 1946, after paying off the debt to Canadian Pacific, Falk moved with her mother to Chilliwack in southern British Columbia, to be closer to Agatha's cousins in Yale and Sardis and to Jack, who was living in Vancouver. Again, Gathie was responsible for her mother's support, and again she took on menial work: chicken plucking, raspberry picking and waiting table. But she longed for a more urban environment, and after eight months, moved with her mother to Vancouver, into rented rooms. By this time, Gordon too was living in the city.

In Vancouver, Gathie found a compatible Mennonite church and community and secured work in a luggage factory, sewing pockets into suitcases. This job has been much remarked upon by critics and curators as formative to her capacity for detailed handiwork and repetition within the context of artmaking. (Her warehouse packing work has also been seen as significant to her later art prac-

tice of placing objects and images inside boxes, cabinets and cases.⁹) Although she started off badly, breaking "hundreds" of needles while learning to operate the power sewing machines, she eventually became the speediest worker in the factory. She could not, however, convince her boss to pay her as much as he was paying his male employees.

However inequitable and tedious the pocket-making job may have been, first in one factory, then another, the years from 1947 to 1952 were crammed with activity. While working full-time, Falk took violin and music-theory lessons, played in a church orchestra, sang in two choirs, participated in a number of social activities at her church, read compulsively, completed grades eleven and twelve by correspondence, and saved enough money to make a down payment on a small house. She also continued to draw periodically, copying pictures and rendering portraits in pastel, and recalls taking a pastel drawing of a young child, copied freehand from a newspaper photograph, to the art department of Eaton's in downtown Vancouver, hoping for a critique. (Falk had previously spent time looking at art books in Eaton's, and her association with the department store seems, incongruously enough, to have been one of culture and learning. Indeed, in that time and place, Eaton's was one of the few serious dealers in art.) The Eaton's clerk accused Falk of having merely coloured over a photograph, and she left feeling humiliated and degraded. On another occasion, Falk tried to find an art teacher with whom she might talk. She visited the Vancouver School of Art, but it was not in session, and although she was given the address of one of its instructors and searched for the place, she failed to find it.

The impulse to make art was struggling, in a naive and inchoate way, to realize itself. Falk was searching for a means and a measure of being *good* at what she did, despite having little time, few opportunities and no encouragement to develop as an artist. Then, in the early 1950s, she experienced a crisis with her music that was ultimately a crisis of self-expression. After having made quick progress with the violin, she hit a plateau, unable to further improve. Quite suddenly, she understood that she would never achieve her long-dreamed-of career in music. Disheartened and discouraged, she began to experience debilitating rheumatic pain in her arms and shoulders. (In retrospect, Falk believes the symptoms were triggered by her deep anxiety.) Because of her pain and obvious desperation, her mother and her music teacher jointly decided she must make a change of occupation. Falk also saw the need for change, but was too unsure of herself to declare her desire to be an artist. Her future was set out by her elders: she must become a schoolteacher.

Despite having absolutely no desire to teach, Falk allowed herself to be carried along by the scheme. In 1952, she made arrangements for her brothers to support their mother for a year while she attended teacher training at the Normal School. She also worked in the luggage factory at night and cleaned houses on weekends in order to support herself.

The extent of Falk's art education at Normal School was to learn, as a child would learn, primitive printmaking and clay-modelling techniques. More interesting was the after-school art club she joined, which held activities such as life drawing and art appreciation. Falk's natural talents were acknowledged and she was greatly encouraged. During the year at Normal School, she had a modern-art epiphany, appropriately enough occasioned by looking at some Gauguin reproductions in the window of a framing shop. (There's a tidy symmetry in the closing down of her appreciation of modern art in her early teens and its reopening a decade later.) Quite suddenly, she saw the expressive possibilities of colour and form, and understood the creative significance of the passages of Post-Impressionist flatness.

Falk's first teaching position was a grade three-four split at a school so overpopulated that classes were taught in shifts and the curriculum had to be compressed into half days. A small horror — portent of a larger and protracted one — occurred after that first stint of teaching. Instead of being able to live for two months on her last paycheque and attend teacher training courses at summer school, Falk was forced to spend July and August labouring

as a waitress, housecleaner and canning-factory worker. Agatha, who managed the household accounts and to whom Gathie had entrusted her pay, lost the entire amount. It was an inexplicable occurrence, one that could only be comprehended many years later, after Agatha had been diagnosed with Alzheimer's disease.

In the fall of 1954, Falk secured a teaching position at Douglas Road School in Burnaby, a suburb of Vancouver, where she would remain for the next eleven years. When not teaching, she pursued a bachelor's degree in education — and learned how to make art. In 1955 and 1956, she attended summer school in Victoria and, in addition to academic courses, studied design, drawing and painting with Bill West, a local artist and high-school teacher. The design course introduced her to modernist principles and colour theory, and the drawing course, in which students worked quite traditionally from still-life arrangements and the figure, laid down the fundamentals of line, form, light and shadow. Falk particularly remembers one formative exercise that West assigned his students: folding a piece of paper in multiple vertical folds or curves and drawing it illusionistically — but without shading. The mental challenge was rigorous, she recalls, and gratifying.

In 1957, Falk began taking summer courses at the University of British Columbia: drawing and painting with J.A.S. (Jim) Macdonald, and a survey art history course with Ian McNairn. Over the next few years, she took two further courses from Macdonald, a figurative painter with expressionist roots, and credits him with many of the advances she made in understanding and technique. Macdonald did not actively direct his students how to paint. Instead, he would assign them a project and then critique what they had done. Falk recalls that he would stand behind her and say things like "Everything's milking down on the left there" or "Everything's taking off into orbit over there." At first, she didn't know what he meant, but eventually, after much hard looking, she was able to see that the balance or composition was flawed. Through trial and error, she would then determine how to correct the problem.

During the next few years, Falk accelerated her art education by seeking out instruction at the Vancouver School of Art as well as at the University of British Columbia. Among her instructors were Lawren Harris, Jr. ("a dead loss"), Jacques de Tonnancour ("very, very thorough"), Audrey Doray, Bill Mayrs, David Mayrs and Ron Stonier. As an incentive to paint, despite the demands and exhaustions of teaching, she also took evening courses offered through school boards and community centres. "It was easier than getting out the paints at home, and I still seemed to need to have somebody standing behind me."[10] A painting course she took at Central High in Burnaby from Roy Oxlade (an English artist who lived briefly in Vancouver) had a significant impact on her ability to abstract an image from a figure or landscape. Oxlade's method was to forbid the use of bright colour in his class: students could paint only in monochromes of brown, grey, black and white. The process was both gruelling and exasperating, Falk recalls, but she learned how to make "a meaningful brushstroke" — and how to both abstract and depict a three-dimensional form on a flat surface. She points to the distinctive and expressive brushwork in her recent paintings to demonstrate the lasting impact of Oxlade's course on her ability to manipulate the medium.

Falk had a much longer apprenticeship than most artists and for a considerable time she felt unready to proceed on her own. But in 1962, at the age of thirty-four, she had an important revelation. "I thought, 'I don't want to hear another person's opinion. I know now what I want to do . . . I don't need to be helped along.'" She did, however, continue to take courses at the University of British Columbia, although with a greater confidence in her own facility and a greater conviction about her own direction.

Not much remains of Falk's student paintings: many were thrown out and some were given to friends, not to hang in their living rooms but to use as lining material for their basement cupboards. The oldest surviving body of work seems to be from 1962, the breakthrough year. Falk was exploring a number of subjects and genres,

including still lifes, landscapes, figures and interiors. Although she had begun exhibiting in 1960, in the *B.C. Annual* at the Vancouver Art Gallery, she was still a long way from achieving her distinctive style or visual vocabulary. Her strongest influences were American abstract expressionism and European figurative expressionism. She says that although she was very attracted to abstraction, and although she considerably abstracted her painted forms, she always needed to work from "a concrete subject."

Falk has cited Emil Nolde and Ernst Kirchner as artists whose work she early admired, but never consciously emulated.[11] She has also acknowledged her debt as a colourist to the Post-Impressionist Pierre Bonnard, and as a surrealist to the magical disjunctions of Marc Chagall and René Magritte. Being isolated in Vancouver meant that, during the 1950s, Falk saw most contemporary and historic, European and American artworks in reproduction only. Not until 1962, at the Seattle World's Fair, did she see the work of important American abstractionists "in the flesh." She was much moved by their scale, boldness and calligraphic energies. "It was stunning to stand in front of these great big marks that Motherwell painted, and Kline." She also saw works by Neo-Dada artists Jasper Johns and Robert Rauschenberg, and was much affected by Johns's gesturally painted map of the United States. That he could make such expressive art out of such an inexpressive and prosaic subject, out of such ordinariness, was a revelation.

Falk's early palette was highly keyed and emotionally charged, and her images have an intentional awkwardness about them. While heavily impasted, the forms are flattened and distorted, pushed up against the picture plane; they defy the conventions of Renaissance perspective as they declare their own powerful presence. Falk was not, she says, "into painting pretty pictures." What she was striving for was strength, emotionality, originality, intelligence—no small order for a fledgling artist. Apart from that conscious assignment, a sense of distress and foreboding characterizes the paintings of the early to mid-1960s.

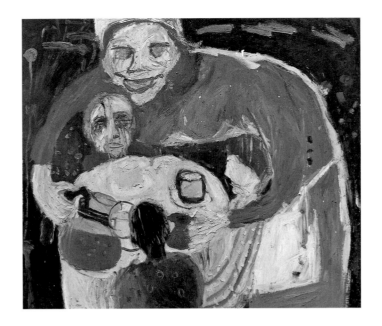

The Waitress, 1965, oil and soya oil on masonite, 76.0 x 91.5 cm, collection of the artist. Photo by Stan Douglas, Vancouver Art Gallery

The source of some of this unhappy mood might have been professional: Falk was becoming increasingly anxious to leave her teaching job and pursue her art full-time. But it might also have been personal: Falk was finding her mother's behaviour more and more frightening and less and less comprehensible.

Besides losing her short-term memory, Agatha was experiencing bursts of rage, restlessness and violent delusions, and Gathie began to fear for her own as well as her mother's safety. This "grisly fear" finds some expression in *The Staircase* (1962), a depiction of a dark interior that employs Edvard Munch-like shadows and skewed perspectives to convey a sense of lonely angst and agitation. More telling, however, is *The Waitress* (1965), in which a large, scary woman in apron and cap overwhelms three small and distraught customers sitting at a table.

Falk had been noticing, with interest, the formal and pictorial possibilities of coffee shops, cafeterias and banquet halls: the rows of custard cups and cream pitchers, the stacks of teacups and saucers, the configurations of countertops, tables and chairs. Some of that visual interest is manifest in her mid-1960s depictions of dining and banqueting, but in *The Waitress* there is a more urgent

Crucifixion I, 1966, oil on masonite, 132.0 x 121.6 cm, collection of the artist.
Photo by Stan Douglas, Vancouver Art Gallery

emotional note. Falk's own reading of the work—she sees the waitress as "a mother," a figure of both power and servitude—accords with the sense that this maternal figure is the inverse of nurturing, that she is a devouring mother, a creature of myth and fairy tale as well as flesh and blood. Certainly, the grey-faced little customer, pinned between her right arm and breast, could be that monstrous mother's prematurely aged child. Falk recalls labouring long hours on the customer's face, whose wrinkles look like the tracks of countless tears. The image bears no physical resemblance to the artist, but she identifies with it nonetheless. It's a kind of psychological self-portrait, and it speaks of her sorrow, distress and sense of helplessness.

For a time in the mid-sixties, Falk also explored the traditional subject of the Crucifixion (more sorrow and distress), but in distinctly untraditional ways. In one painting, she depicted a Christmas tree covered with myriad crucifixes instead of ornaments. In another, *Crucifixion I* (1966), the nude figure of Christ is hung upside down,

like a slaughtered animal in an abattoir. Behind Christ, the blood-red cross sends out feathery growth (again, suggestive of a conifer or Christmas tree); a tiny pink scene sketchily represents a Mennonite settlement; and the scarcely human faces and figures that line the hilltop, this strange Golgotha, communicate a stunned or smirking indifference to the violence. The perspective here is so curiously skewed and uptilted that the viewer seems to be hovering in the air above the action, like some antic spirit or astral projection.

Falk wanted to paint an upside down crucifixion (as did occur historically, she says) because "that seemed more horrible" than the conventional depiction. And horrible it is, but with a paradoxical "juicy" quality to the way it is made. The paint is thick and luscious, the figure of Christ is vividly pink and fleshy and, in the minds of some critics, phallic. Falk herself was so appalled by this sexual reading, so distressed by the way spiritual anguish could be misconstrued, that she abandoned religious scenes altogether. And not just religious scenes, she says, but any subject with a "serious message." She resolved to continue to paint expressionistically, to convey mood and emotion through colour, form and brushwork, but she would no longer invest her work with a Biblical or literary meaning that could be misinterpreted.

Around this time, Falk also painted a few self-portraits, very sad in mood, including an image of herself crucified. The image speaks less about her relationship to her faith, her job or her home life than about her sense of isolation within the contemporary art scene, she says. Having come of creative age during the 1950s, the apogee of American expressionism, she was feeling, by the mid-1960s, distinctly out of step with the times. Many of her fellow artists had leapt onto the post-painterly bandwagon and were producing hard-edge or op-art works for which she could muster little personal interest or aptitude. She remained, on foot, on the lonely path of figurative expressionism. Falk had hoped for validation and support for her

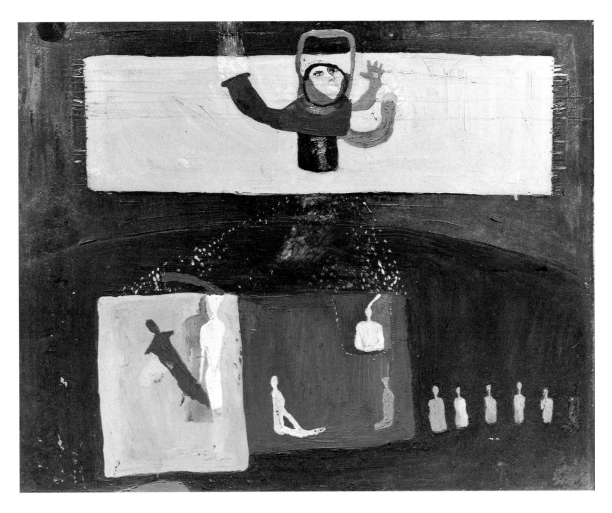

Flying Carpet with Machine & Line Up, 1966, oil and mixed paint on masonite, 80.9 x 102.0 cm, collection of the artist. Photo by Jim Gorman

art in the form of a Canada Council grant, but she could not find a sponsor for her application. She felt herself isolated and overlooked.

The year 1965 was crucial: Falk cashed in her pension and took a year's leave from her teaching job, travelled to Europe for the first time, and had her first solo exhibition. The latter took place at a commercial gallery called The Canvas Shack, in Vancouver, and was reviewed by David Watmough. He preferred her figurative works to her still lifes, and described them as possessing "vivid resources of color and a primitive crudity [generating] its own velocity."[12] In a later review, Watmough would write about the "strange and menacing themes" of the paintings, their "almost psychotic strength" and "nightmarish curves and sweeps of fantasy."[13]

However unsuited Falk felt to hard-edge abstraction, it did have an impact on her work. She reduced her tonal range and began to juxtapose her thickly impasted figures and motifs with broad, flat passages of much thinner paint. These passages are not entirely unmodulated, but they certainly contain more subdued and less expressive brushwork than in her earlier paintings. They also employ straight-sided architectural and geometric forms, although these are drawn freehand and possess a disarming wobble. The figures are faceless, with small heads and only partially articulated bodies, and were influenced by Henry Moore's wartime drawings of human figures sheltering in the London Underground, which Falk saw in London in 1965.

A series of paintings called Boxes, begun after her art-filled trip to Europe, depicts imaginary spaces: boxes

unfolding within boxes, like architectural forms or tunnels. The whole series seems to be an exercise in perception and representation, in the production and disruption of pictorial illusion. Despite their sad figures, skewed perspective and claustrophobic mood, Boxes eschew the brushiness and raw emotionalism of her portraits and crucifixions. Some of them make reference to the repetitive advertising panels that she saw in the Paris Métro, anticipating her future strategies of repetition and serialism. They also signal a new awareness of popular culture and the art that was being spawned out of it.

Falk produced Boxes alongside a strange and fantastical series of paintings titled Flying Carpets: organic shapes float above the picture plane in a manner reminiscent of Mark Rothko's amorphous abstractions. Unlike Rothko, however, Falk introduced figurative and mechanistic elements and a slightly hallucinatory mood into the composition, lending a sense of a science-fiction or fairy-tale narrative. The formal problem she set herself in these works was to create "upper and lower spaces" out of roughly rectangular and oval forms — the flying carpet or "idealistic" space above and the gritty, real-world space below — and then to establish some occasional form of movement or communication between the two realms. Such movement is enacted by tiny and extremely primitive figures and by connecting devices like pipes or ladders or speckled trails of colour. Falk admits to employing sarcasm in some of these works and, despite her earlier resolution, inserting an element of social commentary, although that commentary remains fairly oblique. Within these strange paintings of 1965–66, however, are isolated images that will recur more significantly later, such as a man's suit jacket and a topiary tree in a pot.

These were to be Falk's last paintings for over a decade. In 1964, she had started studying ceramics at the University of British Columbia. It was her good fortune, she has said, that her ceramic teacher was Glenn Lewis. A gifted ceramicist, Lewis had apprenticed with the great British potter Bernard Leach in Cornwall and worked with the Canadian potter John Reeves in Devonshire. Leach advocated an attitude and æsthetics in which "art and life should penetrate one another to the heart,"[14] and Lewis, in addition to teaching the rudiments of pottery, communicated this philosophy to his students. "[Glenn] was teaching us about a simple way of living," Falk remembers. That way included a Zen-like awareness of the forms and rituals of everyday life, a unity of mind and spirit, and a disavowal of overconsumption and materialism. Falk recognized the plainness, mindfulness, frugality and anti-materialism from the teachings of her own religion. She later observed that the simplicity and control in her art owed something to Mennonitism. "If you have a strong religion, you're disciplined in your life."[15]

Previous to her ceramics courses, Falk had felt little interest in creating three-dimensional art and remembers telling Jim Macdonald that she didn't know how to look at abstract sculpture because she didn't know where it ended. "There's no frame," she had said. Happily, her interest in sculpting coincided with a cultural shift in attitudes toward clay, in which the medium was being liberated from its craft and functional connotations to become a vehicle for "high art" concerns. In 1966, Falk produced one of her rare political statements in art, an anti–Vietnam war sculpture titled The General Explaining Why He Had to Use Napalm. (The General could also be seen as a religious statement, since pacifism is a significant aspect of Mennonitism.) More significant, however, is that during the process of constructing the work, she experimented with separate and simplified ceramic representations of a leg, shoes, boots and a suit coat — more portents of things to come.

Through many daily economies, including shopping at thrift stores (something Lewis recommended), renting out the main floor of her house and sleeping in her unfinished basement (and, for a period, in her garage), then sharing her house with friends, Falk was able to extend her one-year leave from teaching indefinitely. She set up a small pottery business with Charmian Johnson and taught continuing education art courses until she

began to achieve institutional and public recognition for her ceramic sculpture and to make a modest income from it. In 1967, she bought an electric kiln and built a 50-cubic-foot gas kiln in her garage. That same year, she jammed a three-person show at The Canvas Shack with nearly three hundred pottery items of her own making. She wrote: "I think of pottery as pure sculpture where a strong form, warm emotional qualities, surprise, and imagination together with the strengths of tradition are combined. I think of the potter as standing in a very important, needed place in society."[16] Important as that place might be, however, Falk did not become her true self in clay until she freed herself from pottery.

Pop art, which originated in England in the late 1950s and found its most characteristic expression in the United States, was slow to reach Vancouver. By the mid-1960s, however, the art movement that took its subjects from popular culture and commonplace objects was having an impact on Falk's art practice. (Two important exhibitions of American Pop art were held in Vancouver in 1967.) Claes Oldenburg's early treatment of the everyday appears to be both formally and thematically akin to Falk's, especially the plaster sculptures of shoes, clothes, food and accessories he created during his 1961–62 *Store* project. Falk does not recall seeing the *Store* sculptures, although she does remember seeing and being jolted by a magazine photo of his mixed-media *Bedroom* ensemble. Oldenburg's *Bedroom* was hard-edged and cool, quite unlike the warmly expressionistic objects he produced for the *Store*. Still, it was concertedly about the ordinary, the commonplace, what had previously been thought of as banal.

Closely related to Pop was the Funk ceramic movement, whose cartoonish, realistic or surrealistic representations of everyday objects communicated its anti-art position. With its elements of absurd humour, satire and vulgarity, Funk emerged in California as a reaction against middle-class notions of craftsmanship and good taste and the cerebral seriousness of High Modernist abstraction. From the early 1960s, Robert Arneson (the father of Funk

Gathie Falk outside her garage studio, Vancouver, 1967.

ceramics) was making sculptures of banal household items such as toilets, toasters, typewriters and soft drink bottles.[17] Other artists followed suit.

Although Falk does not remember studying Funk art per se, she was undoubtedly exposed to it, as Glenn Lewis was himself turning from functional pottery to Funk-flavoured ceramic sculpture. However, she does remember seeing a reproduction in an art magazine of *A Shoe Named Bruce*, a Funk sculpture that triggered a significant revelation, similar to her viewing of Jasper Johns's map. Suddenly, Falk understood that sculpture did not have to be either abstract or heroic, that it could be a representation — however slick or clunky, witty or funky, naturalistic or surreal — of an everyday object. Sculpture could embrace the banal, although, being art, it could also

transform that banality, transport it into another realm of visual understanding.

Between 1966 and 1968, Falk constructed a number of everyday objects in clay, including a life-size bowler hat with a thistle, shamrock, rose and maple leaf on its brim; an Egyptian-paste tap extruding fat drops of Egyptian-paste water; a hand vacuum (also in Egyptian paste) with purple velvet bag; bowls, saucers and eggcups full of eggs glazed black, white or gold; ornately painted gift boxes with ribbon rosettes on top; women's purses, men's ties and a pair of heel-less high-heeled shoes. Falk had intended to attach the ceramic shoes to a pair of glittery plastic heels she'd found in a junk shop, but after firing, the shoes didn't fit. Eventually, she floated them in a cube of polyester resin, to ghostly and refractive effect.

Falk also began a series of Art School Teaching Aids, which were still-life interpretations in clay of historical painting movements, such as Impressionism and hard-edge abstraction. As part of this series, and at the urging of a new friend, curator Glenn Allison, Falk made three memento mori pieces, with skulls, books and candles worked in porcelain and stoneware, and with additions of actual dried flowers. Some of the Teaching Aids were finished with acrylic paint instead of glaze, and their painterly surfaces illustrate the way she was able to integrate the concerns of one discipline into another. Although she had ostensibly given up painting for sculpture, Falk was realizing painting ideas *as* sculpture. She was painting in three dimensions.

On the last day of 1967, an ambitious young art dealer named Doug Christmas invited Falk to put together a show for his cutting-edge exhibition space, the Douglas Gallery in Vancouver. She first conceived an attic "environment" (as installation art was then called) and later settled on the conceit of a living room as a way of pulling together some of the objects she had already created with many she had yet to create. "My idea was to use the stuff of blatantly bad taste in living arrangements, to change it and make a living space which might make the

flesh crawl and at the same time be visually glorious."[18] Once the theme was established, Falk worked prodigiously, making dozens more sculptures in clay and experimenting with Plexiglas, polyester resin, acetate buterate and chromed and cold-rolled metal, as mediums for augmenting, displaying and supporting the ceramic objects. As a significant element of the installation, she also collected and altered furniture, such as chairs, tables, dressers and a desk.

Falk had discovered that by repeatedly soaking fabric (either upholstery or clothing) in enamel paint and undercoat, she could harden it to simulate the appearance of glazed ceramic. She had also discovered the kitsch value of flocking. Using these methods on both handmade and found objects, she integrated their looks and apparent function. Except for a sideboard finished in candy-apple red car lacquer, the furniture was painted or flocked dark grey or peachy pink. Accessories, appliances and artworks were placed on and around the furniture; themes of food, games and clothing were reiterated throughout; framed prints were hung on the walls; plain wallpaper was silk-screened with dinner and dessert patterns; a drawing of a man's shirt and tie was mounted behind the screen of a simulated TV. *Living Room, Environmental Sculpture and Prints* opened at the Douglas Gallery in July 1968, to laudatory reviews,[19] public excitement, the admiration of her peers — and few sales. (Falk believes that the work was too new to have found a market. "People have to be told over and over again that your work is worth something," she says.) The installation and its nearly fifty components were of a kind not seen before in Vancouver. Placed in still-life arrangements, the ceramic objects interacted wittily with the altered furniture, the curious Living Room Units and the eerily frozen objects within them.

By combining the handmade and the industrially manufactured, by making artworks like ordinary objects and ordinary objects like artworks, and by attempting to surround or envelope viewers with a comprehensive environment rather than presenting them with an exhibition of separate artworks, Falk was enacting articles of Pop-

Funk-Fluxus-Neo-Dada-Happening faith. The desire was to work across categories of art production and conjoin different media and disciplines, to harvest the banal facts of modern urban existence, to stimulate an experience or a series of sensations rather than simply display work for sale within the context of the marketplace — and to "abolish the distance between art and life."[20]

Falk, however, was not trying to debunk or even demystify art but to enhance her viewers' awareness of the everyday. She was also coming to understand the power her art had to transform or disrupt that very everydayness, even as she was juxtaposing ordinariness with other, incompatible ordinariness. By attaching an oilcan to a telephone, laying a fish on a chair arm, setting a dance shoe on a checkerboard, she was discovering her own method of understated surrealism. She was discovering her own sculptural style, too, somewhere between realism and expressionism, between Pop and Funk, between the acutely observed and the humorously (or scarily) distorted.

While some critics admired the witty and playful elements in *Living Room*, others remarked on its darkness, and on Falk's ability to fold grotesquerie into beauty, horror into charm, death into everyday life.[21] Certainly, there are deathly elements in the ceramic shoes and food mummified in resin; in the plucked and eviscerated chicken in the birdcage; in the silvery-grey TV dinner (ghostly companion to the full-colour one, it also evokes thoughts of everyday life fossilized in the ashes of Pompeii). There is death, too, in the empty "throne" created out of a pink enamelled armchair, on whose arms she placed iridescent ceramic fish. A man's suit coat, also treated with pink enamel paint and decorated with a herringbone pattern, was suspended above the chair-throne as a canopy. Viewed from behind, this canopy-coat has a protective or sheltering appearance, but from the front, it looks like a hovering ghost, a spectre, a disembodied spirit. Falk says that the chair communicated to her a sense of "father or king," a paternal or sovereign presence. It also evokes a paternal or sovereign *absence*.[22]

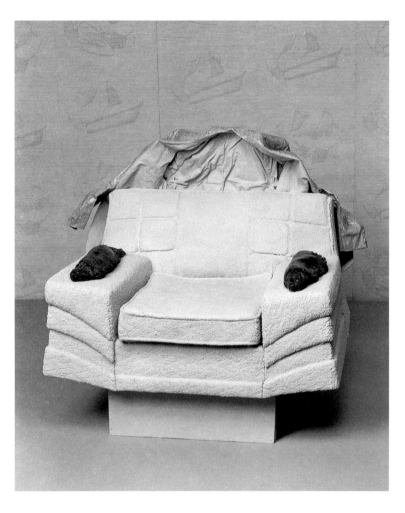

Home Environment (detail of chair), 1968, ceramic, paint, flock, varnish, polyester resin, silkscreen print, paper, Plexiglas and steel, 244.0 x 305.0 x 305.0 cm, Vancouver Art Gallery, 86.32. Photo by Jim Jardine, Vancouver Art Gallery

Living Room, later retitled *Home Environment*, legitimized Falk as a vanguard artist. Almost immediately, she was invited to stage an altered version of the piece at the Newport Harbor Art Museum in California. Other exhibitions, honours, grants and commissions followed and, eventually, sales did, too. Also significant is the emergence of some characteristic images and motifs (eggs, fruit, shoes, clothing, furniture), the early evolution of some persistent themes (what she called "the mediation of opposites," such as emotion and control, beauty and ugliness, softness and hardness), and the development of her tableau approach to sculpture. The individual still-life arrangements within the larger still life of the installation were probably its most successful aspect.[23] *(continued on page 40)*

Home Environment
1968, 1985 and 1986

by Ian M. Thom

I have worked throughout my life at mediating opposites: soft and hard, painterly and densely flat, form and space; emotion and control, beautiful and ugly. A synthesis of my work can be said to consist of a desire for control of opposites. — Gathie Falk[1]

Home Environment represented a number of firsts for Gathie Falk: her first one-person show of sculpture; her first installation work; her first serious critical attention; her first efforts at print-making; and, finally, the first opportunity to fully realize a large-scale idea. The evolution of the work is quite complex. In late 1967, Douglas Christmas invited Falk to exhibit at the Douglas Gallery in Vancouver. Initially, she was to do an attic environment, pulling together things that might be found in an old attic, but gradually the idea evolved into doing a living room. Falk began with an object that she had already made—a large pink chair with two ceramic fish placed on the arms—and eventually made a large number of other objects. These included altered furniture—painted or flocked or sometimes both—as well as ceramic games, various appliances, telephones and several prints of game boards. Altogether, there were more than forty items. These objects occupied the whole of the gallery for her 1968 exhibition *Living Room, Environmental Sculpture and Prints*. The objects were each conceived of as individual works, but the whole was also an installation piece.

The exhibition was very favourably received and some pieces were sold. As critic Marguerite Pinney noted in her *artscanada* piece, "Falk emerges from her first one-man show at the Douglas Gallery, as an artist of stature."[2] The reviews recognized several points about the exhibit: there were elements of humour and fun; Falk was very interested in ideas of transformation; there was an undercurrent of the grotesque in many of the objects; and the installation caused viewers to re-examine their own environments.[3]

Subsequently, elements of the installation were shown in several other exhibitions,[4] including the 1985 *Gathie Falk Retrospective* held at the Vancouver Art Gallery. In that exhibition, the work was retitled *Home Environment* and was defined as a room with walls and a specific scale, rather than an installation that might expand or contract depending on the vagaries of the exhibition space. When the Vancouver Art Gallery approached Falk about purchasing the work, she again revisited it in 1986. As the work now stands, it incorporates some fifteen elements, most of which were in the original installation of 1968, with the exception of *Synopsis A*, the two folded ceramic men's jackets in a small Plexiglas shrine, which also dates from 1968 but after the original installation.

A description, or at least a list, of the contents of the room will hint at the complexity of *Home Environment*: a large chair painted pink-peach, with two grey ceramic fish on the arms, and

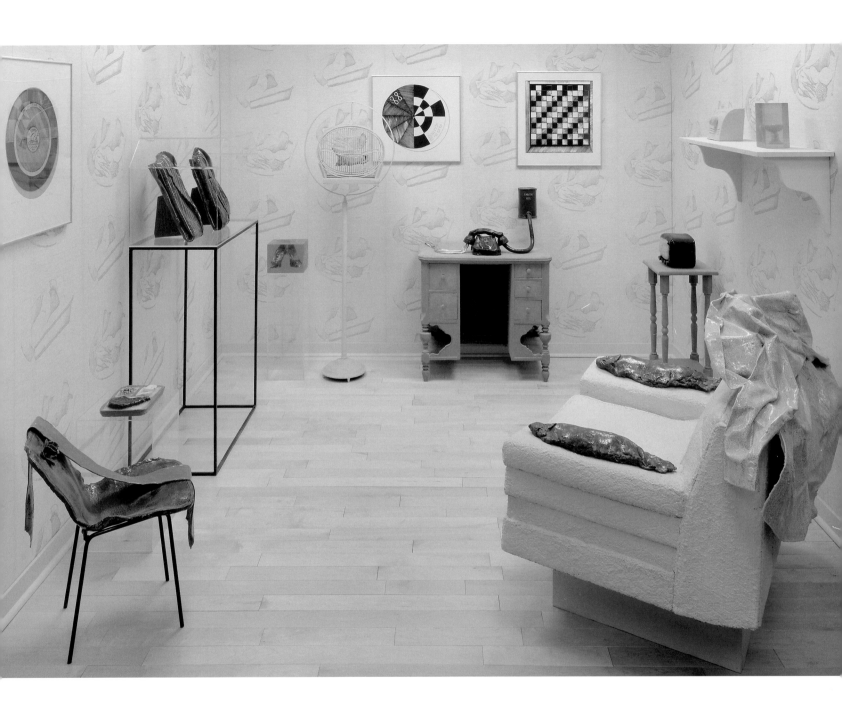

Home Environment, 1968, ceramic, paint, flock, varnish, polyester resin, silkscreen print, paper, Plexiglas and steel, 244.0 x 305.0 x 305.0 cm, Vancouver Art Gallery, 86.32. Photo by Teresa Healy, Vancouver Art Gallery

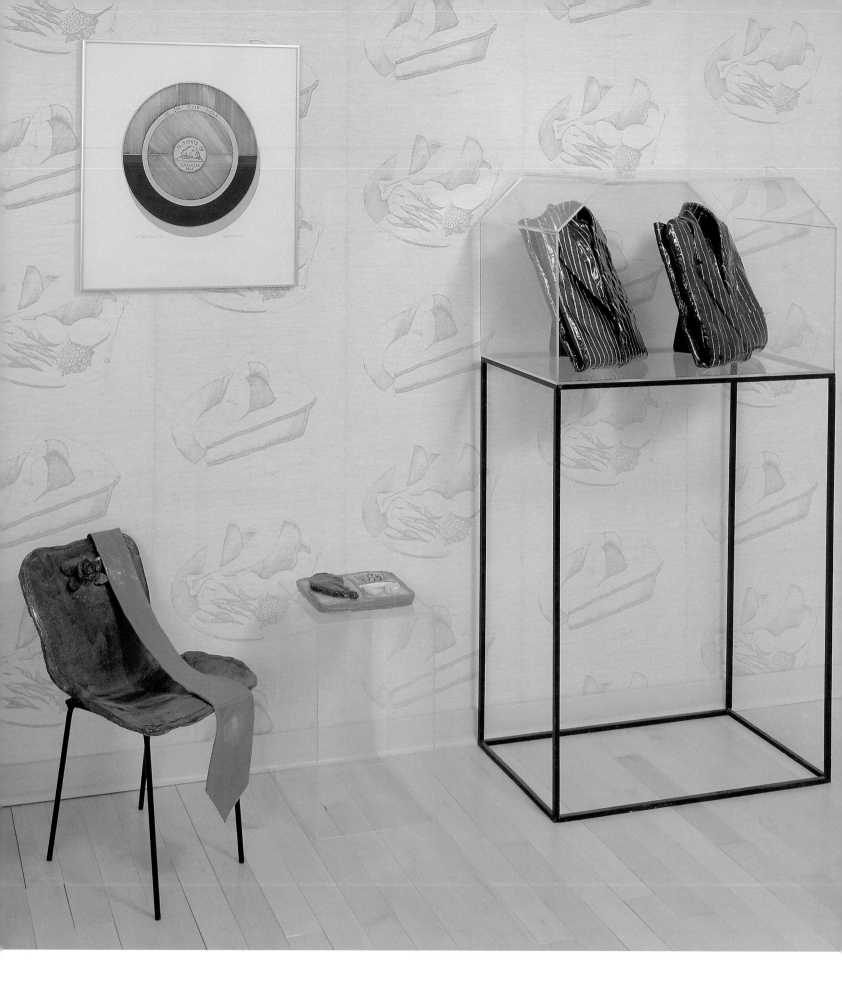

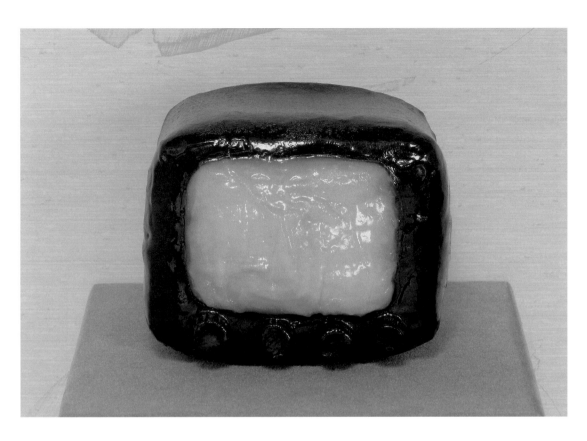

Left and above: *Home Environment* (two details), 1968. Photos by Teresa Healy, Vancouver Art Gallery

a coat, stiffened with paint and covered with a pattern of black lines and then varnished, resting on the back of it like a mantle; a ceramic chair, with metal legs, and a tie draped over it; a ceramic and resin TV dinner on a Plexiglas stand; two glazed, folded, ceramic men's jackets in a Plexiglas framing element on a metal stand; a pair of ceramic shoes embedded in resin, on a Plexiglas stand; a birdcage flocked pink, containing a ceramic plucked chicken; a ceramic telephone, connected to an oilcan and extruding a mass of ceramic silver threads, resting on a desk painted and flocked grey; a ceramic television with a resin screen, sitting on a small table painted and flocked grey; a shelf, painted pink, upon which sit a small ceramic radio and a ceramic doorknob embedded in resin; three screenprinted game boards (two modified dart boards and one checkerboard).[5] All these are contained within a small room papered with wallpaper screenprinted with images of a chicken dinner and a dessert (pie à la mode).

This installation is a complex and varied group of objects that are at once familiar and yet strange. They have a particular, almost uncanny, resonance, since Falk has very carefully controlled the selection and the placement of the objects. "The control of opposites," to which she has alluded, seems to govern *Home Environment*. Utilitarian objects are rendered un-useful by their transformation—the paint-soaked chair and coat—and other objects are made to resemble familiar ones, but always with a twist, an edge, to challenge our assumptions. What is striking, in fact, is that these strange juxtapositions work: grey fish and a pink-peach coloured chair, a

ceramic TV dinner, the ceramic plucked chicken in the birdcage. Each vignette or tableau creates a startling image, and the whole dazzles and surprises.

Falk firmly rejects iconographic interpretations of this work, and I do not propose one here. However, it is important to assess *Home Environment* for a number of reasons. Firstly, it has an extraordinary sense of æsthetic cohesiveness and is highly original. There are repeated motifs and patterns: the food on the wallpaper and the food in the TV dinner and the chicken in the cage; the deadened communications, a blank television screen and silent radio; the careful control of the colour range. Falk came to sculpture from painting, and in a sense this work is an extremely elaborate painted still life, with the added complications of a real third dimension. As with any composition, this work is filled with a series of complementary and contrasting colours and shapes—hard/soft; dark/light; open/closed. The colour scheme was dictated by the choice of grey and pink-peach flocking, and all the other decisions about colour progressed from that. Secondly, the work allows for a number of different and personal readings. While it may hint at the shallowness of much social intercourse—the oilcan and telephone suggest oily conversation—and larger issues of human society, it is also, quite simply, a wonderful visual treat. It moves from the ordinary image of the chicken dinner to the exceptional image of the chicken in a pink-flocked birdcage, from what we think we know to a realm that challenges any and all conceptions about what a home environment should be.

Home Environment asks us to stretch our understanding of media, and Falk, not originally trained as a ceramicist, makes up her own rules—painting, glazing, flocking or combining the techniques as need be. In addition, perhaps because the process of evolution to a final form was such a lengthy one, the work has a distilled quality that makes it very much a piece for both understanding the past and the present. While the work clearly dates from a historical period now past, it nevertheless retains a vital presence and relevance. We still must expand our visual and intellectual horizons to value things that are too often ignored in the lived environment. Finally, the work both honours the made—the mark of the artist—and gives credit to emotions of horror, amusement, fear and pleasure, all of which might be involved in our reading of and reactions to this work. *Home Environment* continues to have much to teach us.

Notes 1 Gathie Falk, "Home Environment," unpublished statement, 1986. Curatorial files, Vancouver Art Gallery. 2 Marguerite Pinney, "Vancouver: In the Galleries." 3 In addition to Pinney, see Joan Lowndes, "Glorious Fun-k Art of Gathie Falk," and Ann Rosenberg, "About Art . . ." 4 *The New Art of Vancouver*, Newport Harbor Art Museum, 1969, and *Survey/Sondage*, Musée des beaux-arts de Montréal, 1970; both shows travelled. Some elements of the work were also included in Alvin Balkind et al., *Vancouver: Art and Artists 1931–1983*. 5 These prints were made from screens based on Falk drawings and printed by Bill (now Terra) Bonnieman. Each print exists in an edition of approximately fifty. Bonnieman also prepared the screens for the wallpaper, but this was printed by Falk herself. Conversation with the author, 28 June 1999.

Home Environment (detail), 1968. Photo by Teresa Healy, Vancouver Art Gallery

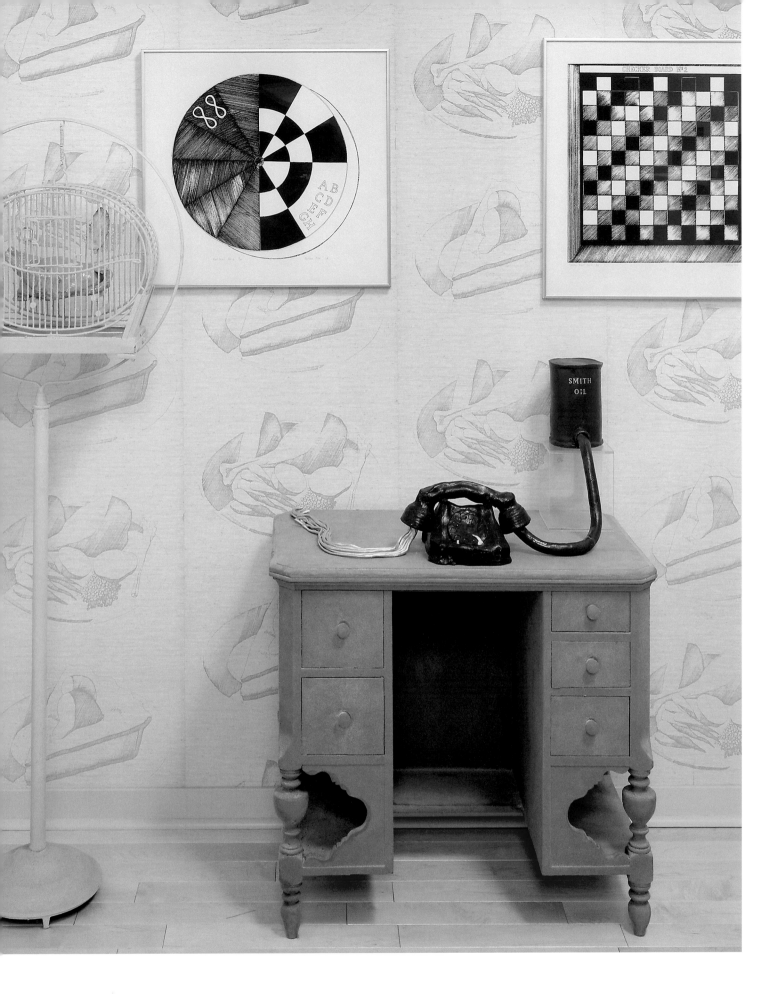

Low Clouds, performance documentation, Vancouver, 1984 (first performed at the Vancouver Art Gallery, 1972). Photo by Chick Rice

The 1960s were a time of social and cultural ferment, of counterculture protests and artistic innovation. Within that context of radical politics and youthful idealism, Falk was experiencing her own changes and personal revolutions, her own losses and gains, which could hardly be separated from the everyday subjects of her art. Critic Joan Lowndes has identified 1966 as a "pivotal year" for Vancouver's cultural life: "Gifted artists, imaginative curators, money, and a supportive art press came together to make a scene."[24] It was personally significant to Falk, too, since that is the year her mother voluntarily moved into a Mennonite nursing home. Gathie was relieved of the daily fears and stresses of Agatha's care, but she experienced a dreadful sense of loss after her mother's move, and after each regular visit to her mother over the next six years. As Falk was experiencing this loss, however, she was also building a community of friends through her art, many of whom would assist her in creating large projects and public commissions — and in performance works.

Friends such as Glenn Lewis and Michael Morris introduced Falk to ideas of interdisciplinary, collaborative and alternative forms of artmaking. She remembers convivial evenings spent talking and snacking at the New Era Social Club, a communal live-work space on Pender

Street, out of which Intermedia was born in 1967. (It dissolved in 1972.) Intermedia was an artist's collective which "served as an umbrella organization for art practices that included sound, sculpture, music, poetry, video, performance, happenings, dance, fashion, cooking, craft, printmaking, photography and filmmaking."[25] Although Falk maintained her own prolific, individual practice, she was also a member of Intermedia and participated in the happenings, performances and exhibitions it staged at the Vancouver Art Gallery and elsewhere.[26] (The gallery was a key player in the development of alternative art practices during the 1960s and hosted many of Intermedia's events.) However, she was not really disposed to relinquish authorship of her art to the collective process or the spontaneous happening. Her powerful sense of form and design, her hard-won vision and individuality as an artist, dictated a certain control over objects and actions. In April 1969, she was extremely distressed when her shredded paper sculpture *Excelsior* was incorporated into — and destroyed by — a spontaneous "happening" during an Intermedia exhibition at the VAG.[27] Involving the public in a role other than audience was not part of Falk's program.

Although she wasn't interested in audience participation, involving other performers became an important aspect of Falk's art practice, as did engaging her own body and voice in the realization of performance ideas. These were in many instances pictorial and sculptural ideas animated; they were like moving assemblages. In the summer of 1968, just a few weeks before the opening of *Living Room*, Falk had been enrolled by Doug Christmas in workshops led by Deborah Hay, a contemporary dancer turned performance artist.[28] Hay had worked with Merce Cunningham and Robert Rauschenberg and was a member of the experimental Judson Dance Theater in New York. Initially, Falk had no desire to attend what she thought would be a dance workshop, but she quickly discovered that performance art, this new form of expression, was entirely suited to her sensibilities.[29] It was formally and thematically akin to her ceramic sculpture, with the significant addition of sound and movement and the

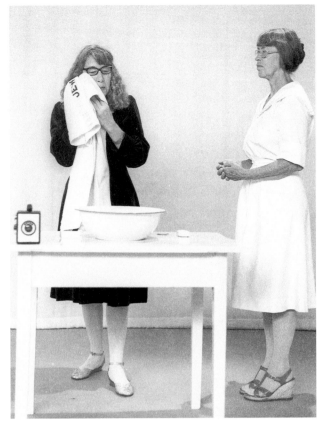

Left: *Ballet for Bass-Baritone*, performance documentation, Vancouver, 1971 (first performed at the Vancouver Art Gallery, 1971). Photo by Judi Osburn. Right: *A Bird Is Known by His Feathers Alone*, performance documentation at Capilano College, Vancouver, 1984 (first performed at the Vancouver Art Gallery, 1968; revised, 1972). Photo by Chick Rice

dimension of time. Unlike many of her peers, Falk was not concerned with using performance to disrupt or unsettle the cultural or social order.[30] "I wasn't fighting any battles," she wrote, "just doing, creating, with different material, the things I also made with more traditional materials."[31] What stimulated her interest and creative energies was the close examination of everyday life.

Although Falk's images and actions were, indeed, drawn from the everyday, her performances have a surreal or dreamlike quality in their unexpected juxtapositions and transpositions. These include sitting at an antique sewing machine amidst a setting of office desks and moving clouds, and stitching cabbage leaves together into a long chain (*Low Clouds*); using make-up to create a painting and applying syrup to her face as if it were make-up (*A Bird Is Known by His Feathers Alone*); shining the shoes of a performer as he sings an opera aria and walks backward out of the concert

hall (*Ballet for Bass-Baritone*); pouring out one hundred cups of tea and placing them on the floor (*Tea*); spray painting a red rectangle on a garden hedge (*Landscape Painting*—a nifty pun); and staging a picnic in the produce department of a supermarket. Repetition was a significant aspect of Falk's performance process, although often with small, absurd disruptions within otherwise routine movements. In *A Bird Is Known*, for instance, she oddly disordered the process of taking off her glasses, pinning back her hair, rolling up her sleeves, and washing and drying her face. She reversed and repeated the disordered process several times.

The performances were not based on Dada-esque chance or Happening-like spontaneous invention; rather, they were carefully designed and composed and often involved props, sets and rehearsals. Even so—and although Falk called her version of the new art form "Theatre Art Works" (this was before the term "performance art" had

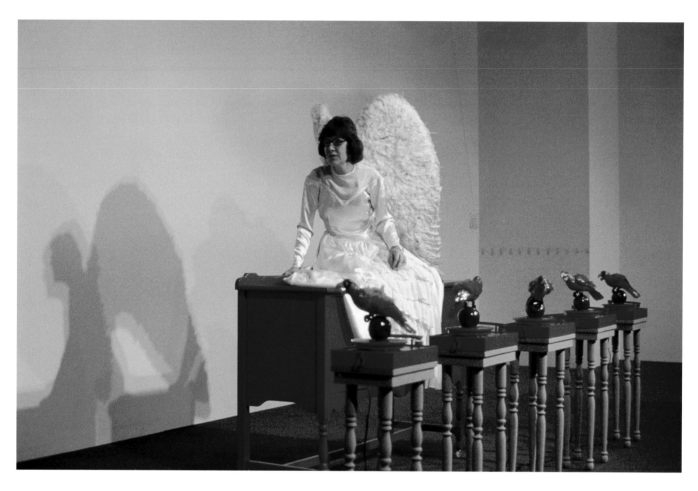

Red Angel, performance documentation at the National Gallery of Canada, Ottawa, 1975 (first performed at the Vancouver Art Gallery, 1972). Photo by Nomi Kaplan

been coined) — she warned audiences not to expect plot, character development, satire or any of the conventions of narrative theatre.[32] She especially warned them not to expect to be given fixed or easily verbalized meanings; just as the themes, motifs and repetitions of music could be experienced without story or explanation, so, she believed, could performance art. "I never think of what things mean," Falk says now of those early works. "I just think in terms of how they will look and how they will be effective."

Although the overall structure might have been based on a musical model, there were many more painterly and sculptural than musical elements. Through the placement and movement of people and props, Falk created striking and poignant still-life tableaux and landscapes. For instance, in the opening scene of *Red Angel*, which one

critic likened to a Renaissance painting of the Annunciation,[33] Falk sits in profile on a brilliant red sideboard (the same one she'd used in *Home Environment*), wearing a white satin wedding dress and huge white wings. In front of her are five assemblages, each composed of a red plastic parrot with feathers, paint and flocking; a red ceramic apple; a red turntable and a grey stand. (Although the wings give Falk the unmistakable aspect of an angel, she herself thinks of the parrots as the angels of the piece.) The scene is so pictorial, you feel you could frame it.

In another instance of intense pictorialism, maraschino cherries, plastic cocktail glasses and ceramic oranges lie scattered across the "landscape" of furniture and miniature Christmas trees in the aftermath of *A Bird Is Known*. Immense poignancy is communicated by the scene that precedes this visual composition: from the opening of the

performance, a man and a woman lie prone on oppo-
site sides of the stage. They lie this way throughout the
sequence of scenes, then begin to slowly and with diffi-
culty work their way across the floor, still on their backs
and looking only upward. The man uses his body to push
one hundred cocktail glasses containing one cherry each;
the woman, one hundred ceramic oranges. Slowly and
awkwardly, they move across the floor, and slowly and
awkwardly, without looking at each other or speaking or
touching, they manoeuvre their way around each other
and continue on toward the opposite walls. Their car-
goes of tinkling glasses, squashed cherries and rumbling
oranges, however, have met and intermingled. Falk thinks
of the two performers as "two trains shunting back and
forth and trying to pass each other." It's also possible to see
the scene as an image of the difficulty of true connection,
true understanding between men and women. At this
point in her life, Falk says, she had been in love many
times, "but always with the wrong man."

In the performances, there are more sightings
of what will become familiar images: eggs (that remem-
bered perfect form of currency from childhood), apples,
oranges, shoes, clouds, kitchen chairs, miniature Christ-
mas trees. There is also, again, the marriage of opposites:
beauty and horror, sadness and hilarity, gentleness and
brutality. Pacifist that she always has been, she created an
absurdly warlike scenario in *Drill*, in which two teams face
off, brandishing popsicles as if they were weapons, and
march toward each other as if into battle. Ultimately,
however, absurdity prevails, and the performers, with
plastic flowers in their back pockets, avoid actual violence.
Warfare or war games are an image, too, in *Some Are Egger
Than I*. Dressed like an Edwardian child, Falk performs
here solo; she alternates eating soft-boiled eggs and bat-
ting around ceramic eggs with a ruler, smashing the real
eggs that are laid out among them. The contrast between
her complacent eating scenes and her brutal scenes of
destruction is all the more powerful because of the femi-
nine inversion of weapons of war. Instead of using phallic

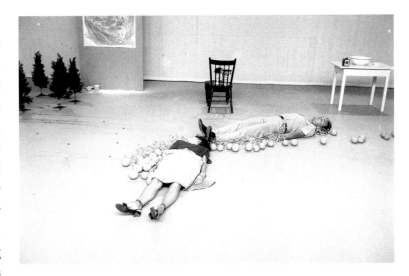

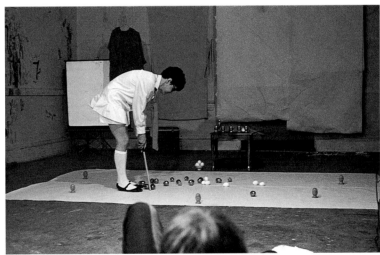

Top: *A Bird Is Known by His Feathers Alone*, performance documentation at Capi-
lano College, Vancouver, 1984 (first performed at the Vancouver Art Gallery, 1968;
revised, 1972). Photo by Chick Rice. Bottom: *Some Are Egger Than I*, performance
documentation at the New Era Social Club, Vancouver, 1969 (first performed at the
New Era Social Club, 1969). Photo by Michael de Courcy

missiles, bullets and bombs, Falk uses ova, eggs. Still, there
is the prevailing metaphor of procreation monstrously
converted to destruction.

Falk created some fifteen theatre-art pieces be-
tween 1968 and 1972 (including three short pieces for
film, with which she briefly experimented), and per-
formed them locally and in major centres across Canada
until 1977. Two of them — *Tea* and *Cross Campus Croquet*

43

—were produced in collaboration with Tom Graff, a classically trained singer whom Falk met in 1970. She describes Graff's performance work as "exotic, baroque and complicated" and credits him with influencing her own simpler style, which she opened up to include songs, dances and theatrical sets.

Performance art seems the ideal vehicle for the visual artist who was once a thwarted entertainer, for the painter and sculptor whose youthful desire had been to sing and dance and play a musical instrument. Falk did not, however, enjoy the stresses and exhaustions of being sole producer of her ephemeral and unmarketable performance works. "When you get older, you get tired of lugging around heavy boxes, looking for a round dishpan in a major Canadian city, and teaching a new crew to crow," Falk wrote about why she gave it all up.[34] An element of performance, however, lives on in her paintings and sculptures. In retrospect, Falk is seen as a pioneer of performance art in Canada, although one whose contributions have not been fully appreciated.[35]

Through the late sixties and early seventies, a number of sculptural and drawing projects evolved out of images that had begun to coalesce in *Home Environment*, and that had also found expression in the performance pieces. One image was that of a life-size, man's suit coat, folded like a shirt and installed upright within a Plexiglas "shrine" atop a tall plinth. Some of the suit coats were thrift-shop finds hardened with enamel undercoat, painted with acrylic and aluminum paint, then coated with polyester resin; others were fashioned out of clay, glazed and fired. Irrespective of origin, the folded suit coats of *Synopses A—F* take on the character of portraits or relics, their ordinariness contrasting with their almost sacred presentation. Although suits in the 1990s have become symbols of corporate power, they were not so encumbered in the 1960s. For Falk, they represented a form of dressing up that even humble folk could participate in for a solemn or holy occasion—a wedding, a funeral, a reli-

gious service. Still, *Synopses* are marked by contradictions, oppositions. Folding the suit coats into rectangles may reduce or compress their power, may add to their humility or enhance their sacredness. It may also connote absence or abandonment. There is something deeply melancholy in these unoccupied garments, as if they had been folded up after a death. But there is also something a bit comical: the dark suit coats with silver stripes, especially, read like a caricature of gangsterism.

Another related series of works, *Man Compositions*, placed found or made clothing as symbolic devices within Plexiglas cabinets or cases. These objects are almost unbearably poignant in the way they integrate elements of the feminine and the girlish with miniature evocations of masculinity. In *Man Composition #2* (1970), a little girl's red velvet shoes are set within the white porcelain ring of a man's belt, suggesting an almost magical circle of protection or guardianship. In *Man Composition #3* (1970), two porcelain lilies are juxtaposed with a porcelain shirt collar, and the formal correspondences are breathtaking, as is the sense of annunciatory purity. In both works, there is a suggestion of love and loss.

The ink drawing of a man's shirt and tie in *Home Environment* inspired a series on the same subject in the same medium between 1968 and 1970. The same image —shirt front, tie and little pocket—was also the basis of *Veneration of the White Collar Worker #1* and *#2*, Falk's first public commission. *Veneration* consisted of two ceramic murals of twenty-four panels each, installed in 1973 in the cafeteria of the new External Affairs building in Ottawa. (The panels were arranged in a grid, three panels high and eight long; each mural measured nine-and-a-half feet by twenty-eight feet.) Falk employed serial versions of the shirt front (some with ties, some without), drawing and painting directly on the prepared and slightly undulating surface of the ceramic panels. Each of the forty-eight panels had six separate components which had to be cemented together after firing. She installed the massive work with the help of Elizabeth Klassen, Tom Graff and Glenn Allison.

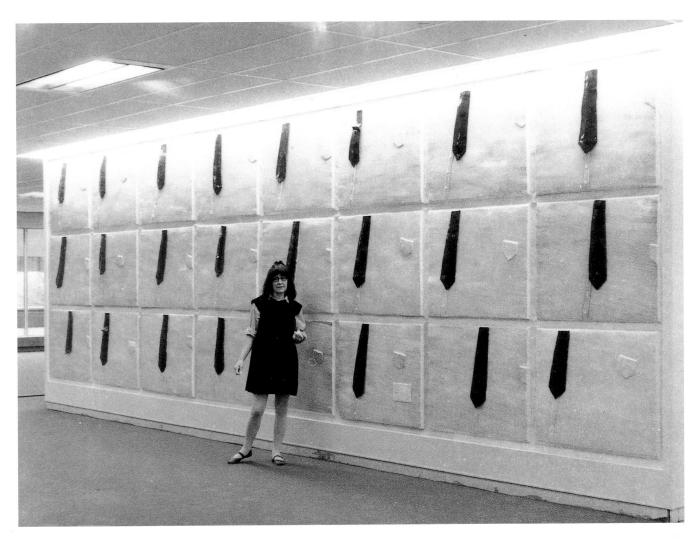

Gathie Falk in front of her newly installed *Veneration of the White Collar Worker #1*, Ottawa, 1973. Photo by Tom Graff

The title of the murals is not ironic: Falk's respect for and interest in her subject was genuine, as was her identification of the department as an essentially masculine domain. She sees ties as interesting formal devices; coloured shirts (then in vogue for men) as a delightful social phenomenon (the first mural develops variations on a white shirt with red tie, the second mural represents shirts in shades of blue); and clothing as a means of representing human beings. Even as ordinary office workers are here venerated and monumentalized, however, it's possible to perceive a little nudge of satire on the conformity, the static hierarchies of bureaucracies.[36] And for the persistently ghoulish, it's also possible to see the work as a kind of burial place, a vault, a tomb with rows and rows of commemorative plaques. As in *Home Environment* and Man Compositions, the unoccupied garments can connote lively presence or deathly absence.

Around the time that Falk was working on *Home Environment*, she also set herself a project of luscious beauty, a series of brilliantly glazed piles of ceramic fruit on which she worked for nearly three years and which culminated in a two-person show, with Glenn Lewis, at the Vancouver Art Gallery in 1970. During this same period, she was also producing individual sculptures of ceramic fruit, including wedges of watermelons, which for years sat on the floor beneath her piano; dozens of apples, which she gathered into bags, baskets or bowls in

45

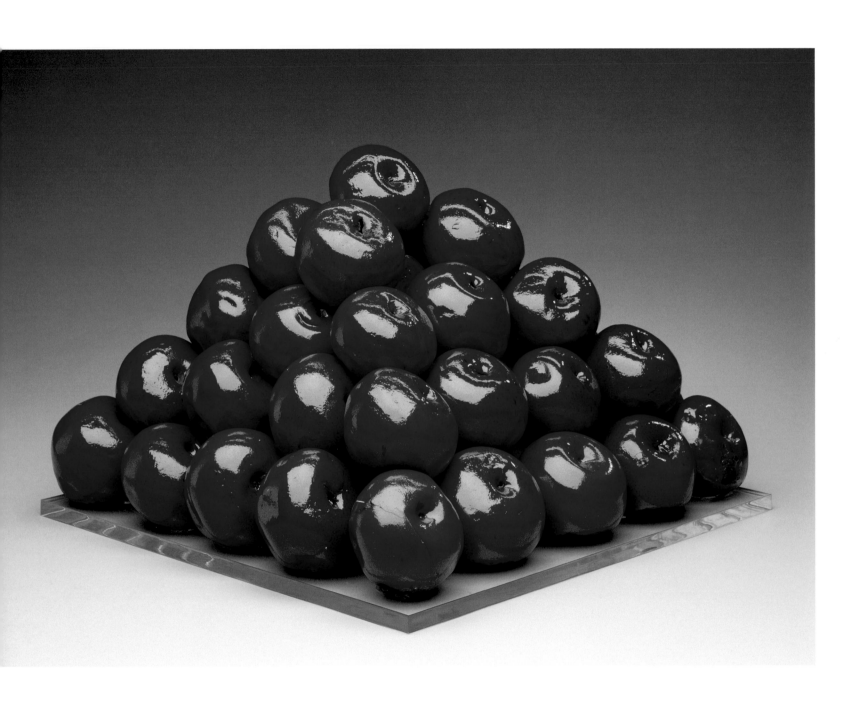

55 Rotten Apples, 1969–70, ceramic and Plexiglas stand, 30.5 x 43.8 x 47.0 cm, collection of Mr. and Mrs. John C. Kerr.
Photo by Teresa Healy, Vancouver Art Gallery

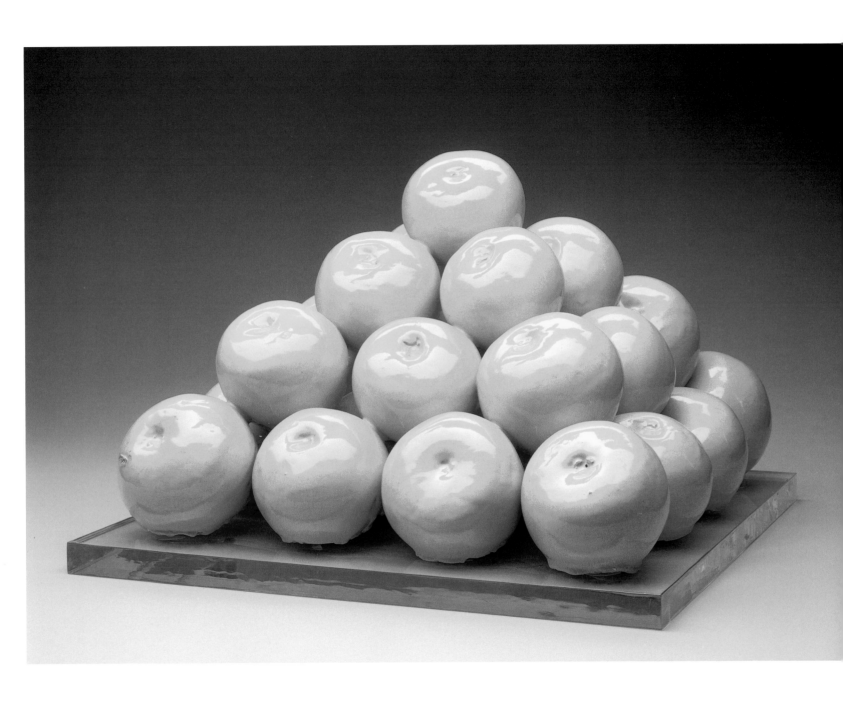

30 Grapefruit, 1970, ceramic and Plexiglas stand, 32.4 x 49.5 x 49.5 cm, Vancouver Art Gallery, 70.112.
Photo by Teresa Healy, Vancouver Art Gallery

her home; sixty-nine grapefruit, which she scattered across the floor of the Douglas Gallery; and one hundred ceramic oranges, which she used as props in her performance *A Bird Is Known by His Feathers Alone*.

Typically, Falk was inspired by her daily environment, having noticed a pyramid of apples at the corner grocery. She understood—and this is crucial to her art practice—that she could transform the simple subject through her art, make it more beautiful, more arresting, *better*. "This very ordinary thing will be made very special," she says. In addition to her attraction to the subjects of fruit and pyramid, to the organic within the geometric, there may have been another impetus to the series. Ann Rosenberg, a local critic and friend, had remarked to Falk that while her work was strong, it wasn't beautiful—not the way Glenn Lewis's work was beautiful. Falk, who admits to a streak of perverseness, said to herself, "Man, I can make beautiful if I want to." And, indeed, her Fruit Piles are gorgeous and glamorous, sensuous and richly sensual. She speaks of the quality of skin with which she imbues her ceramic objects, the "slow curves" and subtle undulations that make her fruit or clothing surrogates for the human figure.

As for Falk's perverseness, it doesn't account for the three years—1968 through 1970—of finicky, repetitive and nerve-wracking labour (especially with the ever-present possibility that the fruit could roll during firing and the whole structure could collapse[37]) that went into the production of some twenty-five fruit piles on three simple subjects: apples, oranges and grapefruit. The piles range in size from 14 to 196 pieces of fruit; each individual fruit was handthrown on the potter's wheel, its bottom shaped with a knife and the tiny blossom of each fruit's inception incised there, the texture of the orange or grapefruit impressed into the surface with a metal screen, all the hollow pieces carefully arranged for firing, then glazed and fired again.

The hundreds of fruit and dozens of fruit piles represent Falk's biggest commitment yet to serial imagery. She was not using multiple versions of the same image to critique consumerism or to undermine the unique and precious commodity status of the work of art, but because she understood that an image repeated many times has much more power than an image produced only once.

Falk was interested only in round fruits and in fruits that were decidedly ordinary, fruits that could be found in every Canadian family's refrigerator or fruit bowl. Yet even an ordinary object may carry symbolic weight. The apple, especially, is loaded with cultural and religious connotations; in the Christian West, it is the fruit of both sin and salvation. In a biographical context, it may also signify something festive, since apples were a Christmas treat during her impoverished childhood. The pyramid, too, connotes historical, architectural and religious consequence—majesty and monumentality, power and entombment. For Falk, the pyramid was both a logical and magical way to stack fruit, and possessed a touch of surreality. "It has four-square stability at the bottom but goes off into . . . intangibility at the top."[38] For the exhibition, she mounted the Fruit Piles on tall, clear, custom-built, Plexiglas plinths,[39] and the solid pyramids seemed to float in space, enhancing the sense of surreality and the contrast between the corporeal and the ethereal.

In constructing an architectural form out of organic components, Falk placed her art at the interface between nature and culture, anticipating one of postmodernism's preoccupations: the invention of the concept of nature by culture. In the performance works she was concurrently developing, Falk was also integrating the natural into the cultural, constructing "landscapes" out of furniture, fruit and fake trees, or out of office desks, cabbage leaves and painted clouds. In other works, as well, she was stirring up the real and the fake, the natural and the cultural. Her mixed-media Table Settings (1970–74) juxtaposed real and ceramic insects, ceramic birds and found postcards, drawn acorns and sculpted teacups.

Looking at the Fruit Piles, critic Ann Rosenberg remarked on the shift in Falk's artmaking: "The horrific and the ugly that had been part of her early æsthetic began, increasingly, to give way to her admission of the

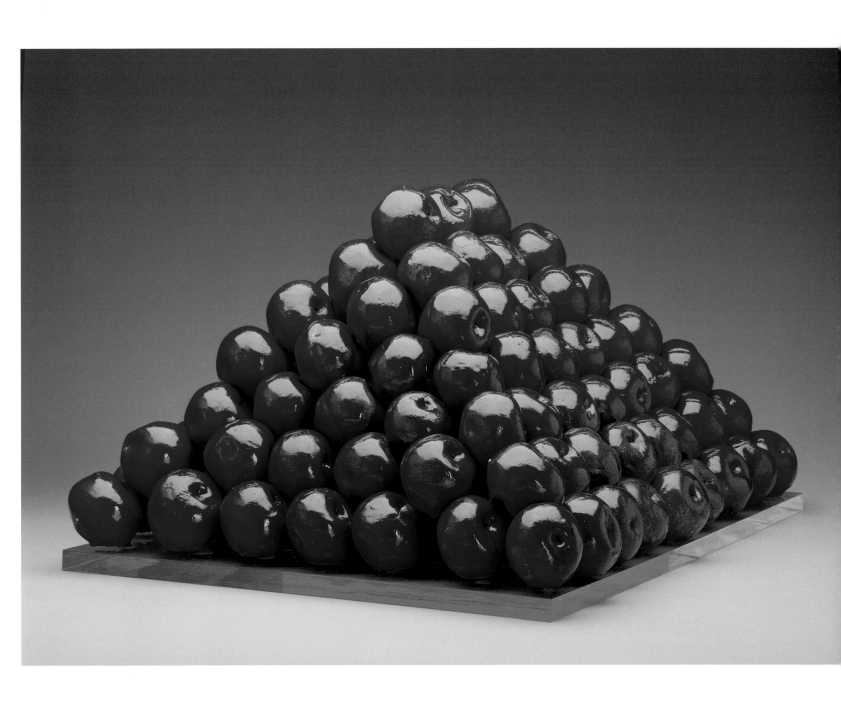

196 Apples, 1969–70, ceramic and Plexiglas stand, 40.6 x 88.3 x 66.7 cm, collection of the artist.
Photo by Teresa Healy, Vancouver Art Gallery

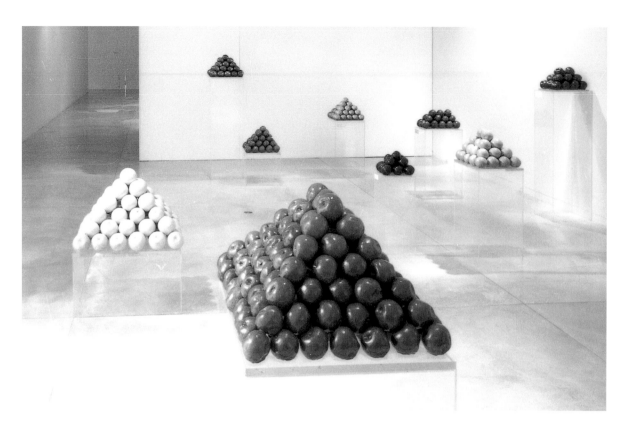

Installation view: Fruit Piles at the Vancouver Art Gallery, 1985.

beautiful."[40] Not that the horrific was ever completely banished, but there was, for a while, a greater accommodation to loveliness, one that seemed to accord with a period of intense creativity, growing stature as a professional artist and satisfaction in her personal life. In 1970, Falk bought a house in the Kitsilano neighbourhood of Vancouver, and over the next couple of decades, she would become more and more closely identified with it and with her garden as sources of imagery and inspiration. Since Falk's house and garden came to look like works of art themselves, journalists, critics and curators began a tradition of commenting on the interpenetration of her life and her art.[41] She would also become identified with her community of friends, who not only assisted her in large projects, performed with her and travelled with her on research projects, but also shared her house and, eventually, became the subjects of her art. (In the early 1970s, Elizabeth Klassen, a teacher and school librarian, and Tom Graff lived in separate apartments in Falk's house; all three took meals together on Falk's main floor. From 1990,

Klassen has once more become Falk's housemate, sharing domestic and gardening duties and assisting with larger projects.) The significant role of her friends reflects both the idealisms and collective impulses of the 1960s and 1970s and the strength of the concept of community in Mennonite tradition.

For years, Agatha Falk had cooked, gardened and kept house as Gathie had laboured to support them both. Now, Gathie was immersing herself in these domestic roles, even as she was expanding her practice as an artist, and each activity seemed to enrich the other. Recently, she remarked that the recurring motif of eggs in her work may have had more to do with the bowl of eggs that sat beside the stove as she belatedly learned to cook than with her much-quoted memory from childhood. She was daily struck by the beauty and economy of the egg's form. What Gathie Falk gave to her house and garden, what she sowed there, she would later reap in her art. Nothing in her life, not one action, object or observation, was thrown on barren ground. *(continued on page 58)*

Eight Red Boots

by Mayo Graham

Single Right Men's Shoes: Eight Red Boots (1973) comprises a wall-mounted display case with glass double doors, containing eight right-footed men's ankle boots, carefully placed on the four shelves, two per shelf. Each boot "faces" left, revealing its unzipped inner side. The wood case is painted layer upon layer, inside and out, in a dark red. This red is a varnish into which Falk has mixed powdered pigments in order to achieve a transparent and blood-red surface. With repeated coats, the surface has acquired a painterly unevenness. The boots are made of clay and fired with a deep red ceramic glaze. It is an object at once both ordinary and unusual. Footwear in a display case: something Falk once saw. But eight luscious red, nearly identical clay boots?

A few biographical anecdotes provide some interesting connections regarding Falk's use of shoes, as well as clothing and colour. When she was young, "her mother made most of the family's clothing, including cloth shoes with soles made of braided jute."[1] The jute was tied to the back of a chair in three strands, and, at the ages of four and five, Falk braided it. Published in Jane Lind's book on the artist is a wonderfully glamorous photograph of Falk, at age thirteen, in front of the family's Winnipeg house, which was painted dark red with white trim. "I loved the colour of that house."[2] The fashionable outfit was one that she had purchased with hard-earned strawberry-picking money. Later, when Falk had her first full-time jobs (packing food and then sewing pockets in luggage), she "found you could buy shoes over and over again: they didn't cost very much."[3]

Falk also loved dancing. "I still do. When I was young I used to shut myself in the spare room — it was too cold in winter for use — and dance away."[4] Also "I danced on the porch where I could make a lot of noise."[5]

After working at various jobs and then teaching for twelve years, Falk decided to go to the University of British Columbia, where she studied art and started making sculptures and pottery. "It was like magic."[6] By the mid-sixties, Falk had turned full-time to being an artist. In September 1965, she exhibited a number of paintings at a Vancouver gallery called The Canvas Shack. Among them was *Woman with Red Shoes*, which Falk had painted the previous year. While the title is a handle to identify the work, it does however signify a subject — clothing, and more particularly shoes — that has periodically and frequently occupied a space in Falk's artwork to the present time. A reviewer of that first exhibition remarked on her "vivid resources of colour" and "her decidedly unusual imagination."[7]

In her first exhibition of ceramic sculpture, at Vancouver's Douglas Gallery in August 1968, clothing, furniture and food creations were featured. "One of the most surrealist pieces, mingling with the Pop, is a pair of heel-less, high-heeled shoes of high lustre ceramic set in a block of resin [*Preserved Shoes*]."[8] She had found a pair of plastic, rhinestoned heels in a thrift shop, and decided to make shoes for them. In the end she rejected the heels and used just the shoes.

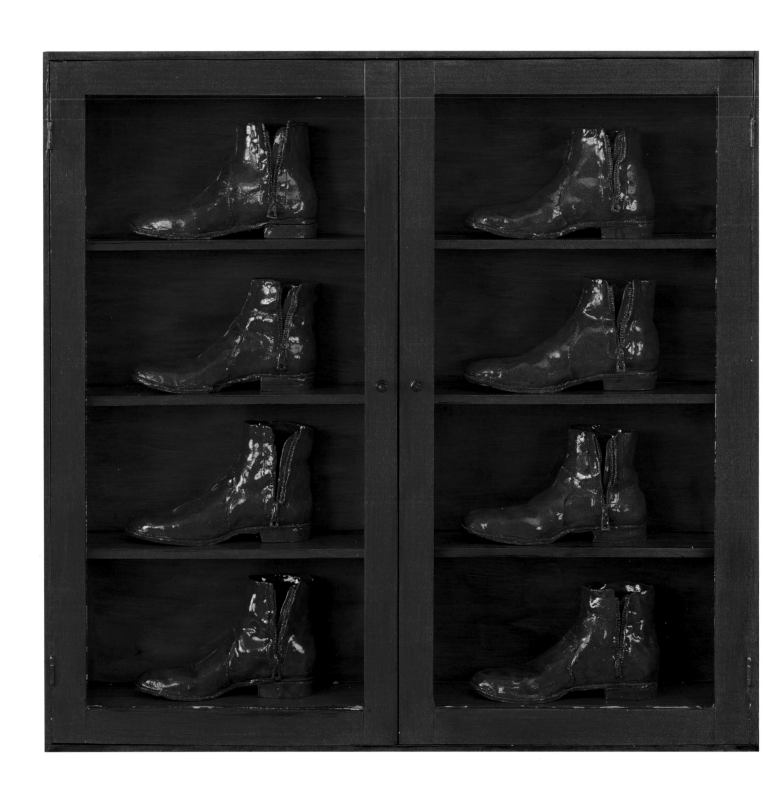

Single Right Men's Shoes: Eight Red Boots, 1973, glazed ceramic, glass and coloured varnish on wood, 101.2 x 105.7 x 15.5 cm, National Gallery of Canada, Ottawa, 18157. Photo courtesy National Gallery of Canada

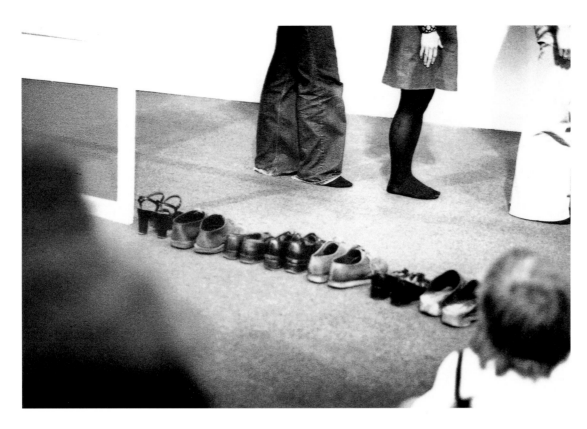

Skipping Ropes, performance documentation at the National Gallery of Canada, Ottawa, 1975
(first performed at the Vancouver Art Gallery, 1968). Photo by Mayo Graham

Falk acknowledges some affinities between her work of that time with the work of Claes Oldenburg and Bob Arneson. "I knew of Oldenburg's work. He was in Vancouver in the late sixties and had a show at the Douglas Gallery, where I was showing. Arneson I learned about through Glenn Lewis, with whom I had studied [1964–67]. I'd heard about his ceramic *Typewriter* [1966] — perhaps I saw it in a magazine."[9]

Also in 1968, Falk was introduced to performance art through a workshop given by New York artist-dancer Deborah Hay at Intermedia in Vancouver. "Hay, collaborator with Merce Cunningham and Robert Rauschenberg, introduced Falk to ideas that she found sympathetic — the use of ordinary movement in dance, the visual and sculptural use of time through repetition."[10]

During this performance workshop, Hay gave participants an assignment to do a piece in which the structure depended on one's voice. Falk asked her fellow participants to take off their shoes and put them in a pile. Taking one pair and placing them together on the floor, Falk then counted out loud ten floorboards and placed a second pair; then pointing and counting nine floorboards, she placed the third pair; and thus it proceeded with diminishing intervals until she reached a wall and turned 90 degrees to complete the arrangement.[11] This was the nucleus for *Skipping Ropes* (1968), later part of Falk's repertoire, which included a segment where each performer would take off his/her shoes, before climbing through an empty frame and grabbing hold of a skipping rope stretched horizontally overhead. Each performer would place his/her shoes

neatly in a row next to the previous person's. Combining performance and sculpture, this was the beginning of Falk's "Theatre Art Works," which she developed and performed from 1968 to 1976. Over time, the number and complexity of props — painted, sculpted, sewn and found — increased, and the performances became considerably longer.

Shoes were part of another performance, *Ballet for Bass-Baritone* (1971), in which a man (Tom Graff), dressed in white tie and tails, walked backward singing an operatic aria while other performers followed him, shining his shoes. And elaborate dresses are featured in *Red Angel* (1972), worn by the lead performer (Gathie Falk) perched on top of a candy-apple red buffet. Exotic in their juxtaposition, the component parts in themselves are fairly common. "The activities that I used belonged together in that mysterious way that all things in every strong work of art belong together."[12]

From 1968 to 1970, Falk made many folded men's shirts, both sculpted in clay and drawn. This preoccupation culminated in a major commission, for the new Lester B. Pearson Building in Ottawa, of the *Veneration of the White Collar Worker #1* and *#2* (1971–73), in which one wall featured rows of white shirt fronts sporting dark red ties. The series of smaller compositions of that time included *Man Composition #2* (1970), comprising a child's pair of red velvet party shoes surrounded by a white porcelain belt in a Plexiglas box.

During the same period, Falk was producing Fruit Piles — lustrous pyramids of dazzling red apples, brilliant yellow grapefruit and gleaming oranges — organic forms neatly piled into pyramids, mounted high on clear Plexiglas bases. Then boots and bootcases — seventeen of them — dominated in the years 1970 to 1973. "The chief colours . . . were red, white, grey and black. However, the blue of the running shoes . . . and an orange case with orange shoes, created a variety in hue."[13] These were followed by Picnics, one of which starred a pair of red shoes (1976).

By the late seventies, Falk had returned primarily to painting. Dresses floated on well-upholstered chairs, and occasionally a shoe would appear. In one painting in the Soft Chairs series, a row of men's shoes sat in front of the chair (1986).

Boots and shoes as an image bring to mind van Gogh's paintings, including his *Three Pairs of Shoes* of December 1889 (Fogg Art Museum). Although Falk hadn't seen these boots, one can't help but think of them and how her men's shoes of 1973–74 connect, empty yet bearing the traces of the wearer and of time. Falk's single boots all present "the instep, the vulnerable part . . . with seams and zippers, the parts that are typically hidden."[14] Van Gogh's often show a sole. Without an explicit subject in both cases, they nonetheless are keys to a narrative.

There is something poignant about these absences, as there is with Falk's lushly painted, papier-mâché sculptured dresses, exhibited in the *Traces* installation at the Equinox Gallery in Vancouver in September–October 1998. "The dresses are not round enough or big enough to hold a whole body. The body is not there, but it has been there."[15]

Traces comprises six dresses with objects, mounted on plinths, a wall of vellum-printed photographs of the repeated image of a woman's "Crossed Ankles" (wearing shoes), three paintings, a chair and a shelf with various small objects. In the gallery office, outside the exhibition *per*

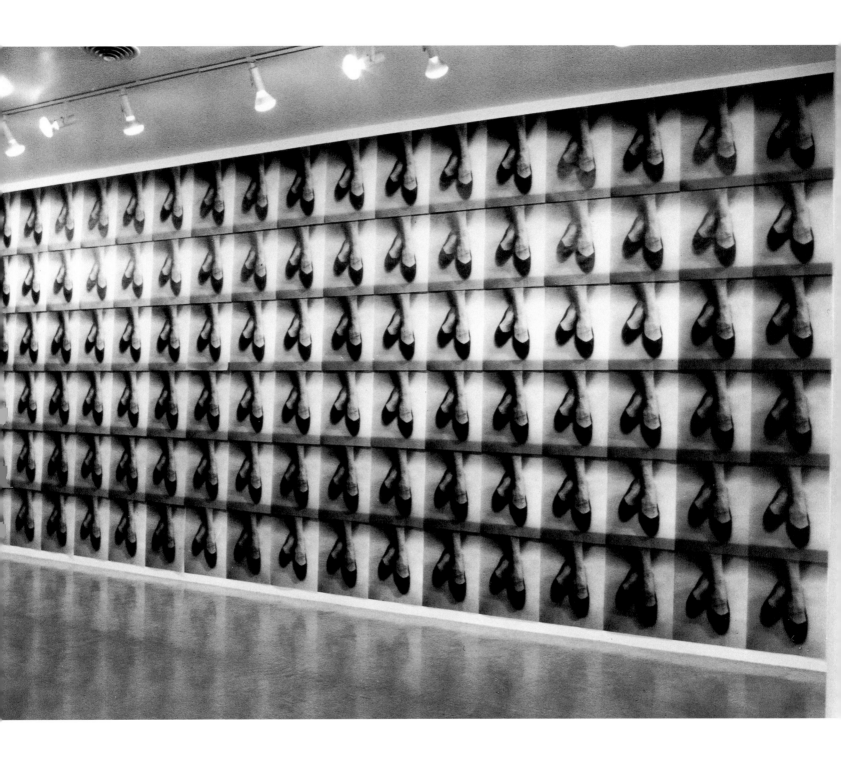

Installation view: *Crossed Ankles* at the Equinox Gallery, Vancouver, 1998. Photo courtesy Equinox Gallery

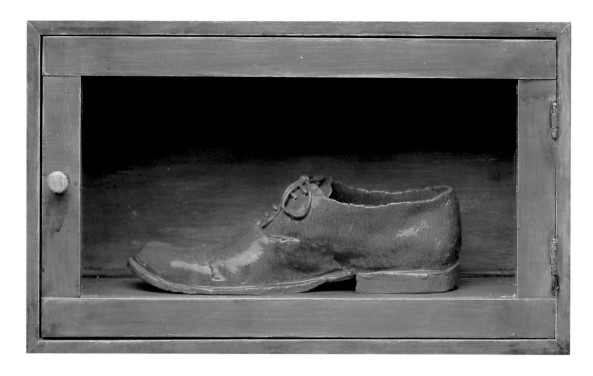

Above: *Single Right Men's Shoes: Bootcase with 1 Green Banker's Shoe*, 1972, glazed ceramic, painted wood and glass, 68.6 x 113.0 x 39.4 cm, private collection. Right: *Single Right Men's Shoes: Bootcase with 6 Orange Brogues*, 1973, glazed ceramic, painted wood and glass, 70.2 x 94.9 cm, collection of the artist. Photos by Teresa Healy, Vancouver Art Gallery

se, were a number of pairs of painted papier-mâché women's shoes and shoeboxes. More recently Falk has completed *The Column*, which consists of twelve shoeboxes, each holding a pair of her created women's shoes. Viewers may lift the lids and examine the contents, but they are contained at first glance and invisible.

Like these shoeboxes, the bootcase of *Eight Red Boots* is the repository for the orderly display (or concealment) of the boot objects. They are arranged and embraced. While in *The Column* the stack itself is iconic, in *Eight Red Boots* the glass-fronted cabinet turns its contents into symbols of admiration. "My Cinderella complex has directed itself to ordinary things like men's shoes, making icons of them by putting them in glass cases."[16] The methodical structuring is very important in these sculptures, as indeed it is in Falk's performance pieces and in her paintings. "You see more when you put them in a tight structure, when you compact them into a bootcase. Putting things exactly in the right place has a strong visual effect. As for shoes, they complete the body and finish off the whole thing."[17]

Similarly, repetition and serial images are very important to Falk. One red boot is not right, whereas eight are. In referring to one of her paintings, Falk remarked: "You have to admit that painting one light bulb is not as powerful as painting fifty light bulbs."[18] As with structure, repetition is a key element of performance work as well as her other art forms. "I have to work it out until everything fits and the piece is perfect, emotionally and visually. Then it's like a piece of music without words."[19] *Eight Red Boots*: a perfect colourful octet.

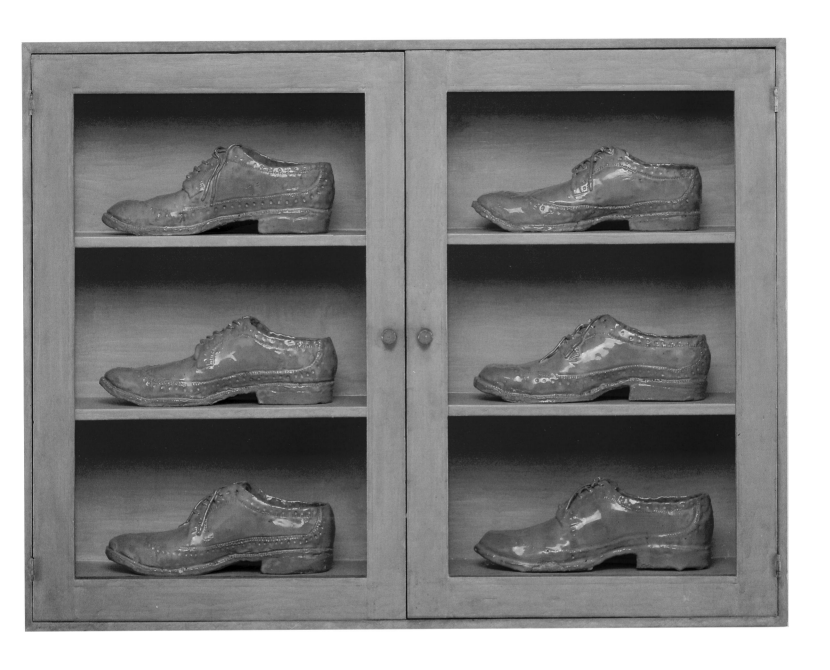

Notes 1 Jane Lind, *Gathie Falk*, 8. 2 Conversation with the author on 9 June 1999. 3 Ibid. 4 Ibid. 5 Gareth Sirotnik, "Gathie Falk: Things That Go Bump in the Day," 10. 6 Ibid. 7 David Watmough, "The Canvas Shack: Falk Art Strong in Human Focus." 8 Joan Lowndes, "Glorious Fun-k Art of Gathie Falk." 9 Conversation with the author, 9 June 1999. 10 Scott Watson, "Gathie Falk's Sources and Rituals," 59. 11 As described in a letter from the artist to Gile Hétu, 16 April 1979, copy in the National Gallery of Canada archives file of *Eighteen Pairs of Red Shoes with Roses*. 12 Gathie Falk, "A Short History of Performance Art As It Influenced or Failed to Influence My Work," 13. 13 Ann Rosenberg, "Single Right Men's Shoes" in "Gathie Falk Works," 27. 14 Ibid., 24. 15 Conversation with the author, 9 June 1999. 16 Gathie Falk, "Soft Chairs," n.p. 17 Conversation with the author, 9 June 1999. 18 Lind, *Gathie Falk*, 31. 19 Gathie Falk, "Statements."

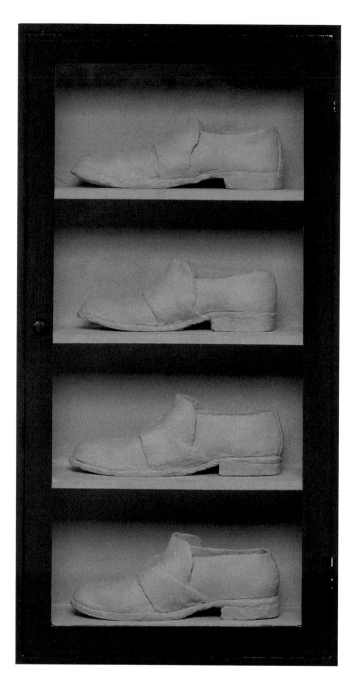

Single Right Men's Shoes: Bootcase with Single Right Men's Shoes, 1973, flocked ceramic, painted wood and glass, 82.5 x 43.7 x 15.0 cm, private collection. Photo by Teresa Healy, Vancouver Art Gallery

But, of course, everyday life extends beyond the home and, in the early 1970s, Falk took inspiration from the window display of a shoe store. What caught her attention was an open-fronted case of men's single shoes, but what leapt into her head was a series of sculptures. "In my mind I saw a bootcase, many bootcases, like china cabinets, full of precious objects," Falk wrote.[42] After some experimenting, she chose to make a series out of repetition, using one style of shoe three, four, six, eight or nine times within each glass-fronted "bootcase." Throughout the series of Single Right Men's Shoes, she evolved seven different styles of footwear, based on the shoes of friends (Tom Graff's zippered ankle boots, Glenn Allison's running shoes, Salmon Harris's brogues) with the addition of four traditional styles (bluchers, spectators, banker's shoes and patent-leather shoes). She was striving for ordinariness, even "restraint," but with her usual sense of contradiction she finished many of her ordinary shoes in extraordinary colours: orange, green, candy-apple red. And she also reversed the retail-display convention, turning the shoes around so that the public or "cosmetic" outside of the shoe faced away from the viewer and the private or "emotional" instep side was exposed.

The bootcases themselves, painted with strong colours that reiterate or complement the colour of the shoes, are integral, just as the pyramids were to the Fruit Piles. Initially, Falk found a glass-fronted tool cabinet in a second-hand store and added shelves and glossy paint. For the rest of the series, she had cases custom-built in different sizes and configurations. As with the fruit, all the shoes are similar, but none are the same. Either glazed or painted, they are less luscious than the fruit but are more literal and more expressive in their form and finish. Falk's objects are individual, each bearing what she calls "the mark of the human body" in its creases, bulges and flesh-and-bone undulations. The shoes clearly have been worn, but not to the point of broken-down sentimentality. As with the shirts and suit coats, she uses the shoes to represent human beings. This is one of her great gifts: the ability

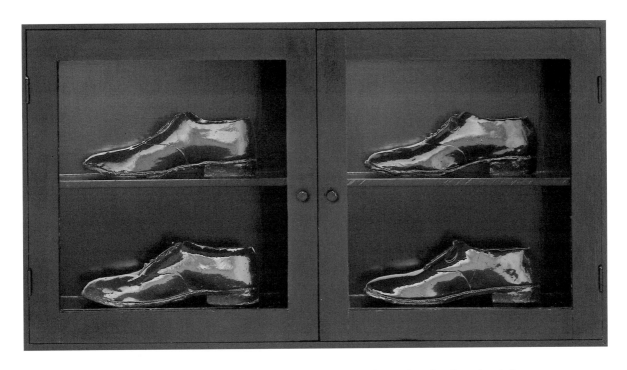

Single Right Men's Shoes: Bootcase with 4 Patent Leather Shoes, 1973, painted ceramic, painted wood and glass, 52.0 x 95.5 x 18.0 cm, collection of Ron and Jacqueline Longstaffe. Photo by Teresa Healy, Vancouver Art Gallery

to depict ordinary beings through their ordinary apparel. At the same time, she bestows an iconic character upon this, well, pedestrian wear.

Falk produced some seventeen bootcases, which she first exhibited in a group show at the Vancouver Art Gallery in 1973. (These boots were made for walking: they were later exhibited in Victoria, Toronto and New York, and in a solo show at the Canadian Cultural Centre in Paris.) Critic Joan Lowndes lavished praise on the artist's abilities "to transform the banal into the beautiful" and "to invent variations on her theme."[43] In the same installation, Falk also exhibited *18 Pairs of Red Shoes with Roses*, a long line of ceramic men's shoes and boots, in pairs, encompassing all her different styles. (She gave visual coherence to the piece by finishing every shoe in luminous red and placing a rose decal on the inside of each heel.) Set in a long line directly on the floor and running at an angle across the gallery, these shoes provoke different feelings from those of their case-mounted fellows. They're more humble but at the same time more surreal, more mysterious, even a little ominous. They speak of a bodily presence but look more abandoned, somehow, than

the shoes in the cases. *18 Pairs* has formal precedents in a line of single ceramic apples which Falk had earlier constructed, and in the lines of shoes that evolved in her performance pieces. The first of these, she improvised during her initial workshop with Deborah Hay, asking participants to remove their shoes, then arranging them in a line while counting out the floorboards between each shoe. The second, she developed as a formal element in *Skipping Ropes*: performers remove their shoes and place them in a line before passing through a picture frame. Both *Skipping Ropes* and *18 Pairs* make a strange association of the homely with the holocaustic. What has become of the men who wore these shoes? Again, Falk evokes presence through absence, and absence through presence—through the material evidence of the ordinary.

Between 1974 and 1976, Falk extended the formal device of Single Right Men's Shoes within a suite of thirty-nine graphite drawings. The drawings are still lifes, rendered in a semi-naive, semi-realistic style and consisting of quotidian subjects within the sometimes impossible confines of glass-fronted cabinets, which she again called "bootcases," but which again evoke something holy—

59

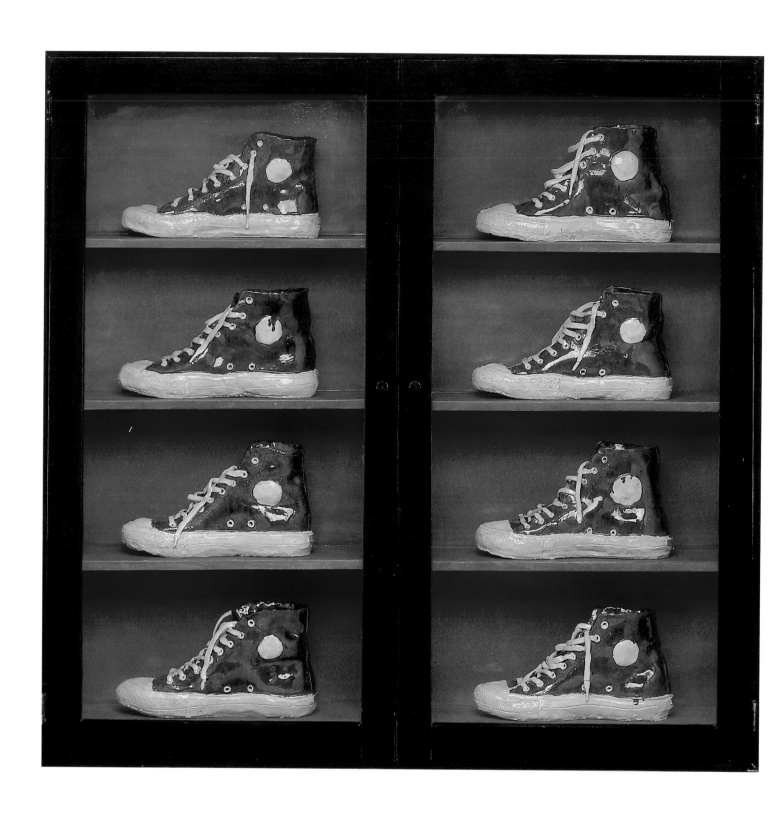

Single Right Men's Shoes: Blue Running Shoes, 1973, glazed ceramic, glass and coloured varnish on wood, 101.5 x 105.4 x 16.1 cm, Vancouver Art Gallery, 83.41 a-i. Photo by Teresa Healy, Vancouver Art Gallery

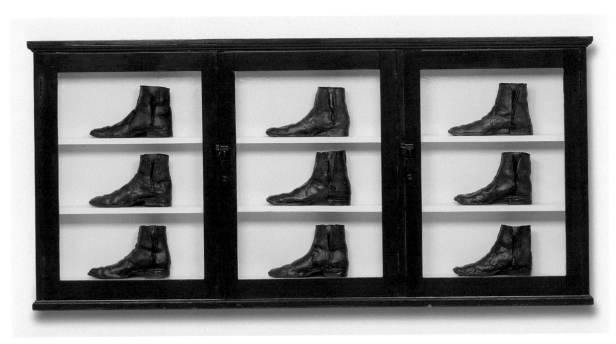

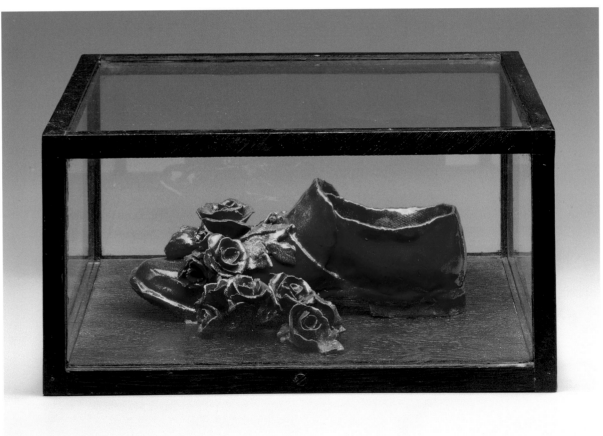

Top: *Single Right Men's Shoes: Bootcase with 9 Black Boots*, c. 1973, earthenware painted with acrylic, painted wood and glass, 88.9 x 192.4 x 17.2 cm, Vancouver Art Gallery, 76.4 a–j. Bottom: *Single Right Men's Shoes: Bootcase with 1 Shoe with Roses*, 1973, glazed ceramic, painted wood, varnish and glass, 20.4 x 41.1 x 41.2 cm, Vancouver Art Gallery, 91.34.1. Photos by Teresa Healy, Vancouver Art Gallery

shrines or icons or altarpieces. The subjects range through potted plants, hot-chocolate cups, apples, eggs, ducks, clocks, cabbages, watermelons, Vaseline jars and Albrecht Dürer's famous hare. She borrowed the hare from Dürer's watercolour and gouache drawing of 1502, but had to "rearrange" the perspective and flatten the ears to fit the creature into the bootcase. She also doubled the image, placing two hares on shelves inside one cabinet. An air of gentle surrealism prevails, even an occasional air of whimsy, although Falk deplores the characterization of her art as "whimsical." That term, she believes, undercuts the seriousness of her practice. Whimsy suggests that her art is too playful, too easily accomplished, when in fact it is carefully considered and realized through hard work. Whimsy also denies the darker aspect of the imagery, which in this instance would be the condition of containment, imprisonment, even entombment, that is the other side of enshrinement.

Falk has remarked that she seeks out different styles for different series in order to best realize the image that is in her head. "[E]very time I have a new subject I'm experimenting with a new way of expressing it."[44] Even from her earliest works, Falk has been adjusting her style and her medium to suit her project. This is why her still-life drawings of 1976 look so different from her shirt drawings of 1968–70, and the shirts, so different from the anguished expressionism of her paintings of the early 1960s. This is why, too, her ceramic sculpture ranges through various degrees of distortion and naturalism, realism and surrealism.[45]

If the personal is political, as the second wave of feminism has claimed, then Gathie Falk was leading a highly politicized existence. In March of 1972, Agatha Falk died after a protracted and debilitating illness. Gathie, who had been mother to her mother in varying degrees since childhood, experienced "many dark hours"[46] during the last years of Agatha's life, and considerable grief after her death. More grief was to follow. In November of 1974, Gathie Falk married Dwight Swanson, a man almost twenty years her junior, whom she had known for a little over a year. While a prisoner in the provincial penitentiary, Swanson had heard a radio interview with Falk and written to her; Falk corresponded with Swanson, began visiting him in prison, fell in love and agreed to marry him on his release. After their wedding, Swanson moved into Falk's house and, for a few months, she made and exhibited art as Gathie Swanson.

In retrospect, Falk remarks that she didn't understand what a difficult situation she had married into. Swanson, she says, had spent most of his life in jail. She also says that, despite previous charitable prison visits she had undertaken through her church and through an extension program of the Vancouver Art Gallery, she had no idea how hard it was for a recidivist to function in the outside world. The couple separated in the spring of 1975, and Gathie reclaimed the name of Falk. (They were divorced in 1979.) Despite the separation, she continued to be supportive of Swanson, standing by him during his subsequent arrest, attending his trials and visiting him in prison after his convictions. But the relationship, undertaken in innocence and hopefulness, dragged Falk into a jagged emotional terrain. "The stress of my marriage did not stop me from working," she said, "but it has undoubtedly affected much of what I have since done."[47] Indeed, the impact of the marriage and its aftermath is most clearly visible in her cut-out and painted plywood sculptures, *Herd One* and *Herd Two* (both 1975), and in her series of ceramic still lifes, Picnics (1977).

Although Falk had conceived the idea for her two Herds in 1973, the execution of the work coincided with the months of her marriage (she finished the last horse on the day her husband moved out of her house), and an intense mood of panic informs the stampeding creatures. "It is probable that my anxieties were reflected in those fleeing horses,"[48] she has said. Many critics and viewers have seen the horses as galloping away in a spooked herd; until the invention of photography in the nineteenth cen-

Herd Two, 1975, plywood with pencil and eraser over white enamel paint, 500.0 x 250.0 cm. irregular, National Gallery of Canada, Ottawa, 18459. Photo of installation view, Vancouver Art Gallery, 1975, courtesy National Gallery of Canada

tury, artists conventionally depicted galloping horses with all four legs stretched outward, off the ground, as Falk's horses are depicted. Falk, however, was making a popular culture rather than an art historical reference and thinks of the creatures as "leaping." Their collective leap contributes to their air of unreality, as does their small size and the degree of their animation, somewhere between observation and invention. Generically, their form is based on carousel horses and the coin-operated horses that children ride at supermarkets. Specifically, they were inspired by a dappled-grey, kiddie-ride horse that Tom Graff had incorporated into one of his performance pieces in 1973.

Falk's horses are riderless, but each wears a saddle, blanket and bridle.

Falk originally imagined the installation—each herd composed of twenty-four small horses, suspended a few feet above the ground—in clay, but quickly realized the impracticality of that medium. She settled on three-quarter-inch plywood, cut out, rounded on the edges, primed and then painted (*Herd One*) or drawn (*Herd Two*) on both sides. Within each herd, there are different thicknesses of necks and legs, different flares of manes and tails, different colours and surface treatments, different eyes and facial expressions, different floral insignia on the

Low Clouds, performance documentation, Vancouver, 1984 (first performed at the Vancouver Art Gallery, 1972). Photo by Chick Rice

saddle blankets. Falk was experimenting with degrees of abstraction and illusionism, degrees of reality and unreality. The drawn version, she feels, is more abstract, more removed from life than the painted herd. As with her two TV dinners in *Home Environment*, *Herd Two* is like the ghostly version of *Herd One*; paradoxically, however, it is the more lively of the two.

Related to the Herds' mix of mediums are the painted plywood clouds Falk had created for her performance piece *Low Clouds*, and a painted plywood sheep she'd made for a Christmas pageant. There was no precedent in her largely still-life and tableau-oriented sculpture, however, for the swift movement conveyed by Herds. With her characteristic mediation of opposites, Falk has also brought a dreamlike quality of suspended animation to her creatures. And more opposites are conjoined here: delight and desperation, wildness and domestication, the innocence of childhood and the angst of an infinitely more complicated middle age.

Both Herds, along with a bootcase, two bootcase drawings, three Saddles (from a small, quirky series of ceramic saddles adorned with such items as coffee cups, roses, eggs or bees) and *18 Pairs of Red Shoes with Roses*, appeared in the National Gallery's 1975 exhibition *Some Canadian Women Artists*. (Falk also presented five of her "Theatre Art Works" in Ottawa during the exhibition's run.) Curated by Mayo Graham, the show was intended to celebrate International Women's Year, to spotlight emerging (rather than established) women artists, examine their practices and understand whether there were lines of formal, material and thematic connection between or among them.[49]

Falk herself was initially opposed to the idea of participating in a show of women's art. She had turned down such invitations before but realized, after long discussions with Graham, what an important exhibition this would be. (It should be noted that as late as 1972, William Withrow, director of the Art Gallery of Ontario, had written and published what was thought to be a significant book, *Contemporary Canadian Painting*, in which only one of the twenty-four artists surveyed was a woman. That woman was Joyce Wieland.) Falk wanted and wants to be identified as *an artist*, not as *a woman artist*. Although she had protested, in childhood, against the social constraints placed upon girls, and during her factory days, against inequities in pay, and although she continues to be deeply committed to social justice, Falk says that in the 1970s she did not want to be known as a feminist. She found the associations too militant and misandrous. She also insists that her gender has never been an obstacle to her success. Perhaps, she suggests, it has even been an asset, and she has benefited from "tokenism." Nevertheless, she counts as significant a series of feminist lectures she attended in 1977. Given by Kathy Storrie, a teacher of women's studies visiting Vancouver from Saskatoon, the lectures expanded Falk's thinking about gender issues. "It turned out I really was a feminist," she says with humorous simplicity.

Just as Falk resists gender affiliation in her art, she also resists the identification of her subject matter as "domestic." Realms of activity, however, have long connoted gender roles, and in the patriarchal order, the domestic realm has been considered feminine and inconsequential. As with the description of her art as whimsical, Falk sees the term domestic as deprecating or trivializing. Her art, she says, is about the personal and the ordinary — not the domestic. Also pertaining to gender roles, she believes that her early attraction to the subject of men's shoes and clothing had nothing to do with the patriarchal power that might be invested in them. She was attracted to the way these objects looked and functioned in the everyday world, and by their potential as forms of portraiture or figuration. By the late 1970s, Falk had established a modernist art practice distinctly hers and quite separate from the increasingly issue-oriented art world.

Among the souvenirs of Falk's brief marriage was a 1936 Ford business coupe with flame-painted doors, which had been acquired by her husband and whose payments she had assumed when the couple separated. After looking at the elaborately decorated vehicle for a couple of years, trying to find a context in which to exhibit it, she decided to fill it with ceramic watermelons (childhood memories of hot Manitoba summers, cool watermelon flesh, sticky dripping juice) and park it on a bed of Astro-turf at the Vancouver Art Gallery. It was the centrepiece around which her 1976–77 series of ceramic still-life sculptures, Picnics, was installed. The impulse to make these sculptures had originated in 1970, when Falk and Tom Graff staged a series of picnics in half a dozen locations in Vancouver and documented them in slide form. (Falk later developed a picnic-themed theatre piece using the slides.) The picnics had taken place in incongruous places, such as on the floor of an artificial-flower shop, in front of a bank and in front of a George Segal sculpture at the Vancouver Art Galley. The artists dressed in elegant, summery clothes and seated themselves on a patch of synthetic grass, which they carried with them along with a picnic basket, itself full of unexpected things. It was the rectangle of grass, however, the visual notion of an excised area of turf or sod, that held Falk's interest. For years she had thought about cutting out pieces of sod and embalming them in polyester resin but realized that the grass would die and fade. Eventually, she resolved to create her own pieces of sod out of clay, each blade of grass painstakingly articulated and guaranteed to retain its vivid green hue.

Three of Falk's Picnics are composed within open-fronted cases, a formal link with her bootcases. The rest of the two dozen, however, are set on pieces of ceramic sod, spread with lacy, white or floral-patterned cloth, also in ceramic. When she first saw the works installed at the Vancouver Art Gallery, each still-life sculpture mounted on a plinth, she thought they looked like "gorgeous headstones" and that the whole installation looked like "a beautiful graveyard." The impression was not, for Falk, a negative one: she finds cemeteries beautiful and honourable places. And if her art has explored many ways of venerating the ordinary, she recognizes tombstones as "the final veneration."

It had not been her *conscious* intention to make the picnics look like grave markers, but neither did she want people to think she was advancing the cheery notion that life was a picnic or that artmaking was "just a lot of fun." She suggested, however, analogies between life and picnics in their combination of beauty and discomfort, and that the metaphor of unlovely or even nasty contingency could also be extended to artmaking. "[M]y picnics are figments of the imagination that are given to one like splats of bird droppings from above, unexpected, unearned," she wrote.[50]

Some of the objects in the picnics are the quintessence of ordinary: watermelons, lemons, green bottles, eggs, cakes. Some are oddly incongruous with the picnic theme: clocks, crowns, cabbages, high-heeled shoes, a stack of fat, red, cartoon-style hearts. And some, in their unexpected juxtapositions, create a mood of gallows humour and death-in-life surreality: golf balls sprinkled like monstrous peppercorns on three dead fish; a black bird lying dead atop a red mantel clock; a grey dog like a tomb figure guarding an offertory pot of pink camellias; a

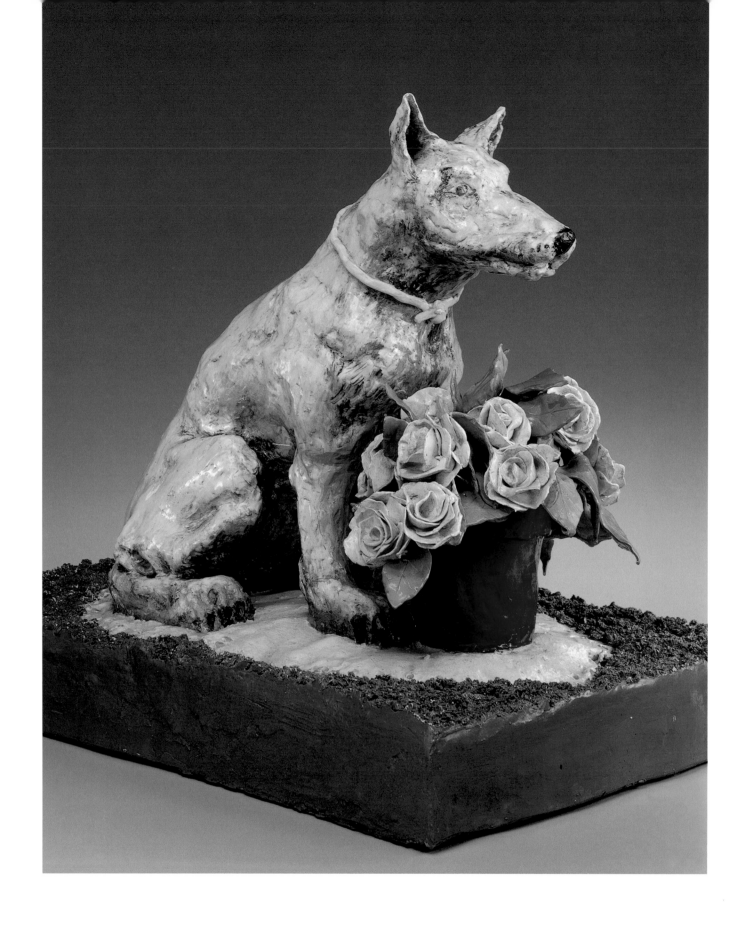

Picnic with Dog and Potted Camellia, 1976–77, ceramic, acrylic paint and varnish, 66.0 x 45.7 x 57.2 cm, collection of John and Sherry Keith-King. Photo by Teresa Healy, Vancouver Art Gallery

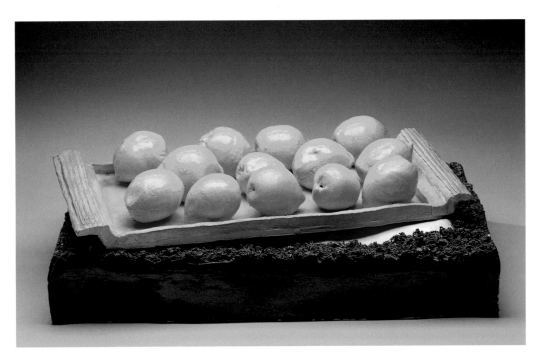

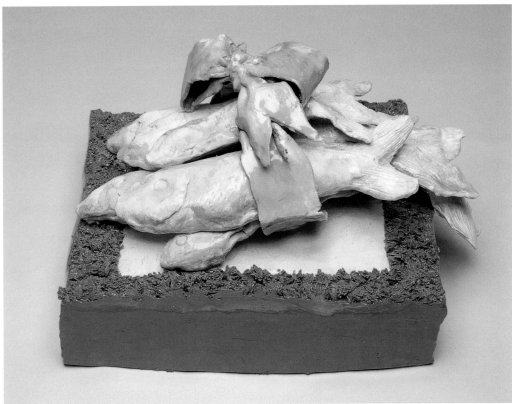

Top: *Picnic with Lemons*, 1976, ceramic, acrylic paint and varnish, 17.5 x 53.5 x 33.5 cm, collection of John and Elizabeth Nichol. Photo by Teresa Healy, Vancouver Art Gallery. Bottom: *Picnic with Fish and Ribbon*, 1977, ceramic, acrylic paint and varnish, 20.0 x 33.7 x 27.8 cm, National Gallery of Canada, Ottawa, 18845. Photo courtesy National Gallery of Canada

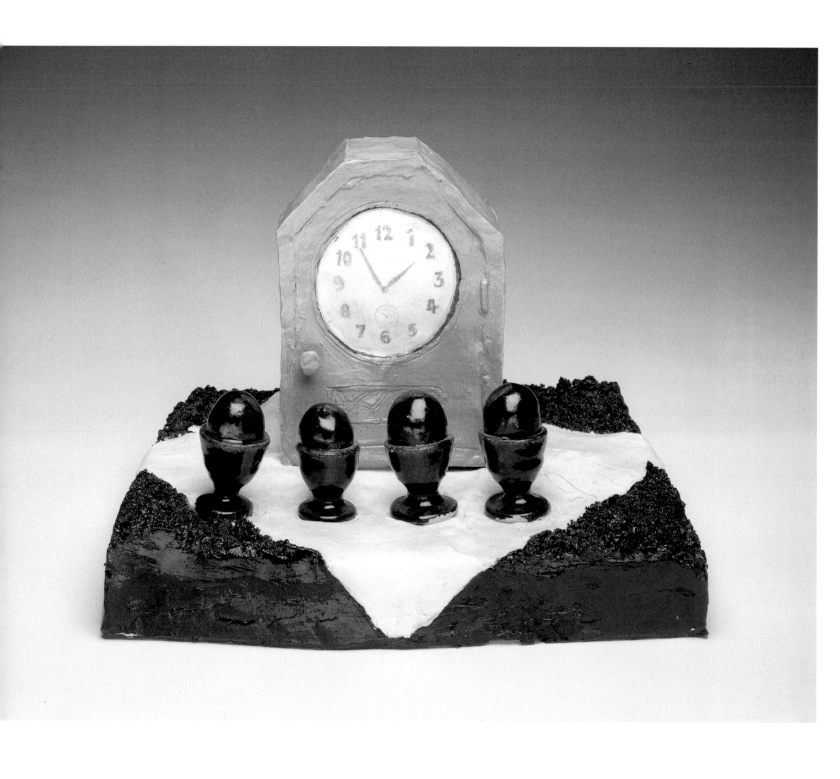

Picnic with Clock and Egg Cups, 1976, ceramic, acrylic paint and varnish, 27.5 x 36.0 x 28.0 cm,
National Gallery of Canada, Ottawa, 18846. Photo courtesy National Gallery of Canada

Left: *Picnic with Birthday Cake and Blue Sky*, 1976, ceramic, acrylic paint, varnish and wood, 63.6 x 63.4 x 59.7 cm, National Gallery of Canada, Ottawa, 18872. Photo courtesy National Gallery of Canada. Right: *Picnic with Yellow Maple Leaves and Blue Sky*, 1977, ceramic, acrylic paint, varnish and wood, 58.0 x 50.8 x 57.2 cm (destroyed in an accident). Photo by Joe Gould

teacup whose contents are engulfed in enormous flames. Enormous flames also spring from a pile of hearts, from a heap of maple leaves and from a decorated birthday cake. And, of course, flames are painted (but not by Falk) on the sides of the Ford coupe.

The flaming birthday cake was Falk's visual rendering of an anecdote told to her by a friend, about the foil wrapping around the top of a cake with lighted candles catching fire. Fire is also a popular motif of Magritte's, to whom she acknowledges a debt. But fire has always engaged Falk. She is attracted to the spectacle, the drama, the dangerous beauty. She also cites an important association from childhood, when she and her brother were assigned to burn the grass around their home each spring, keeping the flames under control with wet sacks. Since new grass would grow where the old, winter-dead grass had been burned off, fire came to signify purification and renewal as well as danger and destruction.

Fire could also be an agent of pain, punishment or sacrifice. "It is a certainty that I went through fire in those years," Falk has said, speaking of her marriage and her husband's trials and re-imprisonment.[51] A grim association with flames was that the image painted on Dwight Swanson's car was at one point used as evidence against him. And then there are the fat hearts and flaming hearts, offered up on altar-like slabs of sod. They send an especially painful message, although now she sees the hearts as cliché and regrets having made them. Sacrifice, punishment and horror are also present in the way the ceramic watermelons are cut open, revealing their bloody red flesh, and in the way the ceramic maple leaves are nailed like pieces of flayed skin — or crucified like small bodies — onto the side of the case which houses *Picnic with Yellow Maples Leaves and Blue Sky*. Falk sees the form and colour of maple leaves as an important visual equivalent to flames, one that she would use in subsequent series. (The image

69

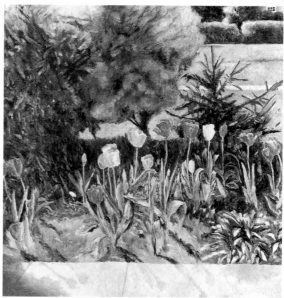

West Border in Five Parts, 1978, oil on canvas, 182.9 x 182.9 cm each (five panels), collection of the artist. Photo by Tod Greenaway

of burning maple leaves in another of her Picnics is curiously cannibalistic: flames devouring flames.)

As in Herds, Falk beautifully integrates painterly and sculptural elements, especially in those Picnics which, like Single Right Men's Shoes, are mounted in painted cases. She had solved her student quandary about looking at sculpture — the problem of its lack of a frame — by placing some of her own sculptures inside the defining edges of cases or cabinets or setting them on the neat rectangles of tabletops or pieces of sod.

The increasing painterliness of Falk's three-dimensional art signalled the beginning of another shift in her practice, a return to pure painting — and to unfettered beauty. In the spring of 1977, she travelled with Elizabeth Klassen to join Tom Graff in Venice. During their stay, the friends went to Padua to view Giotto's frescoes in the Scrovegni Chapel, popularly known as the Arena Chapel. Painted on the walls of the chapel in the early years of the fourteenth century, the frescoes depict scenes from the life of the Virgin and the life and Passion of Christ, in what was then a radically naturalistic manner.[52] Falk was "stunned" by the work. What she retained — and retains, still — is a vision of the vaulted ceiling, the "peacock blue" heavens against which Giotto set sun, moon and golden, eight-pointed stars. It's a vision Falk would store in her mind for a couple of years (and decades), just as she would reserve the sight of the sun glinting off the green water in Venice. But the impulse to paint — to purely paint — had been reignited.

On her return to Vancouver, Falk was so delighted by the appearance of her spring garden, especially the portion bordering the east side of the front yard, that she took a series of photos of it. The documentation had a conceptual aspect: starting at one end of the border, she took a shot, moved four steps to the right, took another shot, moved four steps to the right, and so on. The content of each photo significantly overlapped the next, so that together they constituted not a panorama but a time-based series of progressions and regressions, remembrances and reconsiderations — a wonderful concept for a series of paintings, Falk thought. Both visually and psychologically, they suggest the slight shifts of perception and understanding that occur with slight shifts in point of view.

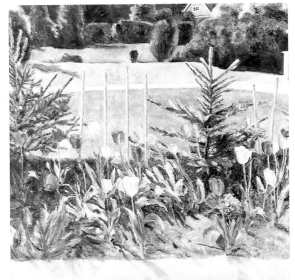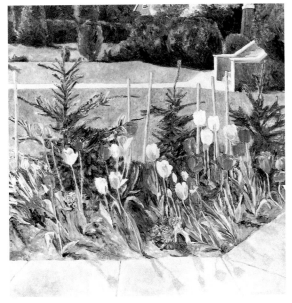

Ann Rosenberg recommended that Falk paint big, and she did, creating four panels, each measuring seven-and-a-half feet by seven feet. Falk was so pleased with the result that she repeated the photographic and painting process in *West Border in Five Parts*, then in *Lawn in Three Parts*. All three projects were completed in 1978. Except for their "command of colour,"[53] they are nothing like the difficult, abstracted and expressionist works with which she had exited painting in the 1960s. The application of the medium is thinner, less gestural and more luminous; the hues, tones and forms, more naturalistic; the overall appearance, more open and accessible. Falk cites Bonnard as an influence; something of his *intimisme* is evident in her immersion in light and colour and the forms and sensations of the everyday. Of particular interest to her was the quality of late afternoon light in *West Border*, "when you can see halos around bushes and tulips are almost transparent and rather flat."[54] The time, she said, was "eerie and benign, and also ordinary."

The Borders paintings are a kind of bridge between the Post-Impressionist debt to photography and the emerging power and presence of photo-based and photo-conceptual art. The work sits between autobiography —

remembered gardens of childhood, including the orchard depicted at the centre of a Parcheesi board, an orchard that the young child Gathie thought of as Heaven; newly experienced gardens of middle age[55] — and the nature-culture problem that was beginning to be explored in contemporary photographs of gardens and urban and suburban development. Falk's embrace of the image and symbolism of the garden is determinedly personal, however, and in her attention to certain motifs — tulips, small evergreen trees, lawns, sidewalks — is the assertion of her distinctive visual vocabulary. After the angst and morbid surrealism of Picnics, the two Borders represent a significant embrace of beauty and life-affirming realism, just as Fruit Piles had done after the black humour and expressionist distortions of *Home Environment*. Having connected with the luminous reality of her spring garden, the artist was then free to pursue the colour-field abstraction of her summer lawn.

Falk was not aware, when she began painting Borders, that she was on the point of abandoning ceramic sculpture. She had recently produced a small series of Apple Boxes (ceramic fruit in partitioned wooden cabinets) and concomitant with her work on Borders and *Lawn*, she was sculpting the 150 cabbages that would hang

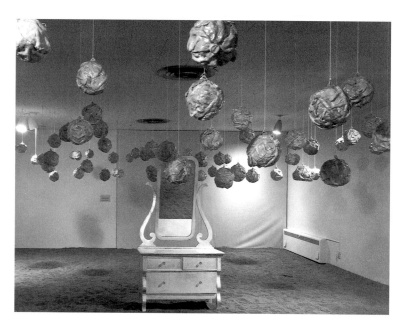

Installation view: *150 Cabbages* at Artcore, Vancouver, 1978.
Photo by Jim Gorman

from the ceiling in an installation of the same name. Falk had used cabbages as an image before, stitching real cabbage leaves together in *Low Clouds* and placing a single ceramic head of cabbage on a doily and sod in Picnics. But *150 Cabbages* was the surreal apotheosis of this humble vegetable, an installation consisting of a bed of sand covering the gallery floor from wall to wall, to a depth of about a foot; a cabbage-coloured dresser with a tilted mirror and drawers containing bundles of facial tissues; and all the ceramic cabbages hanging by kitchen twine from the ceiling. She borrowed the image of a hanging cabbage from a postcard reproduction of a still life by Juan Sánchez Cotán (c. 1561–1627). (The reference is art historical, but it is also about Falk's daily environment, since the postcard, a gift from a friend, was displayed and daily viewed in her dining room.)

As with her ceramic fruit and shoes, Falk handbuilt each life-size vegetable, leaf by painstaking leaf. Each head was painted with great delicacy and glossily varnished, bestowing a jewel-like character upon the homely vegetable. The dresser, whose curling form echoes the

curly-edged cabbage leaves, functions as a connecting device between the upper and lower realms. The *150 Cabbages* installation was a still life into which the viewer could (with some difficulty) walk. Many of the cabbages were sold individually, and when the work was later restaged, it was in a much-reduced format. Visitors to the original *150 Cabbages*, which was exhibited at Artcore in Vancouver along with the new Borders and *Lawn* paintings, agree that it was beautiful, mysterious, filled with unexpected associations.

In 1978, Falk won an important commission for the new B.C. Credit Union Centre in Vancouver. The commission was to "warm" an immense brick wall in the building's lobby and the early expectation, she believes, was that she would produce a ceramic sculpture. Falk knew immediately, however, that ceramics wouldn't work with the brick, that the wall called for "something softer." She also reasoned that the "grassroots" character of the credit union should be reflected in the commission. Grassroots easily translated to grass itself, to lawns and gardens, while the decorative notion of warming was translated into a huge painted quilt or "thermal blanket" stuffed with insulation. Since the credit union centre was being built not far from the artist's home, she decided to depict neighbourhood yards and gardens, which she had observed on many walks with her dog.

The work is very large — eighteen feet high, sixteen feet wide, and some five inches deep — and was an enormous technical and logistical accomplishment for the diminutive Falk. As with *Veneration of the White Collar Worker*, she engaged a crew of friends to help her. Falk stretched, primed and painted fifty-six canvas panels, each two feet by two feet, removed them from their stretchers, then laboriously stitched them together. Even more laborious, and involving half a dozen assistants, was handstitching the front of the work to its canvas back through a layer of construction-grade fibreglass insulation, then stitching around its perimeter and along the grid pattern

created by the panels. The geometric element is a reminder of how much the masculine practice of abstract art borrowed from the feminine practice of quiltmaking. The grid is also a reminder of the ways in which Falk could enlist a minimalist-conceptualist form and strategy in her own idiosyncratic practice.

Twenty of the panels depict flowers in gardens, pots and borders, along with fragments of the built environment: porches, pillars, sidewalks, fences and stairs. The flowers are painted in a loose, representational style and shift in colour from pale pinks, creamy yellows and dusty blues at the bottom of the work, through light magenta and lilac in the centre, to intense reds, oranges and russets at the top. The remaining green panels, which are not literal depictions of grass but colour-field abstractions, range from pale yellowish-green at the bottom to a deep aquamarine at the top. The title of the work, *Beautiful British Columbia Multiple Purpose Thermal Blanket*, is painted in faint, off-white capital letters beneath the image panels.

Although Falk sees *Thermal Blanket* as a "sculpted painting" or a highly painted relief-sculpture rather than a quilt, it is impossible to look at this work without thinking of the fabric, stitchery and quiltmaking traditions which feminist artists invoked during the 1970s. Canadian artist Joyce Wieland had played a significant role in vaulting the quilt into the realm of "high art" — at least, for a while. Aspects of *Thermal Blanket*'s collective construction also coincided with Judy Chicago's *Dinner Party* (1979), which engaged the contributions of dozens of women. As for autobiography, there may be some sweet remembrance of Gathie's mother in this work, a perhaps unconscious homage to Agatha's ability to cultivate beautiful gardens and to create lovely images and useful objects by stitching together humble pieces of cloth. But this is all inference. Falk says she was not alluding to quiltmaking traditions, and she continues to be leery of the marginalizing or trivializing connotations of craft and domesticity.

It seems only fitting that Falk would choose the same medium and methods, although on a smaller scale,

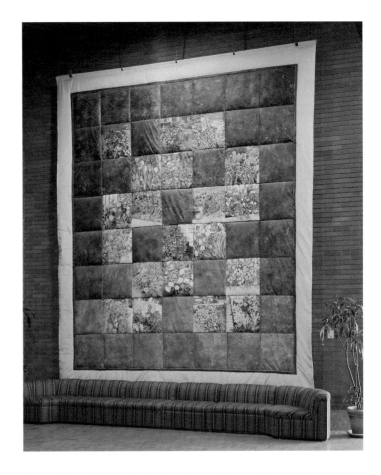

Beautiful British Columbia Multiple Purpose Thermal Blanket, 1979–80, oil on canvas, 490.0 x 550.0 cm, Credit Union Central of British Columbia, Vancouver. Photo by Teresa Healy, Vancouver Art Gallery

to celebrate her friendships and social occasions. Each of the eight Beautiful British Columbia Thermal Blankets made between 1979 and 1981 (during which period she also painted the series of huge Night Skies) is eight feet square and is composed of nine still-life, landscape and figurative panels in a three-by-three grid, surrounded by a wide border. The images, developed from Falk's own snapshots of tea parties, birthday parties and Christmas dinners, include house and garden scenes with furniture and flowers, cookies and cakes, cups and saucers, hedges and cement sidewalks, as well as loosely painted representations of the people to whom the quilts are individually dedicated. All have to do with the sunny pleasures of friendship and the social rituals of shared food and drink. Conventional portraiture, that is, establishing a literal likeness to each person, is not a particular consideration;

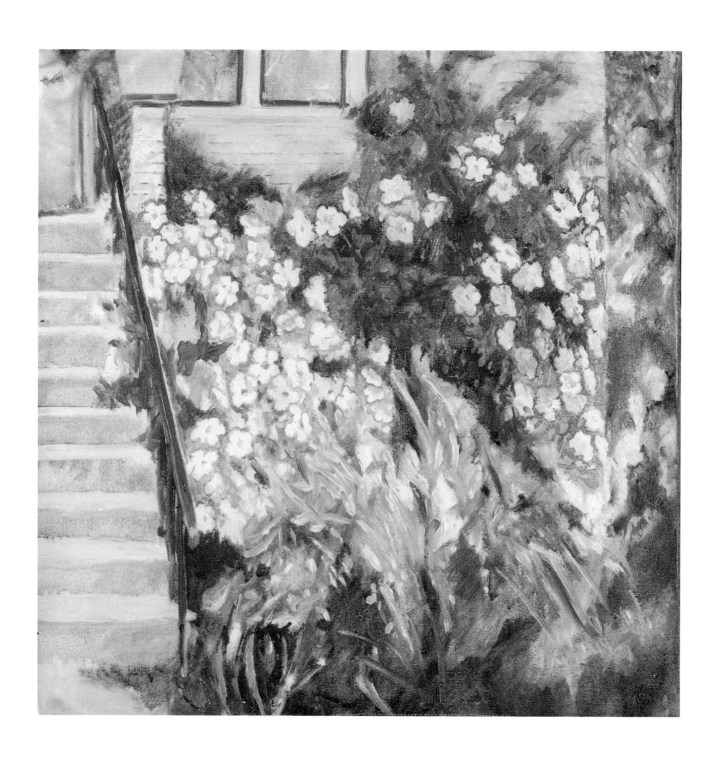

Beautiful British Columbia Multiple Purpose Thermal Blanket (two details, above and right), 1979–80, oil on canvas, 490.0 x 550.0 cm,
Credit Union Central of British Columbia, Vancouver. Photos by Teresa Healy, Vancouver Art Gallery

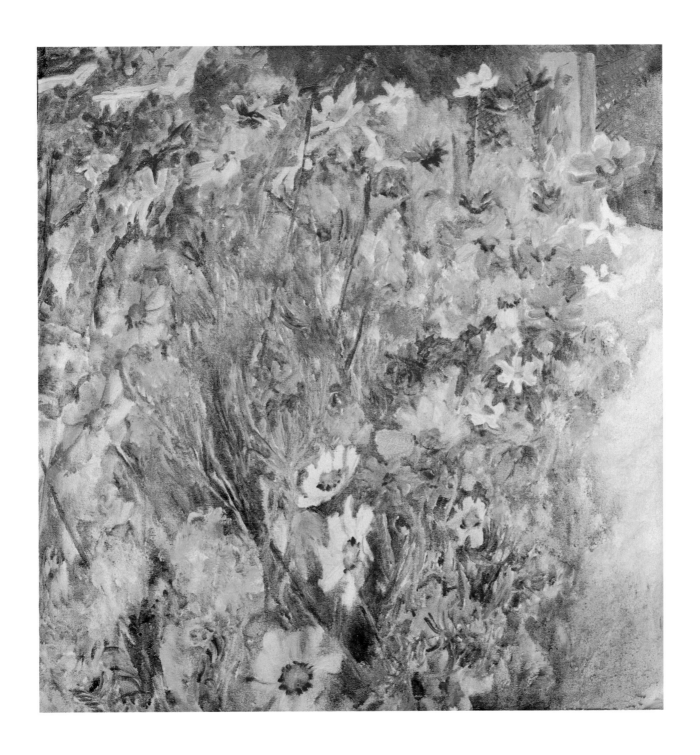

the evocation of friendship, character, human spirit and social communion is. The central panels, reminiscent again of Bonnard, are surrounded by a lawn — that is, a border of green abstraction on the theme of lawn. An evolving tradition for Falk, through her ceramic sculpture and performance art and on into her paintings, is the integration not only of themes of nature and culture but also the intermixing of landscape and still-life genres.

The late 1970s were significant as a period of expanding community and of social activism. In order to pay off debts incurred during her marriage and her husband's trials, Falk had taught ceramics courses at the University of British Columbia between 1975 and 1977. The teaching itself was exhausting, but she developed deep friendships with three of her students, Wendy Hamlin, Gloria Massé and John Clair Watts. They have met regularly for two decades to talk and critique each other's work, to offer moral and technical support to one another. Although their imagery and art practices are quite diverse, they have exhibited twice as a group, in 1990 and again in 1998.

In 1976, Falk had withdrawn from her established church and formed a house church with some Mennonite friends, including Elizabeth Klassen, Tom Graff, Jeremy Wilkins, and Elvira and Alfred Siemens. Its group-run services focussed particularly on music-making, professions of faith, Bible readings, hermeneutical discussions and private prayer. (During the services, Falk was encouraged to take up her violin again, two-and-a-half decades after the crisis that tipped her into teaching — and, ultimately, artmaking.) In 1979, Falk formed a group to sponsor the immigration of two ethnic-Chinese refugees from Vietnam, cousins Huyen and Phong Ha; the sponsorship required an enormous commitment of time, teaching and companionship from her over the next few years. (Huyen is one of the friends celebrated in Thermal Blankets.) Falk's social activism also included a renewed commitment to pacifism: she joined Project Ploughshares and Taxes for Peace (a group which withholds that amount of income tax slated for support of military activities and redirects it

toward anti-war projects), and began writing letters of concern and protest to federal politicians. Community, social justice and pacifism are all significant aspects of Mennonite life, and all have found their way into her art.

Yet another memento of Falk's marriage was a toy poodle — and how unexpectedly the fabric of the past unravels its threads into the present. This tiny grey creature was a gift from her husband and arrived with the odious name of Baby. Sometimes called Maybe and sometimes Lady, she was later depicted leaping over obstacles and through burning hoops in Support Systems (1987–88). In the meantime, however, she registered her presence less literally: Baby/Maybe/Lady had to be taken for walks and waited for while she went about her canine business, sniffing out the colour and shape of the landscape. She thus functioned as the excuse for her owner to be more mindful of the moment, to look about, to observe more intensely her surroundings beyond her house and garden. It was during a nighttime walk in 1979 that Falk, staring up at the sky for the many-thousandth time, heard a voice in her head boom: "Paint the sky! Paint the night sky!" The original concept, of course, had been seeded two years earlier by Giotto's frescoes in the Arena Chapel, but now it was commanded into existence by the river of star-flecked darkness that flowed above her into infinity.

As with East Border, Falk was unsure how she would actually execute her planned series of Night Skies: "How do you paint something that's six and a half feet high and five and a half feet wide, all in one colour, with some stars?" Her solution was to underpaint with cross marks in yellow ochre, raw umber, ultramarine blue, thalo blue, green, alizarin crimson and raw sienna, laying on bands of colour, dark to light, moving down the canvas. She then created seamless shifts of colour by overpainting with a mixture of more ultramarine and umber thinned with dammar varnish.[56] Not wanting to leave a trail of brushstrokes, she "thwacked" the medium onto the surface, bouncing the bristles of her loaded brush against the can-

vas, creating an unusual condition of painterliness without either brushiness or impasto. Even though she was starting from an imagistic premise, Falk was following an early, abstract-expressionist impulse, making the kind of colour-field paintings first hinted at in *Lawn*. Still, the all-over abstraction might at any moment be yanked back to the realm of representation by clouds and five-pointed stars. Throughout the series, the clouds make allusions to human skin, just as her ceramics had earlier. She sees the colour-field paintings as closely related to the 1969 installation of *69 Grapefruit*, in which the ceramic fruits were scattered — like an abstraction — across the floor of the Douglas Gallery.

Falk painted twenty-two Night Skies, five of which were exhibited at the Harbourfront Gallery in Toronto in 1979 and twelve in Lethbridge and Calgary in 1980. Also in 1980, the whole series was shown at the University of British Columbia Fine Arts Gallery, surrounding the viewer with serial windows into the firmament. In her artist's statement, Falk wrote that it didn't concern her whether her skies were considered "cosmic or domestic."[57] Still, critics made attempts to either bind cosmic and domestic concerns together in her work, or to discover in Night Skies a significant shift in her focus. Russell Keziere commented that "Each stellar landscape is composed of thousands and thousands of repeated actions,"[58] indicating the way Falk's working methods relate to (but don't resemble in outcome) *pointillisme*, and also establishing a connection between her painting practice and the repetitive nature of her sculptural process.

While critical, curatorial and collegial response to Night Skies was extremely positive, the public registered mixed reactions. Viewers described the works as visually dazzling and emotionally moving, but a number of them questioned the artist's use of the device of the flat, five-pointed star, a symbolic rather than naturalistic representation of the distant celestial bodies. Falk herself admired the five-pointed star as a readily recognizable symbol and as "a strong and stable figure,"[59] much like the pyramid.

But obviously the juxtaposition of different schools of representation, different visual languages within the same painting, unsettled many, who declared the stars "kitsch," "dumb," "gimmicky" or "disturbing." And yet, it's these very five-pointed stars, with their connotations of storybooks, school awards, military insignia, Pop Art and festive decorations that shift the work from the nineteenth century's concerns with light, colour and atmosphere into the twentieth century's preoccupations with popular culture, linguistic theory and the uncompromising flatness of the picture plane. The treatment of stars advances Falk's paintings from Impressionism through modernism to a postmodern condition, and from generalized abstraction to the representation of a particular way of being in the world. The paintings compress, again, notions of nature and culture, their interface and definition.

At the time, Night Skies called up likenesses to J.M.W. Turner's atmospherics, Vincent van Gogh's starry nights and the phenomenon paintings of Falk's older contemporary, Paterson Ewen.[60] They also bear formal and thematic similarities to the nature-based abstractions of another Canadian artist, Gershon Iskowitz (1921–1988), whose work Falk had seen and been interested in. Commonalities of subject and means can be found in Falk's Night Skies and Iskowitz's *Morning Blue* (1972), a large oil painting whose rectangle of deep blue and violet "sky" is bordered on either side by cloudy white passages flecked with cadmium red, bright green and chrome yellow. They can also be seen in the series of night-themed paintings Iskowitz undertook in 1981, such as *Night Greens* and *Night Blues*. The likenesses may be incidental, but they indicate an unconscious intersection of spirit and sensibility, a shared perception of the immense mysteries into which our everyday occupations and preoccupations are enfolded.

Falk described her next series of paintings, Pieces of Water, as being, like Night Skies, "personal views of small chunks of my environment."[61] Executed in 1981 and 1982, Pieces of Water are based on observations of English

Night Sky #3, 1979, oil on canvas, 198.1 x 167.6 cm, private collection.
Photo by Teresa Healy, Vancouver Art Gallery

Night Sky #22, 1979, oil on canvas, 198.1 x 167.6 cm, collection of the artist.
Photo by Teresa Healy, Vancouver Art Gallery

Bay which Falk made while walking her dog Lady around her Kitsilano neighbourhood. The first tiny genomes of their conception, however, occurred in the qualities of air and water, clarity and shimmering light, that had enchanted her in Venice. With characteristic individuality, she devised a conceit that would enable her to isolate aspects of her own seaside environment without having to make any of the conventional landscape references to the nearby urban surround or the distant horizon line, to confinement or its converse, immensity. Falk's conceit was that each painting represented a piece of water, thirty by twenty-five feet in dimension, which she had cut out of the ocean with a "long sharp knife."[62] This image recalls the pieces of sod upon which Picnics were predicated — slabs or slices of the everyday environment. Each piece of water, however, is tilted up so that the viewer has the impression of hovering above the subject, like a bird or a butterfly. No horizon line is visible; water fills the entire expanse of painted surface.

Falk struggled for six months to find a way to paint her subject, to "work out a vocabulary of marks and shapes that were satisfying."[63] She finally arrived at a technique of rolling her loaded brush at a gentle diagonal across the canvas. The medium was considerably thinned with dammar varnish and left short, sticky drips and trickles on the painted surface. (In order to control the drips, Falk adjusted the amount of drying time between paint applications.) These watery marks, calligraphic without being broadly gestural, range through a lexicon of flecks, dashes, ribbons and jots of colour that have as much to do with the activity of the thinned paint as with the activity of the artist's hand. In their long, slanting rows, the dots with tails — usually in the upper half of the canvas — resemble musical notations. (This is probably an unconscious resemblance, but one with obvious biographical resonance, just as the stickiness of the surface unconsciously recalls Falk's childhood sensation of watermelon juice trickling down her legs.) The marks are not intended to be literal representations of waves or ripples; rather, they are

"a personal and emotional response to the ocean."[64] They do not depict but they do suggest, evoke, convey. And what they convey is a sense of the shifting or rolling surface of water and the sense, also, of bobbing or swaying strands of seaweed. In most of the paintings in the series, diagonal lines of marks run from lower left to upper right; the overall sense of movement rolls like the tides from upper left to lower right. The colours are transparent and range across the spectrum, from deep cobalt blue through mossy greens, earthy umbers, flowery violets and fleshy pinks. (Just as the paint application of Night Skies is cloudy or atmospheric, the paint application of Pieces of Water is watery.) Sometimes the blue hues predominate, sometimes the green, sometimes the pink, so that there are colour-cued subseries within the two dozen paintings.

Although Falk denies the influence or example of Claude Monet's lily pond paintings (she was familiar only with his realistic early paintings), inevitable analogies were and continue to be drawn. Monet incorporated representational hooks — lily pads and flowers, overhanging branches — but he too excluded the horizon line and pushed the depiction of his beloved garden environment a long way toward abstraction. Both artists worked serially, so that an installation of like-themed works would entirely surround the viewer, in a kind of wraparound panorama. There are similarities, too, between the two artists' palettes, tonal range, and dappled treatment of light and colour. Falk's paint application, however, is much thinner than Monet's, and the surface of her water appears to be more active, its activity relating to the waves and tides of the ocean rather than the still reflections on a garden pond.

Falk gave each of the Pieces of Water a subtitle that also included the subject of a newscast, such as *10% Wage Freeze*, *Squamish Highway*, *Libya*, *Israel*, *Constitutional Agreement*, *President Sadat* or *Terry Fox*. Being "very bad with numbers," Falk says that she couldn't identify her own Night Skies from the chronological numbers she'd assigned: "I thought a telling thing, an important thing,

Piece of Water: Happy Ending, 1981, oil on canvas, 198.1 x 167.6 cm, collection of Trans Mountain
Pipe Line Co. Ltd., Vancouver. Photo by Stan Douglas, Vancouver Art Gallery

Piece of Water: President Reagan, 1981, oil on canvas, 198.0 x 167.8 cm, Vancouver Art Gallery, 81.7.

Photo by Teresa Healy, Vancouver Art Gallery

would be to name them after the events of the day that I heard on the news." The subtitles do not constitute social commentary, exactly, but they do manifest social awareness. Critic Gary Michael Dault sees a relationship between the refusal of a horizon line in these paintings and their news-item titles. "Great, still oceans are horizontal," he writes. "Prairies stretch off on either side till we must take their endlessness on faith. But Pieces of Water are angular shards of experience that enter our lives like facts, taking up local habitation—and given names."[65]

The news items alluded to in the titles of Pieces of Water also admit an element of darkness or conflict into the gorgeous benignity of light, colour and movement.[66] A metaphorical shadow is cast across a condition of blessedness. And shadows, both literal and metaphorical, emerged as a theme and motif in the next series of paintings, Cement, developed through 1982 and 1983. Again, the subject is drawn from Falk's daily dog-walking, but it's also drawn from her ability to see beauty and variability where others see only sameness and banality. She talks animatedly about the different kinds and colours of rocks which are incorporated into cement, so that it is not simply a uniform grey. Like an Impressionist, she also observes how different conditions of light and moisture affect the way her subjects look. The depictions of sidewalks are washy and dappled, and range through a spectrum of subtle colours, from pale grey through rosy pinks and sandy ochres. Cement is treated as if it were precious fabric or human skin. It is the recurring nature of her art to find likenesses to figures and flesh in inanimate objects and materials.

The interest in sidewalks as a subject was first expressed in the landscape panels of Thermal Blankets, although seen there only as fragments within lawn and garden environments. Here, the sidewalks expand to fill almost the entire canvas. As in Night Skies and Pieces of Water, the subject is tilted up against the picture plane and the horizon is excluded, along with most external references. With a few exceptions, the Cement series employs the same recurring format: a trapezoidal stretch of sectioned sidewalk, wider at the bottom and receding toward the top, with a thin triangle of grass or garden wedged into the upper left corner. (Although there are no horizons, there are horizontal lines between sections of sidewalk, which seem to subtly allude to the hard-edge paintings of another time.) In Cement with Small Yellow Leaves (1983) and Cement with Maple Leaf (1983), the golden forms of leaves are scattered across the sidewalk and bordering lawn. These leaves are reminiscent in their shape and luminescence of the flames (and flaming maple leaves) in Picnics and the five-pointed stars in Night Skies, and they seem to compress life and death, animation and suspension, into their expressive forms.

Shadows of seen objects (a bed of unruly poppies) and unseen objects (a car, a chain-link fence, the tops of deciduous trees) are cast across a few of these sidewalks. The shadows are painted, like the sidewalks themselves, in a range of unexpected colours, from mauve and silvery blue through russet and charcoal grey. Although most people think of shadows as ominous, portending death, Falk does not. She finds them, in most instances, "friendly," and recites the first line of a Robert Louis Stevenson poem, remembered from childhood: "I have a little shadow that goes in and out with me."[67] Still, the large dark shape cast across the sidewalk in Cement with Black Shadow looks more like a cenotaph or tombstone than a car, and contrasts powerfully with the festive, confetti-like flecks of colour scattered around it. Again, Falk mediates existential opposites. Again, she brings mystery, poignancy and unsettling beauty into a landscape of extreme ordinariness. *(continued on page 88)*

(continued on page 88)

Cement with Black Shadow, 1983, oil on canvas, 198.0 x 122.0 cm, collection of the artist.

Photo by Teresa Healy, Vancouver Art Gallery

Cement with Black Shadow

by Bruce Grenville

The Cement paintings have seldom been shown, and, on those rare occasions, they have often been hung in ancillary spaces while pride of place was given to the concurrent Night Skies or Pieces of Water paintings.

They are admittedly, difficult to warm up to, especially when compared to the rich ultramarine blue of the Night Skies or the mesmerizing surfaces of the Pieces of Water. While water has often been the subject of art, albeit in very different form, I cannot recall another instance of the sidewalk as the principal subject of painting. And yet the Cement paintings are, to my mind, among the richest of Gathie Falk's works. The luscious surfaces are covered in colour—burnt sienna, ultramarine blue, yellow ochre, cadmium red—running from edge to edge with the shallow depth of an abstract colour-field painting. Only a small wedge of grass runs along the margin of the canvas, disrupting the spreading surface of the cement and anchoring the colour to the world.

From the upper right, a black shadow spreads like a stain across the canvas, casting doubt onto an otherwise benign subject. Falk recalls that the image came to her on one of her daily walks to the grocery store with her dog. The dog wouldn't pass over the shadow cast by a parked car. Falk thought the incident rather ominous. As in most of her work, she has painted the event from memory, altering the forms and the circumstance to meet the demands of the painting.

The shadow is emphatic but not strictly representational, as in her later paintings. Its appearance here is evocative, signalling the presence of similar, everyday occurrences that cast their shadow across otherwise uneventful actions. This is the first of Falk's works to be given what she describes as an "uncompromising" shadow, the first in which the shadow is an object in its own right. In the Theatres in B/W and Colour painting series that follows in this same year, the shadows play a critical role. They are objects in their own right, only loosely tied to the optical and physical demands of the pictorial space. Whether the shadows are those of bushes, chairs, bones or cabbages, they speak of another world, a parallel world, a spiritual world, perhaps, that casts its influence across our everyday lives. The two are inextricably bound together and yet irreducibly separate.

In its first appearance here, the shadow is a mystery. It is an inexplicable form that casts an affect upon the work, but which cannot be read as a sign. But if a conventional semiotic reading is subverted, a formal reading is equally problematic. There is no compositional conceit that would explain its appearance. Located as it is in the upper right corner, the shadow makes the painting top heavy. Its amorphous shape is neither organic nor machine made; it appears like a stain across the skin of the cement, seeping into its surface. Where most of the other paintings in the series adopted the strategy of an open, all-over surface, broken only by the wedge of grass, *Cement with Black Shadow* (1983) pushes the series toward a new compositional model.

Assessing the works from this time, Falk recalls an intense interest in abstraction, not as a subject in itself but as an affirmation of the primacy of the physical act of painting. The paint,

rendered and blended, applied in diverse ways to the flat, lightly textured surface of the canvas, is a fundamental subject of this work. Perhaps more than any other, these Cement paintings draw the viewer to their surface. The myriad of marks—some descriptive, others autonomous—are captivating and seductive. Their scale is relatively intimate, human in size compared with the larger Pieces of Water or Night Skies. Where those are intended to overwhelm the senses and submerge the viewer in a field of sensation, the Cement paintings offer a more literal transcription of their subject, virtually duplicating its scale. If the Cement paintings are disorienting, it is because the normally horizontal surface of the sidewalk has been hauled up vertically, leaving the viewer with an uneasy feeling of being face to face (or worse, face down) with this pedestrian subject.

Many of the compositional and conceptual criteria for the development of the cement sidewalks are similar to those of the Night Skies and Pieces of Water. All share subjects that are part of Falk's Kitsilano neighbourhood in Vancouver. Her daily walks with her dog provided plenty of occasions to study the night skies, to observe changing the waters of English Bay and to scrutinize the local walkways. And, if Falk's 1977 trip to Italy provided an impetus to paint the starry night (after seeing Giotto's night sky on the ceiling of the Arena Chapel) or the surface of the water (after visiting Venice), then the Cement paintings must surely be linked to the quattrocento art of fresco-making, where plaster and pigment are melded to produce an uncanny, skin-like surface. The rich surface of the Cement paintings carries that same dry intensity, in which the paint no longer appears to sit on the surface, but *is* the surface.

The sublime, starry night and the undulating surface of the sea are powerful images, awe-inspiring and occasionally frightening. They confront us with our insignificance against their vastness. Conscious of this, Falk may have tried to counteract the sublimity of the Pieces of Water paintings by subtitling them after the leading news events of the day—the eternal brought into alignment with the quotidian. While this decision was strategically subversive, it appears to have been more distracting than effective. Significantly, these sublime themes are rarely the subject of a focussed scrutiny on the part of the artist. They are traditionally represented in formulaic compositions that contrast the miniscule human form against powerful natural forces. Falk rejects this formulaic response in favour of an intense examination of her subject. The Cement paintings offer a very different notion of the sublime, one that is human in scale but offers its own notions of limitlessness and evocative presence. In flipping up the sidewalk to face the viewer, Falk invites us to give it the same contemplation that we might give to the night sky or the water. They are the object of her scrutiny on a daily basis, and their sublimity comes from her acknowledgement of the wondrousness of the everyday.

Of the three series—Night Skies, Pieces of Water and Cement—only the sidewalks bear the traces of a human presence: countless thousands of feet have scuffed across their surface. And it is this ability to encapsulate the direct effects of day-to-day experience that sets this series apart. Within the group itself, *Cement with Black Shadow* provides a moment when the incidental blends with the habitual to create a remarkable effect. The meaning of the work remains intentionally open and ambiguous, without tidy resolution. This is abstraction at its best.

Cement with Grass #1, 1982, oil on canvas, 200.7 x 123.2 cm, collection of the artist.
Photo by Teresa Healy, Vancouver Art Gallery

The 1980s started out eventfully, although they were not, perhaps, as emotionally gruelling as the years just before. Between 1980 and 1985, Falk exhibited widely, often in solo shows; signed on with two prestigious commercial galleries, the Isaacs in Toronto and the Equinox in Vancouver; contributed, again, to the sponsorship of refugees, two from Vietnam and two from Ethiopia; underwent major surgery to remove a large but benign tumour; injured her foot and later underwent more surgery to correct the damage; formed a small company with friends to produce decorative cement tiles and, later, stencilled floor cloths; consulted with Ann Rosenberg on the special double issue of *The Capilano Review*, "Gathie Falk Works," which documented her career from *Home Environment* through the Pieces of Water series; and commissioned her friend and former student, Rob Mackenzie, to design a new studio for her on the site of her old garage. She also began work with Tom Graff on a project to videotape her performance works, with Greg Bellerby on a survey show of her paintings for the Art Gallery of Greater Victoria (1985), and with Jo-Anne Birnie Danzker on a retrospective exhibition for the Vancouver Art Gallery (also in 1985).

At the same time that Falk was reflecting with writers, curators and videographers on what she had so far accomplished — "It had the feel of a career," she says, "but it certainly wasn't finished" — she was dismantling her 50-cubic-foot gas kiln in order to make way for a new painting studio. Until this point in early 1983, she had been painting in a small room in her house and leaning her completed canvases in front of windows. She never really knew what a series of paintings looked like until she saw them installed in a gallery.

Taking down the gas kiln didn't signify the *absolute* end of Falk's ceramic production: she maintained a small electric kiln in her house and, during the following couple of years, spent considerable time remaking and restoring ceramic props for the video documentary of her performance pieces, and sculptures for the 1983 and 1985 restagings of *Home Environment* at the Vancouver Art Gallery. Still, the act of dismantling did seem to confirm the commitment to painting. Some of the paintings in the Cement series, however, signal a re-emerging interest in sculptural, theatrical and surreal imagery, in finding a stage again for the recurring symbols and motifs that distinguish her *œuvre*.

In 1983, Falk created a number of watercolours based on Safeway-brand tulip-bulb boxes. (Not Warhol's Brillo boxes but *tulip-bulb* boxes — bits of nature processed through consumer culture.) Decorated with photographic images of unbounded fields of countless tulips and written over with names and instructions, the boxes were also the subject of a large, three-panel painting titled *Two-Dimensional Rendering of a Large Number*. Just as her loose style consolidates flowers, fields, words and boxes into an imagistic whole — folding pictures within pictures, representational systems within representational systems — so it also integrates landscape and still-life genres. Nature again intersects with — and is defined by — culture.

The phrase "55 billion tulips" is painted around the bottom of the three boxes in the three panels, and the phrase reflects Falk's curiosity about what that number might actually mean. In Canada, the United States and France, she points out, a billion is a thousand millions; in England, it is a million millions. Still, whatever quantity "55 billion" denotes, it's incomprehensibly *big* — image repetition taken to an absurd degree. And, of course, her musings on figures and meanings, on signs and series and systems of representation, are set within the context of a garden. *The* garden. The paradisiacal garden at the centre of the unhorizoned world.

The year 1983 also marked the beginning of a new and complex series of paintings, Theatres in B/W and Colour. Falk used the word "theatre" to signify the subtle drama of growth and change in her garden and as a metaphor for the way "bits of life" are framed by theatre, just as they are framed by art. Theatre is a means of isolating and understanding aspects of existence, she says. The intricate choreography, surreal juxtapositions and prop- and set-

like look of the images also allude to her own "Theatre Art Works" and to her belief that European Surrealists, especially Magritte, were themselves "performance artists," given the theatricality and the temporal dimension conveyed by their paintings.[68] Falk's series has a significant sculptural aspect, too — that is, it is the painterly version of what could be sculptural installations.

The idea for the series, which lines up many repetitions of the same object in receding rows within a lawn or garden setting, had a few points of inception. In the mid-1970s, Falk had envisioned an installation of life-sized cement rabbits, flat as had been her carousel horses, in rows on a grassy slope. The mould for the rabbits was accidentally broken, however, and the idea was never realized — although the image persisted in her mind. Later, at the opening of her solo show at Artcore in 1978, Falk received several bouquets of flowers from friends. These she took home and hung on the nails where her paintings (the ones then on exhibit) had been hanging. The look of the bouquets suspended at intervals on the wall and drying over time into wispy ghosts of themselves appealed to her — she thought they were both tough and beautiful — and this image persisted, too. She also found herself engaged, emotionally and visually, by the look of her garden stakes, which were made out of old wooden laths salvaged from a home renovation. The flat stakes evoked particularly strong feelings in the winter, when the plants and flowers that had been tied to them had died or been cut back. She imagined hats sitting on them, although she never actually painted hats. She painted, instead, bouquets tied one each to the stakes placed in staggered rows, all casting pale, diagonal shadows across a washy lawn. She perched long-tailed birds on top of her stakes, too, and painted rows of them. She also painted rows of ordinary objects without any stakes at all: cabbages with long ribbons dangling like streamers from some unseen place above them; flowering trees with light bulbs hanging above them; white, wooden kitchen chairs with wispy bouquets lying on their seats and flowers tied to their spindle backs; miniature Alberta

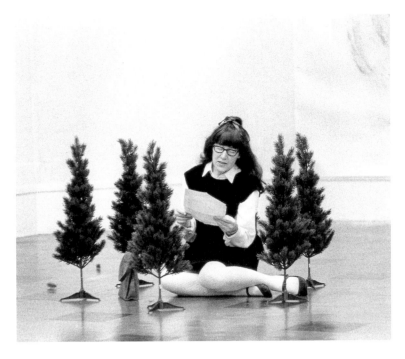

A Bird Is Known by His Feathers Alone, performance documentation at the Vancouver Art Gallery, 1972 (first performed at the Vancouver Art Gallery, 1968; revised, 1972). Photo by Nomi Kaplan

spruce trees in pots with soup bones — her dog's bones — hanging above them; green velour chairs with rocks suspended above them — and so on, through more than thirty variations on the theme.

As with *150 Cabbages*, Falk employed the formal device of groups (in rows or grids) of disjunct images reaching upward and downward toward each other. Indeed, the rocks dangling over the green chairs are cabbage-like in their shape and size. Also familiar from earlier works are fish, flowers, chairs and miniature evergreens. At the same time that she was cultivating Alberta spruce trees in her garden and painting them in Theatres, she was hauling little plastic Christmas trees out of her basement and dusting them off for use in the videotaped restaging of *A Bird Is Known by His Feathers Alone*. Real, painted or plastic, the trees are all seen by Falk as formally and thematically one. Light bulbs emerge as a new motif; they would appear again in her work, in contexts suggestive of theatre or performance. Here, they seem to consolidate earlier motifs, each light bulb combining the beautiful shape of an egg or a piece of fruit with the luminescence of a star or flame.

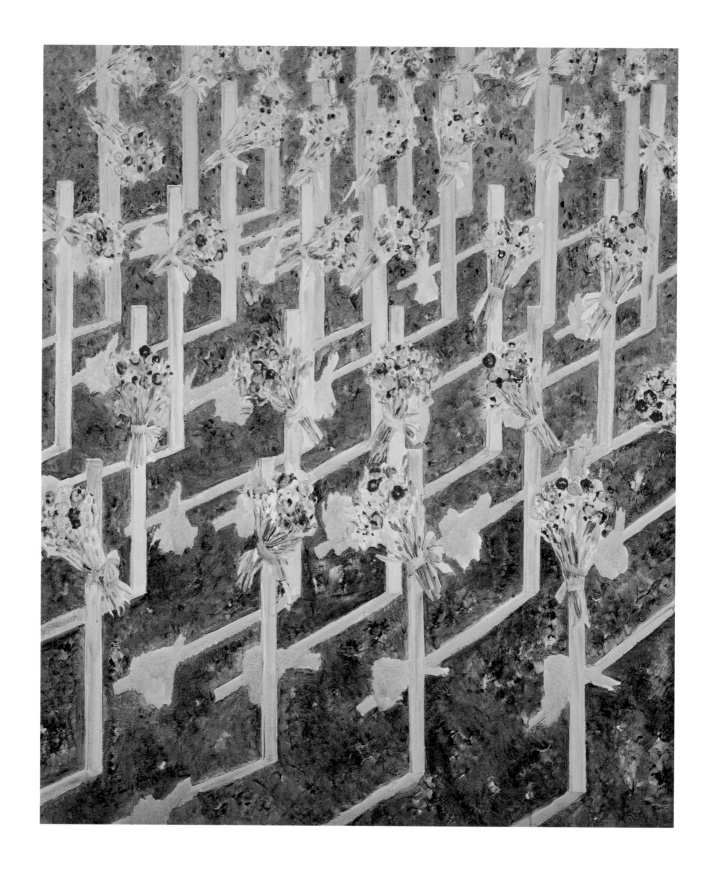

Theatre in B/W and Colour: Bouquets in Colour, 1983, oil on canvas, 198.2 x 167.4 cm, Glenbow-Alberta Institute,
Glenbow Museum, Calgary, 984.31. Photo courtesy Glenbow-Alberta Institute

Theatre in B/W and Colour: Bouquets in B/W, 1983, oil on canvas, 198.1 x 167.6 cm, Vancouver Art Gallery, Gift of J. Ron Longstaffe, 86.203. Photo by Teresa Healy, Vancouver Art Gallery

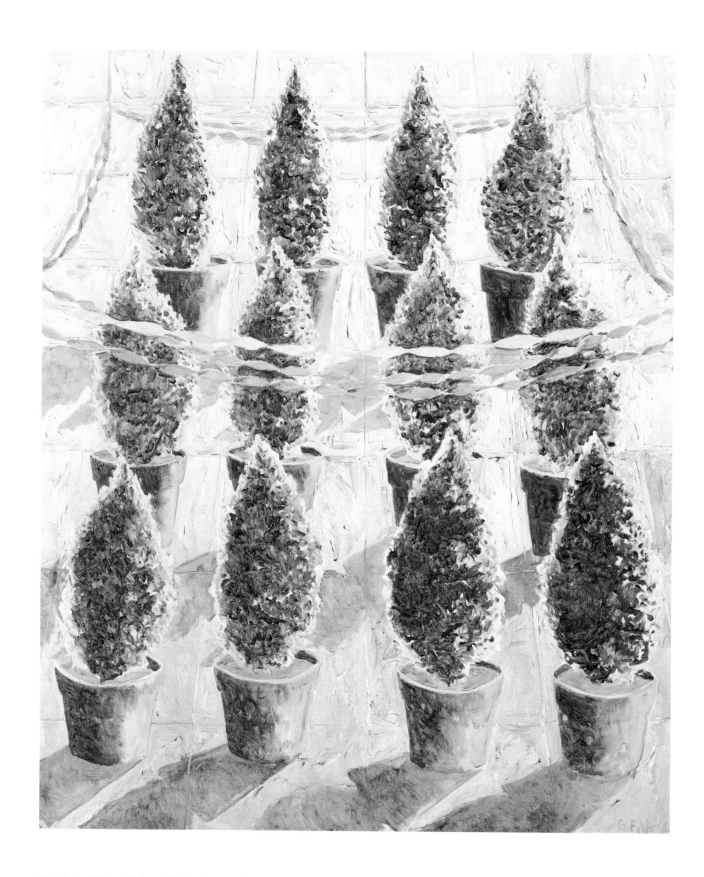

Theatre in B/W and Colour: Alberta Spruce & Streamers in Colour, 1984, oil on canvas, 198.1 x 167.6 cm,
Vancouver Art Gallery Acquisition Fund, 86.31. Photo by Teresa Healy, Vancouver Art Gallery

Theatre in B/W and Colour: Alberta Spruce & Streamers in B/W, 1984, oil on canvas, 198.1 x 167.6 cm, Vancouver Art Gallery Acquisition Fund, 86.3. Photo by Teresa Healy, Vancouver Art Gallery

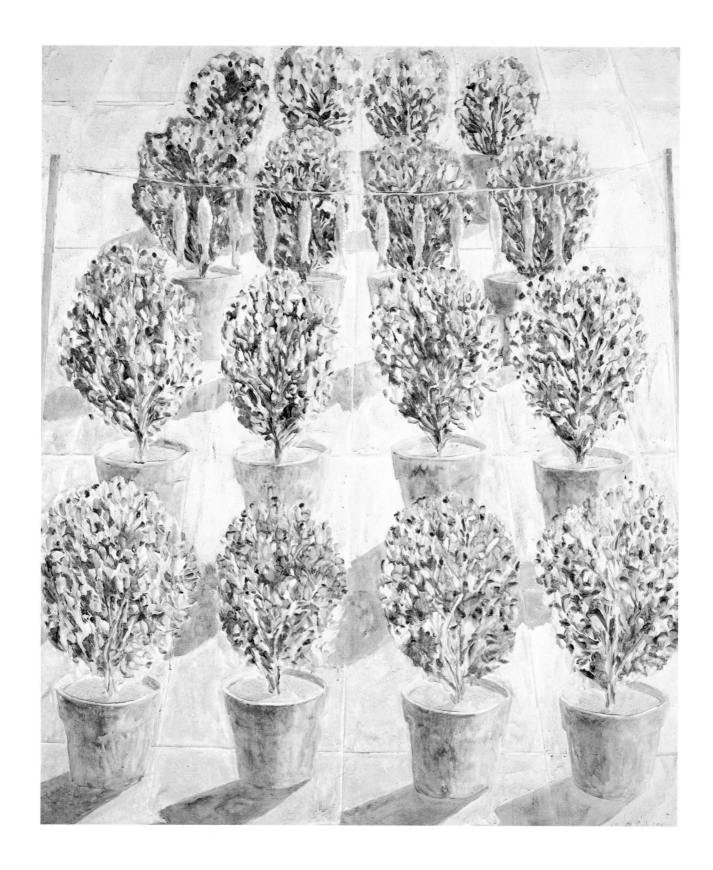

Theatre in B/W and Colour: Bushes with Fish in Colour, 1984, oil on canvas, 198.2 x 167.4 cm,
National Gallery of Canada, Ottawa, 29516.2. Photo courtesy National Gallery of Canada

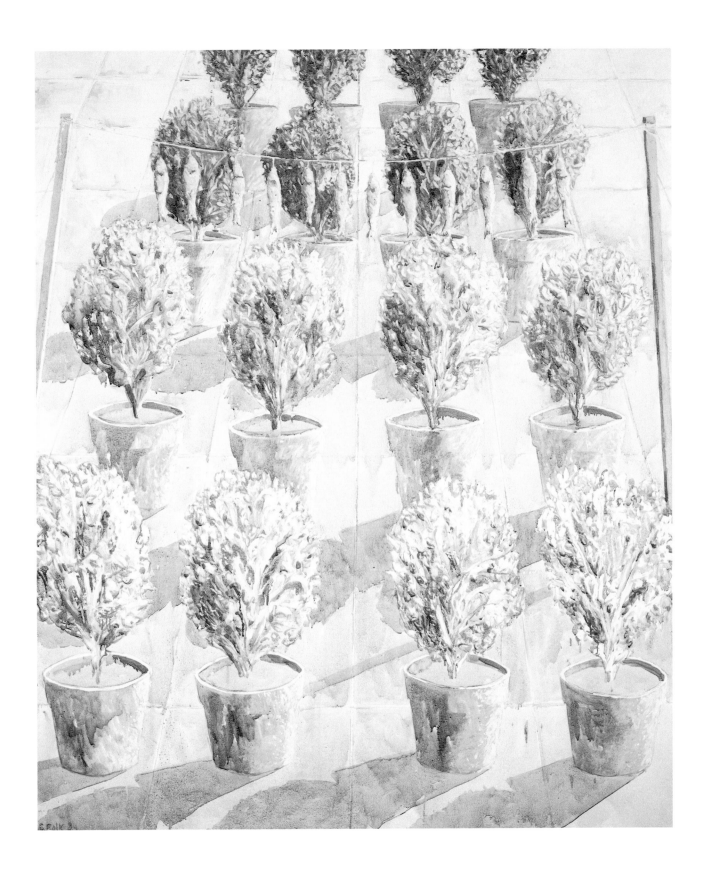

Theatre in B/W and Colour: Bushes with Fish in B/W, 1984, oil on canvas, 198.2 x 167.4 cm,
National Gallery of Canada, Ottawa, 29516.1. Photo courtesy National Gallery of Canada

An important aspect of Theatres in B/W and Colour, indicated by the title, is that Falk produced black-and-white versions of most of the coloured paintings. Again, she was exploring different representational systems, particularly our willingness to accept as real a black-and-white photograph or a black-and-white movie when we know that people and objects are no such shades of grey. Her interest in black-and-white versions of the many-coloured world may have had its origin in her early painting classes with Roy Oxlade, who forced his students to learn brushwork by painting only in grey and brown monochromes. (Greg Bellerby has observed that the black-and-white versions of Theatres are more brushy and aggressive than their colour counterparts.[69]) The black-and-white versus colour impulse certainly goes back to Home Environment's TV dinners, and was much more fully explored in Herds. But the ghostly twinning reaches an imagistic climax in Theatres in B/W and Colour and suggests, once again, the shadow of death that lies across the everyday. Sinister or not, some of Falk's Theatres resemble cemeteries, some of her garden stakes look like crosses or grave markers, some of the objects set out on them have the appearance of offerings.[70] And yet, in a characteristically dualistic way, there is also a festive air, especially in the coloured streamers, beribboned plants and flowering bushes.

Shadows, in both colour and black and white, are also a significant formal aspect of Theatres, although in the coloured works they are painted in such thin washes that they seem like the pale twins of the shadows that should be there. Falk sees the shadows as "hinged" to the three-dimensional objects that cast them, as if object and shadow were one continuous form. Certainly they are one continuous form in her paintings; although representing different dimensions, they are handled with similar degrees of flattening and contouring. Apart from any symbolic implications, the shadows play an important compositional role, extending forms beyond the margins of the paintings and functioning as a kind of matrix or armature upon which the work is constructed. Cast diagonally across the picture plane, as if a strong light were shining from the upper right, the shadows are powerful vehicles for the artist's repetitive strategies and her formal and thematic complexities. Whether the light is theatrical or apocalyptic, only the shadow knows.

My Dog's Bones is an installation that was first staged in Montreal in 1985. Its essential form, however, had been explored in a 1984 painting of the same name in the Theatres series. The installation consists of 690 bones, tied by kitchen twine to a ceiling grid and suspended above another grid, composed of sixteen small evergreen trees in pots, sitting on the floor. Falk adds a this-world/other-worldly dimension to the already surreal composition by painting shadows for the bones and trees on the walls and floor of the gallery in which the work is installed. The painted shadows intermingle with actual shadows, giving the work a powerful metaphysical character.[71] *My Dog's Bones* mixes up mediums, genres and realities — painting and sculpture, landscape and still-life, representation and actuality — just as it mixes up the way that we think about nature and culture.

Falk took the image of white kitchen chairs with wispy bouquets on their seats from Theatres and restaged it in *Two Curves Celebrating*, a 1987 painting commissioned for a billboard to commemorate the centennial of the Manufacturers Life Insurance Company. In this huge work, seven chairs are arranged in a semi-circle, and a white line, like a clothesline minus the washing, hangs in a mirroring semicircle above them. (The overhanging line is reminiscent of those used in Theatres, and of the original, used in an earlier performance, *Skipping Ropes*.) She once described the chair formation as "a domestic Stonehenge,"[72] which neatly encapsulates the sense of ritual potential. The combination of chairs and flowers signifies both "waiting" and "celebration" to Falk, as if the scene had been set out in expectation of a wedding or graduation — or anniversary party.

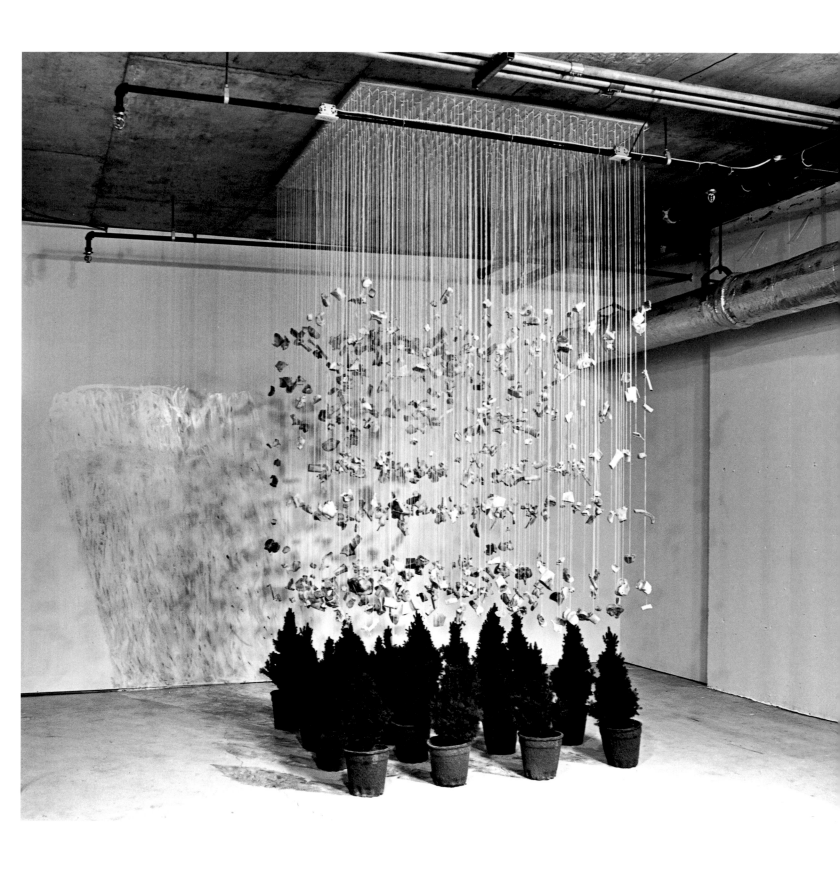

Installation view at Centre international d'art contemporain de Montréal: *My Dog's Bones*, 1985, bones, cord,
Alberta spruce and enamel paint, 309.0 x 109.0 x 109.0 cm, collection of the artist. Photo by Jim Gorman

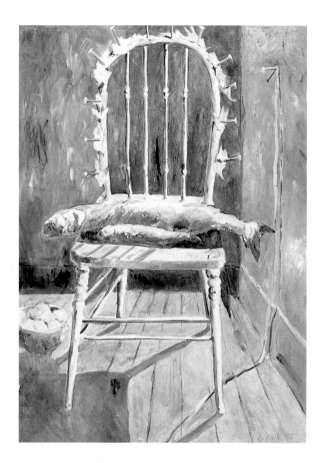

Chair with Fish and Maple Leaves, 1985, oil on canvas, 106.7 x 76.2 cm, private collection. Photo by Stan Douglas

Two Curves Celebrating and *My Dog's Bones* are not the only works that were spun out of Theatres. The white wooden and green velour chairs that appear there form the imagistic basis, along with a dark brown wooden chair, for the next series of paintings in 1984 and 1985. The Chairs are still lifes set in brilliantly lit interiors or equally bright gardens, although in some instances, interior and exterior spaces interpenetrate each other. In other instances, the setting is oddly indeterminate. Within each painting, a single chair, seen from the front, back or side, is juxtaposed with ordinary objects in extraordinary ways: a green wreath and small clouds (revisiting the performance work *Low Clouds*); a waterfall shooting out of an impossibly erect garden hose; topiary rose trees growing directly out of a tiled floor or patio; a skull-like mask and a patch of foxgloves; three pigeons and a striped tie (the latter draped over the front of a chair in a manner reminiscent

of the tie in *Home Environment*); a sleeveless pink dress draped over a pile of fish and casting a watery grey shadow.

Chairs evoke many moods and feelings, ranging from the valedictory to the foreboding, and from the celebratory to the sacrificial. The paint application is thicker and more "emotional" than in Cement or Theatres (although there are thin passages, too), and the shadows are vehicles of considerable painterly abstraction. One of the effects of pulling old paintings (from the early and mid-1960s) out of storage in preparation for the 1985 retrospective was Falk's appreciation for how they were made, especially for their thick and expressive paint application. She resolved to work that way again, employing more difficult colours and more forceful and energetic brushwork.

The humble chairs are themselves emotionally charged images for Falk, with connotations from her childhood of times when her brothers invented games and performances with rearranged and overturned furniture. Chairs resonate with incidents and personalities from her early adulthood and middle age, too. The image of the dark brown chair, for instance, is derived from an article of furniture which Falk's mother bought and then varnished yearly; depicted in conjunction with rose trees and streamers, it is a poignant portrait and memorial. Another chair, heaped with camellia blossoms, relates directly to Falk's habit of picking up fallen camellia blossoms from her garden and making piles with them on the porch stairs of her house — and revelling in the beauty of that spontaneous still life. In the context of Chairs, the flowers also seem offertory.

Fish recur frequently in this series and, laid dead across the seats of altar-like or shrine-like chairs, also connote offerings or sacrifice. Sacrifice is a powerful theme in *Chair with Fish and Maples Leaves* (1985), in which two dead fish, one large, one small, lie on a blood-red cloth across the seat of a white, spindle-backed chair. Golden maple leaves are nailed (as in *Picnic with Yellow Maple Leaves and Blue Sky*) to the chairback. The leaves look like flames licking the curving back of the chair, but they also suggest

crucifixion. It is difficult, in this context, to ignore the art historical fact that for centuries the fish has symbolized Christ. A bowl of eggs, sitting on the floor to the left of the chair, suggests redemption, regeneration, rebirth into eternal life. That the source of the searing light shining across this still life is impossible (the light seems to originate *behind* the walls of the room in which the chair sits) bestows an additional air of the miraculous.

Equally powerful, but for quite different reasons, is *Chair with Black Dress #1* (1985). The black dress, hanging from a nail on a pink wall and draped across an upholstered green chair, is a metaphor for a female figure. The form of the chair pushes out through the fabric of the dress in a way, Falk says, "that suggests manhandling of a not nice nature." The dress's stark, dark, purple-maroon shadow, she notes, "reinforced that feeling for me." The scene alludes to physical transgression that may be sexual, but that also may relate to the protracted medical investigations and painful surgery on her tumour a few years earlier. As with Mary Pratt's depiction of a butchered moose in her painting *The Service Station* (1978), the medical and the sexual are conflated in an image of male trespass on the female body. In Pratt's painting, crucifixion and gynecology are symbolized within the same image, the butchered and splayed hind quarters of a wild animal; in Falk's Chairs, crucifixion and manhandling occur in separate, serial paintings — but suffering, pain and protest are palpable in both.

The paintings in the Chairs series were the most recent included in Falk's 1985 retrospective exhibition at the Vancouver Art Gallery. That retrospective, in concert with her painting survey show circulating from the Art Gallery of Greater Victoria (AGGV), retired any lingering notions that she was merely "a surrealist of good vibes — a funky, bizarre artist for whom play and the recreation of her childhood are her most serious concerns."[73] Where AGGV curator Greg Bellerby focussed on Falk's accomplishments as an expressive painter and colourist, VAG curator Scott Watson interpreted her entire œuvre in the light of her difficult life and her strong Mennonite faith. Beneath the apparent charm, repetition and whimsy in Falk's work, Watson wrote, lay darkness, chaos and death. But there were "intimations," too, of divine presence and the promise of resurrection.[74] Although Falk disagreed with Watson's reading, feeling he wasn't informed enough about Mennonitism to make analogies between its beliefs, rites and sacraments and her own imagery, she did agree that there is a lot more to her art than humour and playfulness. Still, she continues to argue that her images orbit in a system of personal rather than ethno-religious or archetypal symbols. And critics and curators continue to disagree with her. But amiably.

The retrospective gave Falk an obvious opportunity to assess — and feel satisfied with — much that she'd accomplished. One aspect of her work that spoke powerfully in the VAG show was the use of repetition. She had already attributed her repetitive and serial strategies to the repetitive advertisements she noticed in the Paris Métro in 1965. On a later trip to Paris, in 1974, for the opening of her show *Single Right Men's Shoes* at the Canadian Cultural Centre, Falk saw Andy Warhol's exhibition of Chairman Mao paintings and prints. She remembers walking through room after room of Mao heads, the same image repeated over and over in different sizes, mediums and colours, feeling that her own embrace of repetitive imagery had been confirmed. From popular culture, she understood the power of surrounding viewers with many, many like images; in Pop art, she found validation.

Falk's 1986 painting series, Soft Chairs, was an obvious development from but also a contrasting impulse to the Chairs. As a visual antithesis to the "transparent" qualities of both Theatres and Chairs, with their ribbons and stakes, their spindle backs and legs, and their correspondingly "lacy" and intricate shadows, she chose to build her new still lifes around an upholstered sofa and an armchair from the 1940s. The appeal of these large, hefty objects was manifold: she was interested in the personal

and social connotations of such furniture, and also in their sculptural qualities, the condition of solidity and *bulk* they conveyed. Before arriving at the subject of the sofa and armchair, she had a nagging image of some unidentified, large and bulky *thing* at the centre of her canvas. The big, old furniture established what that thing would be.

In the statement for a solo exhibition of Soft Chairs at the 49th Parallel Gallery in New York in 1987, Falk speculated on what feelings would have been invested in such living room furniture at the time it was made. She concluded that, in a lower middle-class family, the suite would have signified pride of ownership after careful and protracted savings, and also, to anyone sitting on the couch or chair, safety, security and regal remove from the grinding reality of everyday work. "And above all else," she wrote, "this living-room suite meant there was a father in the house."[75]

As with the armchair in *Home Environment*, Falk continues to derive a sense of fatherly presence in the surround of big, protective, upholstered furniture. She also, for reasons she can't entirely explain, is "thrilled" by the bulky presence of bushes, hedges and trees, thrilled by the sight of these actual objects and also by the images of such objects in black-and-white movies. "Bulk seizes me," she says, "the substantial weight, the massiveness, the shape." (In contrast — as seen in her ceramic sculpture and in painting series like Cement and Pieces of Water — she is equally seized by the shifting, shimmering and undulating *surfaces* of things, by the skin of the everyday world.) Writing later about the image of a burning bush, Falk declared: "It is hard to do justice to a bush and even harder to give full credit to a tree. A big easy chair, on the other hand, has some bush qualities and is easier to take hold of in paint."[76]

As with Chairs, the still-life images in Soft Chairs are set in interiors or garden landscapes or some ambiguous conjoining of the two. Again, flowering plants in pots and gardens and trees growing out of the floor jostle the line between nature and culture. Again, shadows assert a powerful presence. And again, furniture is juxtaposed

with extraordinarily charged ordinary objects, such as fish, flags, feathers, maple leaves, light bulbs, crepe paper streamers and strands of Christmas lights. The motif of a potted lily emerges, a line of shoes recurs, and there is a particular attention to men's suits and women's dresses.

More forcefully than in any previous series of works, clothing here takes the formal and metaphorical place of the human figure. In *Soft Couch with Suit* (1986), for instance, a dark, pinstriped suit hangs from a line above the sofa. Part of the suit, however, is draped across the seat of the sofa so that it looks like a reclining figure — one of those family members who has acquired, with thrift and hard work, the substantial furniture on which he now sits. In *Soft Chair with Winged Black Dress and Lilies* (1986), a dress with ruffled "wing" sleeves sits like a dark angel or spectre, half-collapsed in its throne-like chair. A pot of lilies stands to the right of the chair, casting annunciatory or commemorative symbolism along with a lilac shadow onto the yellow tile floor. And *Soft Chair with Suit and Black Dress* (1986), is like a wedding portrait: the hanging suit and dress are paired like a bride and groom at the altar.

The deft use of clothes as symbols and surrogates of human figures makes the next series of paintings, Support Systems (1987–88), all the more surprising. These works are fraught with figuration, human and divine. They're fraught with small creatures, too — dogs or dog-wolf-rabbit hybrids — leaping over hurdles and through burning hoops. Around the sometimes-anguished figures and leaping creatures, weather vanes whirl, fires rage, and flowering plants and bushes cast shaggy shadows over an agitated landscape. Funnels of smoke send explosions of colour into the silvery sky, and plants are continuously being staked up, tied up, held up — by human figures and by disembodied human hands. The entire series dances with energy and is flooded with a brilliant, apocalyptic light.

The series began as a meditation on the nature of "support." Working in her garden, staking up plants and young trees, holding and grasping these growing things, Falk was struck by the metaphysical question of whether

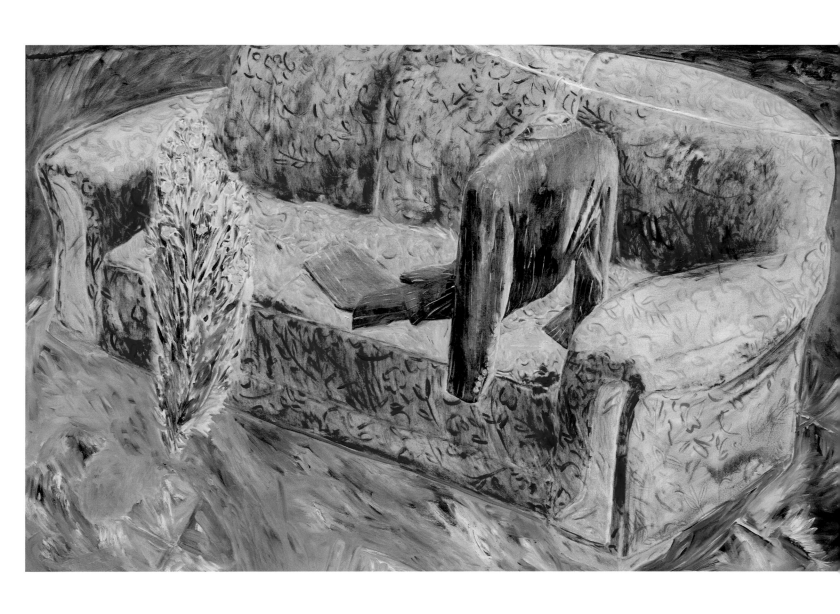

Soft Couch with Suit, 1986, oil on canvas, 124.5 x 199.0 cm, private collection.
Photo by Teresa Healy, Vancouver Art Gallery

she was supporting the plants or the plants were supporting her. She decided to make a "small" series of paintings around the notion of spiritual, emotional and physical support, and the wonder and mystery of garden growth, adding leaping dogs and flaming hoops to contribute to the magical mood. Some of the canine images refer to a friend's dog jumping through a hoop and to the courage and "stoutheartedness" of her own small-sized but large-leaping dog. The series galloped away with her, and she extended the support metaphor to include her friends and church and the refugees she had sponsored. (Since 1979, Falk has participated in four separate sponsorships of two refugees each.)

Into the question of support and the context of the garden, Falk introduced jagged pillars of fire. She was not consciously invoking the Old Testament story of the Israelites being guided through the night desert; rather, she was drawing again upon her own fascination with fire. That all the danger and gorgeousness of fire could be consolidated into a pillar stretching from ground to sky was a "magnificent" concept to her. The flaming hoops are also an exciting image, anticipated in *Chair with Fish and Maple Leaves*.

The painterliness of Support Systems is as rich as its imagery, all explosive movement and luscious colour combined with a new and dramatic use of silvery aluminum paint. (Falk was inspired to apply aluminum house paint to her canvases after viewing some Frank Stella paintings in New York in 1987.) Although one critic saw the rituals depicted as "pagan"[77] — and tree-worshipping cults and solstitial bonfires could certainly be read into these complex and enigmatic images — a sense of the Biblical pervades the series. Around and between the flowering trees and the hoops, arches and pillars of fire, the human figures look like angels with golden wings, or like Adam and Eve in the Garden of Eden. While Falk says she was not consciously alluding to Biblical stories and figures, she also says that her faith and her belief in heavenly help and guidance — divine support systems — are so funda-

Support System with Figure and Pillar of Fire II, 1988, oil on canvas, 213.4 x 152.4 cm, collection of Glenn Allison. Photo by Stan Douglas

mental to her being that they would naturally underlie her metaphysical speculations — and her image-making.

In the late 1980s, Falk was asked by architect Arthur Erickson to create a mural for a long, curving interior wall of the chancery of the Canadian embassy in Washington, D.C. (Two other West Coast artists, Gordon Smith and Bill Reid, were also commissioned to produce works for this building.) Falk painted a sequential, seven-panel work titled *Diary* (1989), and installed it in frame-like niches in the wall. The theme is a visual diary of a border bed of tulips in springtime, from budding birth through to ragged death. Time is a significant conceptual element of the work, as are familiar, repeated motifs:

tulips, garden stakes, shadows and fragments of sectioned sidewalk. The work is saved from mere prettiness by the aggressive presence of the garden stakes, painted in various shades of grey and staggered upward through the narrow, vertical panels, and by the shadows cast by the tulips. The shadows register a greater degree of florescence and senescence than the tulips themselves: they are by turns more restrained, more chaste, more flamboyant, more overblown, more disorderly, more haggard and, ultimately, more deathly than the organic entities that cast them.

In 1989, Falk was also commissioned to paint a large mural for a movie theatre in the Cineplex-Odeon chain. (Other Vancouver artists similarly commissioned were Jack Shadbolt and Alan Wood.) Her four-panel painting, *Development of the Plot in Four Parts*, was installed at the Park and Tilford theatres in North Vancouver, and extends some of the magic and motifs of Support Systems. Leaping dogs, flowering bushes tied with strings, shooting columns of fire and smoke, weather vanes and disembodied arms (these ones, however, holding lighted bulbs), are all familiar from earlier work. Newly invented images include a large, white, accordion fan streaming pink and gold effervescence into the darkness, and a homely row of green onions within a box frame. The work is marked by a cinematic or cartoon-strip sense of sequential images and, again, magical juxtapositions of incompatible objects and inexplicable occurrences.

A less happily realized work was *Salute to the Lions of Vancouver*, a federal-government commission for Canada Place in downtown Vancouver. Originally, Falk conceived the idea of a sculpture of poodles leaping through flaming hoops, an obvious three-dimensional variation on the two-dimensional theme in Support Systems. Her vision of actual, gas-fed flames had to be relinquished because of the windiness of the site, and the poodles had to be relinquished because of the objections of the patron. She proposed many subsequent versions of the sculpture, all of which were rejected. Eventually, she settled on two lions executed in cut aluminum and leaping through lighted

metal hoops. The subject of lions relates quite literally to the twin mountain peaks known as "The Lions," visible from many places in Vancouver, including the plaza for which the work was commissioned.

Falk's unhappiness with the *Lions* project cannot be separated from other demands and difficulties in her personal and professional life. In many ways, she was too busy to have undertaken another public art commission so soon after committing herself to *Diary* and *Development of the Plot*, while working on two new series of paintings and in the midst of a move. In 1987, having decided to sell her Kitsilano house, she purchased a dilapidated property in a quiet east Vancouver neighbourhood. By economizing fiercely and working very hard, she paid off that property within a year. She also designed the house and studio she had always wanted, with a garden courtyard in-between. Her friend Heinz Klassen assisted by adjusting the specifications to meet city-planning guidelines, and her nephew Bob Falk, together with his business partner Garry Nikolychuk, constructed the two buildings, which were completed at the end of January 1989. (Bob and Garry also assisted Gathie in executing the *Lions*, undertaking the heavy cutting, grinding and transporting work.)

In the meantime, Falk had had another accident. In the late winter of 1988, she slipped on some ice, fell and smashed her sacrum. Since then, acute pain has become a constant condition of her existence. Surgery in 1992 to correct the problem would only aggravate it, shifting the pain from chronic to excruciating — and never-ending. The pain and resulting disablement have interfered hugely with her ability to garden, travel, socialize and attend church services. For most of the past decade, however, Falk has not allowed the injury to affect her buoyant hopefulness or her ability to make art, although she has had to make certain accommodations to how and when she works and with what materials.

Who would true valour see,
Let him come hither . . .

(continued on page 109)

103

There Are 11 Ships and a Barge in English Bay, 1990, oil on canvas, 213.4 x 152.4 cm, collection of the artist. Photo by Teresa Healy, Vancouver Art Gallery

There Are 11 Ships and
a Barge in English Bay

by Sarah Milroy

In our family, we have a number of idiosyncratic expressions that tend to make us inscrutable to outsiders. One of the more private is to describe something as "Gathie-ish," which is to say that something is lovely, in a tender sort of way, perhaps slightly sentimental and a bit quirky. A rose bush could be "Gathie-ish," or a tidy pair of children's party shoes, or a bed of peonies, or a pile of plums—anything that seems to be full of life and bounty but is restrained by just the right amount of ceremony and decorum.

Gathie Falk's work came into our family's life because my mother, Elizabeth Nichol, asked her to join the artists at Vancouver's Equinox Gallery in 1980. It was not long before her work cropped up around our home, changing the temperament of the household in several ways. Having Gathie in our midst set us apart.

Although I had already left for university, I remember the parade of exhibitions at the Equinox in the eighties: the *Thermal Blankets* in 1981, the *Pieces of Water* show in 1982, the *Herd* installation in that same year, the marvellous series from 1983 titled *Theatres in B/W and Colour*, in which lush rows of cabbages, chairs and miniature trees were paired with their black-and-white ghosts. These were followed in turn by the *Chairs* in 1985 and the *Support Systems* paintings of 1988.

Notwithstanding Gathie's revered role in our eccentric family life, the Hedge and Clouds series—to which this painting belongs and which came immediately after—was a discovery to me several months ago. I had stopped by the Equinox and found its director, Andy Sylvester, arranging a slide tray of Gathie's work for an impending visit by curators from the Vancouver Art Gallery. Andy and I decided to take a look through the slides for old time's sake, and there we found this puzzling painting.

It had been shown at the gallery along with the rest of the series in 1990, but I had missed the exhibition. Out of the whole show, only one was sold—an unheard of event for this popular artist. I looked at the painting and the painting looked back. It was scowling.

Yet, looking at it projected on the wall in slide form that day, and a month or so later in the flesh in Gathie's studio, I felt its ruminative nature come across to me. This is not a painting that is full of euphoria and grace, but the reverse. It is about those days in the depths of winter in Vancouver when the afternoon is signalled only by a dim brightening in the west—otherwise, all is black and grey, and nighttime comes dankly at 4:00 PM. The clouds hang low and sodden, clinging to the North Shore mountains like grubby dark clumps of wool. The hedges rustle in the southeasterly winds, glossy with rain and harbouring their abandoned nests. Melancholia and a fleet of marooned freighters in English Bay, going nowhere.

As it turns out, the oppressive mood of the work is not surprising. The series was done in 1989, at a difficult time in Gathie's life. She was in the midst of moving to her new house on the east side of Vancouver, and her long-time friend Elizabeth Klassen was suffering from a worrying bout of illness. As well, Gathie was heaped with work: a sculptural commission for Canada Place, a large project for the new Canadian Embassy in Washington, as well as her usual load of exhibitions and requests.

The series reflected Gathie's regimen of walking her dog from her Kitsilano home down to the beach, where she took a daily inventory of the tides and freighters in the harbour before returning home. The ritual added structure to her day, helping her to cope with the ups and downs.

It is interesting that Gathie painted the freighters with the stacks on the wrong end, up front—as if they were either luxury liners or warships—and arranged them so improbably close together. Clearly, the idea of counting was what interested her, not the look of the boats themselves, although she now recalls how she loved to watch the boats on the water at night: "Like great big birthday cakes . . . they seemed like such great illuminations." The soothing rhythm of daily repetition is borne in the title: *There Are 11 Ships and a Barge in English Bay*. These are the things, she seems to be saying, that we can be sure of.

But this daily inventory is overwhelmed by the oppressive chunk of hedge that hovers above the hinged marinescape in what reads as the sky. This constrained piece of nature, so typical of garden design in the lush rain forest of British Columbia, denies the wilderness with its rigid geometry. The bush, brooded over by the boulder cloud, is a ferocious apparition, charmless, rendered in brushstrokes that are fierce and uningratiating, as if Gathie were chiselling through the canvas with her brush to a place underneath.

Dislocations of scale are not untypical of art from British Columbia. For instance, there are the anarchic constructions of Jessica Stockholder (raised and trained as an artist in B.C.), who has noted the impact of the province's dramatic landscape on her sense of space. In the work of both artists, we shift radically from macro to micro and struggle to get our bearings. Which way is up?

This painting of Gathie's is a prime example of such dislocations. The boats should be above the hedge, on the horizon line; instead, they are below. The hedge should be on the ground; instead, it seems to hover in the air, its roots reaching into nothingness. The boats should be bigger than the hedge; instead they are smaller. The hedge should be smaller than the cloud; instead, it is bigger.

As well, the top of the hedge is signalled by a colour change to a lighter hue of green, and the bottom is signalled by the brown branches—a perspectival impossibility. How can we see it from both perspectives at once? Gathie's painting is curiouser and curiouser, a Wonderland vision tinged with anxiety and darkness.

Gathie says that this series takes her back to her earliest paintings, in particular the Flying Carpet series of the mid-1960s. Here, wild shifts in perspective play havoc with the viewer in

Flying Carpet with Hot and Cold, 1966, oil on board, 81.1 x 101.5 cm, collection of the artist.
Photo by Stan Douglas, Vancouver Art Gallery

fanciful works such as *Flying Carpet with Tourist Machine* or *Flying Carpet with Hot and Cold* (both painted in 1966). Things are seen from above, below and the side — all in one visionary moment.

These effects were among Gathie's earliest artistic interests, and they persist through all of her paintings. One of the interesting things about Gathie is that she seems most loyal to the works that have had the hardest time finding an audience. Her interest in spatial distortion, her frenzied and sometimes awkward abandonment to handling paint, can make some of her paintings off-putting to those expecting benign epiphany. But they are her favourites, like the very strange and dreamlike Support Systems paintings of 1987–88 and the Development of the Plot series of 1991–92. I suspect that it is in some of these more strained compositions that her underlying pre-occupations are most nakedly revealed. Even for those who know her and love her well, there is always more to find.

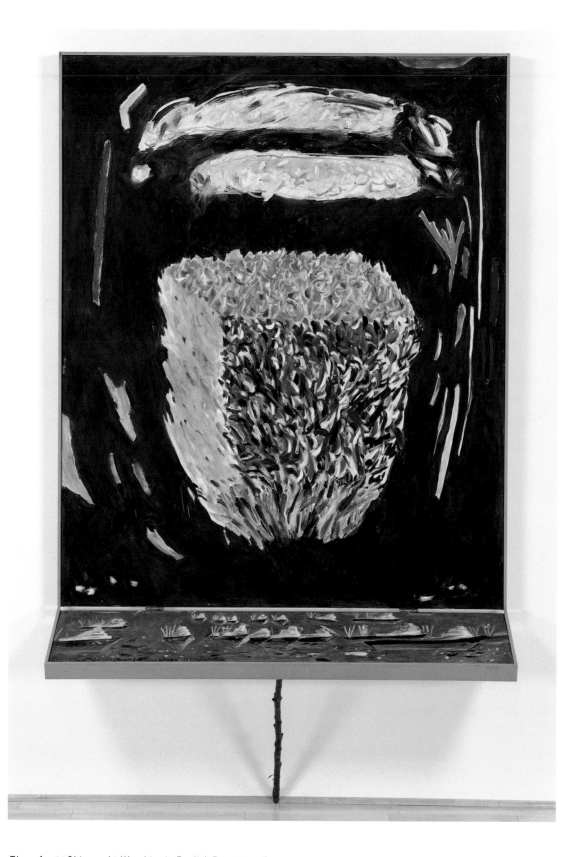

There Are 21 Ships and 3 Warships in English Bay, 1990, oil on canvas, 213.4 x 152.4 cm,
collection of the artist. Photo by Teresa Healy, Vancouver Art Gallery

Optimistic as she was and is, it's possible that Falk's physical suffering contributed to the dark mood of the next body of paintings, the Hedge and Clouds series (1989–90). Certainly, there is a stronger note of political protest than in any of her works since her student days and the egg-smashing protagonist in her early performance, *Some Are Egger Than I*. Although the work was undertaken in her new east Vancouver studio, the imagery originated in her old Kitsilano neighbourhood, and had been on the artist's mind for some time. The paintings depict a series of hedges (embodiments of the "bulk" that so moves and delights her) juxtaposed with clouds (which here also possess a bulky quality), and further juxtaposed with images of ships that the artist had observed anchored in English Bay each day. She saw both clouds and hedges as sculptural, the former being natural and the latter being a combination of the natural and the manmade: that is, living matter shaped into sculpture by human hands.

An earlier attempt to paint hedges had been unsatisfactory, but now Falk found a way to do it: expressively, with short bursts of energetic brush strokes in a range of shapes and hues. The colours of the hedges run from blue-black and forest green through yellow ochre, burnt umber, pale pink and brick red. Some hedges are shaped like thick squat walls, some are cubed, some are seamed, some are split into two or three flat-topped wedges. The clouds that hover above the hedges are just as varied in size, shape and colour, from broad-brimmed grey hats to a scattering of white and yellow medallions to a large pink cotton-candy lozenge with ten little pink buttons below it. The sky-like backgrounds, too, are painted any number of non-naturalistic hues, and are electric with the kind of flecks, ribbons and sparks of colour employed in Support Systems.

The ships are painted on narrow horizontal panels hinged to the bottom of the hedge-and-cloud paintings and propped up and out at varying angles with red "cherry sticks" standing on the floor. (The narrow panels, Falk says, were influenced by the multi-panel paintings of her friend Gloria Massé. The sticks are shorn branches left over from pruning a wild cherry tree in Falk's yard.) The paintings constitute a kind of "diary": each hinged panel registers how many and what kind of ships are at anchor in English Bay: freighters, cruise ships, tugboats, barges and warships. The American warships, with their nuclear capabilities, appall the pacifist artist—not that she treats them imagistically any differently from the other ships at anchor. She simply notes their presence, alerting us that the benign and the malign are intermingled in the harbour of our city, as they are in our lives. There is the potential for violence here, just as there is the potential for goodness. The inclusion of each painting's title, for instance, *There are 9 Ships in English Bay* or *There are 7 Ships and 2 Warships in English Bay*, handwritten along the bottom of the hinged panel, is a relatively new strategy. (Words and figures had appeared in *Two-Dimensional Rendering of a Large Number*.) It seems to admit the influence of image-text art, although within the context of expressive painting and mark-making rather than photo-mechanical type and photographic imagery. The hand is always and everywhere evident in Falk's work. Also evident are the integration of painterly and sculptural impulses, and the interface of notions of nature and culture. The Hedge and Clouds series is one of the artist's most powerful and disturbing bodies of work—imagistically arresting, metaphorically dense and formally inventive.

In 1990, Gathie Falk was awarded the fourth annual Gershon Iskowitz Prize for "the extraordinary range of her work and the substantial contribution she has made to each of the diverse media she has worked in."[78] The choice seems entirely appropriate, given the unconscious concordance between her colour-field paintings of the late 1970s and early 1980s and Iskowitz's own energetic and luminous abstractions. Not that this likeness was a factor in her win. What the prize recognized was Falk's achievement as a Canadian artist, one whose career has been imaginative and coherent, disarming and provocative, across a range of disciplines.

Also in 1990, Falk began work on a series of paintings about travel and travellers, titled Venice Sinks with Postcards from Marco Polo. She was spinning variations — through more than thirty works and after more than a decade since first encounter — on the image of a small sink in a Venice hotel room. During her month in Venice in 1977, she had washed a sleeveless pink dress and hung it over the sink to dry. The image captivated her: she sketched it, then restaged aspects of the hanging or draped garment in both Chairs and Soft Chairs. Still, something about the scene continued to compel her as, eventually, did the story of another traveller, a Venetian named Marco Polo.

While many of Falk's paintings, sculptures and installations suggest a narrative form or content, none has been as deliberately attached to a story as Venice Sinks. Her delightful fiction collapses past and present into the visual now. It also weaves together aspects of history, travel and geography with biography and autobiography. What the artist imagines is that the thirteenth-century adventurer Marco Polo is sending postcards from his twenty-year journey to his girlfriend in Venice. In all but the first painting, two postcards (which serially overlap from picture to picture) are mounted beside a mirror which hangs over a sink. The images in the postcards range through historic sites and objects (a watchtower in the Forbidden City, a Sung dynasty vase, Kublai Khan's summer palace) to modern modes of travel (buses, boats, planes — and camels).

Juxtaposed with the postcards, mirror and sink in the small Venetian room are objects both familiar and unexpected. These include Falk's pink dress (it looks like a mermaid, the ruffle resembling fins); a naked light bulb hanging from a cord and streaming golden energy into the sink (this stream combines aspects of feather boas with pillars of fire); a pear hanging from a string (a variation on the hanging light bulb and hanging cabbages); a small globe; a bicycle; two topiary trees (nature sculpted into culture); lion masks on poles (the lion is the symbol of St. Mark and of the city of Venice); birds in Plexiglas boxes; and model planes.

The planes, suspended above the sinks, allude to both the pioneer aviator Beryl Markham, about whom Falk had been reading, and Falk's own brother, Gordon, who had built and flown model airplanes in his youth. Gordon Falk was dying of cancer as Gathie painted this series, and his long journey, too, is commemorated here. Night and day, light and darkness, life and death, are again married in scenes both odd and elegiac. In Venice Sinks with Postcards from Marco Polo #19, a rabbit-dog leaps over a sink in an arc of fiery energy, an image reminiscent of Support Systems. The sink casts a large, blue, ghostly shadow, which is shaped like a tipping teakettle. It's as if life energy is forming above the sink while below it, this same life is being poured out.

Falk has remarked that each sink (rendered with impossible or surreal perspective so that the viewer can see into it and beneath it at once) is like a glorious plant, the pipe below like a stem growing out of the floor, and the mirror carrying its thrust upward.[79] Each sink, too, is like an altar; the mirror, like an altarpiece; and the objects placed over and around it, like offerings in rituals of lamentation and consolation.

Perhaps the recollection of her Venice hotel room also reminded Falk of Giotto's frescoes, of the deep blue heavens and shining celestial bodies on the walls and ceiling of the Arena Chapel. Perhaps it was walking her old dog in her new neighbourhood each night at ten and scanning the sky, trying to follow the phases of the moon. Searching thus, Falk determined to paint a month of moons. She consulted with her nephew Bob, an amateur astronomer, and learned that June 1992 would be the next occasion on which the lunar month would coincide exactly with the first twenty-eight days of the calendar month. Then she painted each phase of the moon on thirty small, square canvases, to be mounted in three long, horizontal rows. The canvases of June 1992, For a Wall (1991) are not closely abutted but are hung with an eloquent expanse of

wall around each. Unframed and painted over their sides as well as their fronts, they have an aspect of minimalist, wall-mounted sculpture. The geometric spaces between the painted panels resemble a series of crosses.

With the exception of the two final moons, which are depicted as dark orbs swirled about with yet more darkness, Falk painted only the lighted portion of the moon, as a child or cartoonist might. The rest of each image is blank night, rendered in an equally non-naturalistic manner. Instead of painting the deep, rich, atmospheric heavens of Night Skies, Falk scribbled slanting blue-black lines around the lighted crescents, halves and orbs—again as a child might.

Earlier, in the fall of 1990, Falk had been sitting in a hospital emergency room, waiting with

extreme anxiety for her friend Elizabeth Klassen to be examined. (Klassen had earlier had cancer surgery and the subsequent balling of scar tissue was causing severe pain.) Somehow, through the hours of waiting and the storm of pain and fear—her friend's and her own—Falk conceived a series of theatrical images, which she began to sketch on the only ground available, the paper stretched across a nearby examining table. Later, when investigations showed that Klassen's condition was not life-threatening, Falk expanded and refined the sketches as a submission for a mural commission in Toronto. She didn't win the commission but felt the ideas and images she had developed were too good to discard. Out of them, in 1991 and 1992, she evolved a large and sustained project, comprising four series of nine images each. Three of the series are painted in oils, and one is drawn in graphite. All the works within each nine-panel series are the same size, but each series is a different size, ranging from large and proclamatory to small and intimate; all play out variations on the same sequential set of images and are collectively titled Development of the Plot II–V.

Although the numbers are different, the title is the same as that of the Cineplex-Odeon mural a couple of

years earlier, and the Plots share a significant motif: a disembodied arm with a hand clasping a golden light bulb. In other images and motifs and in their sense of the magical or marvellous, however, the second manifestations of Plot are closer to Support Systems. They also owe important forms and gestures to Falk's early performance work *Drill*, in which two groups of participants confront each other with upraised arms, brandishing popsicles as if they were swords. In Plots, of course, the arms brandish light bulbs—but with similar violent absurdity. Painted arms mass and threaten war with each other, then pass, after a miraculous occurrence, without any actual violence. Eventually, the light bulbs float in the cosmos like golden moons, free of the hands that held them, after which they are liberated even from their glassy enclosures and exist as tiny, singular tongues of flame.

If Falk's performances often seemed to be the theatre-art enactments of paintings or sculpture, the Plot paintings and drawings depict a fantastical performance. Theatrical allusions are made to stage sets, lights, ropes and props, as well as to the unfolding yet enigmatic plot of the title. Images within each panel appear and disappear, shift in size and position, build up a tremendous tension of threatened violence, and move through climax and "transformation" to a denouement of blessed calm. Bouquets dangle from ropes above white kitchen chairs; dogs look or leap or peacefully recline; flames and flame-shaped plants play across the ground into which shovels are dug, with or without the agency of human beings; stage-set mountains—double peaks, as in The Lions—establish then relinquish their strange presence in the drama. Consistent throughout the series are the forms of a brightly lit ziggurat and a shadowy man.

The stepped form of the ziggurat has long intrigued Falk, manifesting qualities of both "bulky" sculpture and archaic temple architecture. (In this series, it is reiterated by the mountain, of which it is an ancient symbol.) In an early version of her performance work *A Bird Is Known by His Feathers Alone*, she had introduced the

Development of the Plot III: #1 The Stage Is Set, 1992, oil on canvas, 228.6 x 160.0 cm, collection of the artist. Photo by Teresa Healy, Vancouver Art Gallery

Development of the Plot III: #5 Climax, 1992, oil on canvas, 228.6 x 160.0 cm, collection of the artist. Photo by Teresa Healy, Vancouver Art Gallery

Development of the Plot III: #8 Conclusion, 1992, oil on canvas, 228.6 x 160.0 cm, collection of the artist. Photo by Teresa Healy, Vancouver Art Gallery

element of a stepped platform, which seemed to function symbolically as an altar. The ziggurat is initially depicted in large scale at the bottom margin of the first work in each series; through the progression of panels, it retreats upward and backward, becoming smaller and smaller. This perspectival trick or convention is played out in reverse by the figure of the man, entering the scene very small in the upper right corner and becoming larger and larger as he walks forward, down the canvas. The man is painted in washy, spectral greys and rendered in "low definition contours."[80] His facial features are never articulated, nor is his identity revealed. There is something film-noirish about this stranger, this outsider, suggested by the trenchcoat-like garment and the vagueness and greyness of his aspect, as if seen through a fog in a black-and-white film. But there is also something redemptive — angelic or saviour-like — about him. In the one scene from which he completely disappears, he is replaced by (or has transformed into) what Falk calls an "intervention," a formal and metaphorical device which first appeared in Support Systems as explosive and roiling funnels of smoke and fire. In Plots, the intervention takes a similar form, although in some versions, stylized lightning bolts zigzag out of its bottom. Whatever the shape, it is powerful, peaceful and supernatural, causing the two potentially warring forces to pass each other without harm, after which the grey man re-emerges into the picture frame and onto the stage. At the beginning and end of each series, the juxtaposition of white chairs and bouquets suggests an offering, a prayer or a gesture of thanksgiving. The paint application throughout the series is sketchy, and one of the versions of the Development of the Plot series is entirely drawn. There is a sense of excited speed here, of the artist exploring as many facets of this magical scenario as she can physically manage.

Speed and excitement were replaced by excruciating pain and debility after surgery on Falk's sacrum in the summer of 1992. For months, she could scarcely walk, and for many more months was unable to sit but had to kneel at table. A friend, sculptor John Clair Watts, devised an easel she could move up and down so that she could paint without bending or stretching, activities which had become impossible. Very slowly and gradually, Falk regained her mobility and resumed working. Her house church had dissolved in 1988, and she now worships at a small Anglican church within walking distance of her home.

The next series of paintings, Clean Cuts (1992–93), elaborates on the earlier subject of lighted bodies floating in space, although here, the bodies are terrestrial rather than celestial, and they absorb as much light as they reflect or project. They're the planet Earth. Or, rather, they're variations on the planet Earth as represented by a couple of globes that had caught Falk's attention. (She has long been drawn to maps and globes as visual entities. A small globe on a stand makes an appearance in Venice Sinks.) They hover, these planet-like objects, in a paradoxically constrained square of limitless space. Through two dozen paintings, each globe is viewed from a different angle — North America may predominate, or Africa, or Asia, or Australia — and each is painted in different combinations of colours. Grey continents may float on burgundy oceans, or raw sienna continents on pinkish white oceans, or yellow ochre continents on blackish-purple oceans. The space in which the Earth is suspended is also delivered in a range of colours from her inventive palette, the effect ranging from the semi-naturalistic to the expressionistic. Each globe is marked by parallels of latitude and meridians of longitude, although in Falk's hand these lines have an emotional wobble.

Clean Cuts develop a humorous notion Falk had while painting and listening to radio newscasts about the wars, uprisings and revolutions that followed the breakup of the Soviet Union. She wondered — and her wondering, her conceit, is a visual one, not a political one — why nationalistic separations could not take place neatly and cleanly, along straight lines. The divisions she proposes are either two crossed lines, which divide the square canvases into four smaller squares and which connote the cross-hairs of a high-powered rifle scope or perhaps an

instrument of science or surveillance,[81] or two parallel horizontal lines, which divide the canvas into three flag-like sections of different colours. Falk's expressionist investigation of systems of representation, as well as her seriocomic examination of geopolitical systems, may have roots in an image that had been lodged in her unconscious for thirty years: Jasper Johns's painted map of the United States. Clean Cuts mark a kind of return to Pop simplicity, to the serialization of a single motif like an apple or an orange, or a seamed and creased shoe.

At the time she exhibited Clean Cuts, in the spring of 1993, Falk was working on a small series of light bulb paintings, titled Constellations. Whether produced on small, individual wooden panels — one slightly larger than life-size light bulb per panel — and mounted in a spacious grid on the wall, or painted together in tight grid formation on a single canvas, the works bear a formal relationship to *June 1992, For a Wall* and a metaphorical relationship to Night Skies — for the light bulbs are clearly stars, even if they are shining in a minimalist-conceptualist firmament. The images and ideas contained in Constellations saw their apotheosis in the fall of 1993, in a temporary installation innocuously titled *150 Light Bulbs* and created for *Artropolis 93*, one of a series of huge, hectic, alternate-art exhibitions in Vancouver. The title recalls *150 Cabbages*, but the work's actual construction was something entirely new. It was also something entirely familiar and entirely holy.

150 Light Bulbs consisted of a small, woodframe, one-room "house," unfinished on the outside, white-painted on the inside, with a bronze-coloured, semireflective ceiling. Mounted in spacious rows on the white walls were 150 little wood panels, on each of which was painted a yellow-white light bulb on a deep blue ground. Some of the paintings included tiny triangles of yellow light in their upper corners; some, smaller flecks of yellow; some, nothing but layers of variegated blue darkness. Falk wrote that her work had roots in the many light bulbs she had made in the past, her installation of moon paint-

ings and her Night Skies — but that mostly it took inspiration from Giotto's ceiling in the Arena Chapel.[82] Falk's room, too, was a chapel, a place of worship. Both home and humble light bulb were venerated there: she made the viewer aware of the holiness immanent in the everyday. And the work brought home — literally and metaphorically — the efficacy of her use of repetition. The light bulbs together were like a conceptual constellation of stars, yes, but each individual one was like a prayer, a chant, a visual mantra repeated over and over and over until another state of understanding was reached, an apprehension of the sacred. The conceptual-metaphysical paradox — one that early Renaissance painters seized, on a grander scale — is that the heavens, the firmament, are *within*. You walk into a sacred structure and it opens you up to the endless cosmos. Still, if you had been looking for death in *150 Light Bulbs*, you could have found it there, too. The little house was appropriately tomb-sized and the many bulbs shining within it might have been commemorative candles, flickering, flickering, in the vast enclosing night.

Falk extended her examination of architectural space in a series of three-part paintings, Nice Tables (1993–94). But these triptychs are also an examination of *painted* space, part of modernism's ongoing dialogue between three-dimensional illusion and the two-dimensional actuality of the picture plane. She ably juxtaposes conventional techniques of rendering and one-point perspective, techniques which draw the viewer's eye into the illusory space of the picture, with passages of flat or gestural abstraction. She does this by setting out her basic still-life subject — a kitchen table situated on a patio between two posts and a wall — in the large, square, central panel of each triptych, and then serially varying the scene through the objects introduced into it. The table and the still-life arrangements upon it dictate a representational treatment; the posts and architectural setting demand a certain geometric rigour; the wall, patio

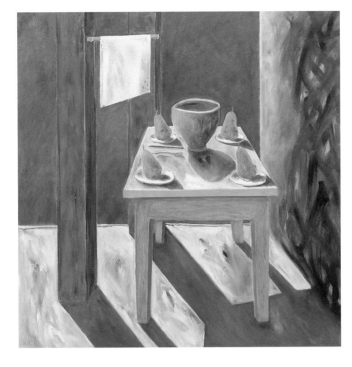

Nice Table with Bowl of Pears and Details, 1993, oil on canvas, 76.4 x 51.0 cm; 122.5 x 122.0 cm; 76.4 x 51.0 cm, private collection. Photo by Teresa Healy, Vancouver Art Gallery

and long shadows are vehicles for lively, abstract mark-making, giving the artist an opportunity to "really swing" her arm.

The smaller, rectangular panels that, with one exception, are mounted on either side of the larger still life, enlarge and isolate its details. They "percolate" space in their own way, Falk wrote, rather than simply repeating the treatment of the central painting as a blow-up would.[83] For instance, the right-hand panel of *Nice Table with Lemons and Details* (1993) is a close-up variation on the tray of lemons set out on the centre table, and the left-hand panel reworks a section of a post and flat space behind it, functioning as a hard-edge abstraction of vertical stripes. Throughout the series, the contrasts between representation and abstraction, and between architectural space and organic still-life objects, set up another dialogue, that between the rational and the emotional.

The real-life inspiration for Nice Tables was the garden between Falk's house and studio, particularly the patio and grapevine-covered bower, a space of safety and refuge in her mind. As always in her work, however,

the shadows on the patio and the dark aggressive marks (abstract but verging on the pictographic) on the wall introduce an element of foreboding into the idyllic scene. The objects on and around the table also complicate simple notions of security and the social gatherings that may take place there. Fruit in big and small bowls, cups in saucers, flowers in vases, lemons on a tray, glass pitchers of water: these all seem like aspects of the communion-like rituals of food and drink which Falk has honoured before. But — and we expect this "but" — she introduces unlikely inventions and notes of low-key surreality. A row of Steller's jays perches on one edge of a table, facing a row of Mexican folk-art birds on the other edge; a two-tiered contraption sifts a pyramid of earth into a big white bowl; a bunsen burner–like contraption heats another bowl, this one filled with chocolate; a lacy little collar hangs on a much too massive "collar stand." The tray of lemons revisits an image from Picnics, while the row of birds recalls the mixed-media *Table Settings* (1970–74). And the table-top "earth sifter" has emerged from the composting process in Falk's own garden to enact an

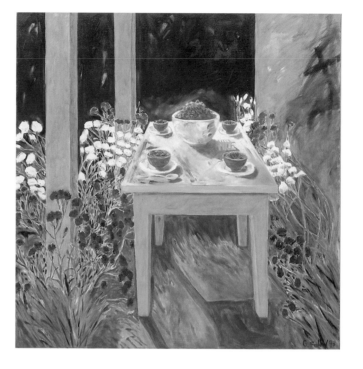

Nice Table with Raspberries, 1993, oil on canvas, 51.0 x 76.0 cm; 122.0 x 122.0 cm; 76.0 x 51.0 cm, collection of Ron and Jacqueline Longstaffe. Photo by Teresa Healy, Vancouver Art Gallery

allegory of mega-scale, mega-time erosion, from mountain to hill to plain.[84]

In *Nice Table with Melon and Details* (1994), sections of cantaloupe are lined up along one edge of the table, and lethal-looking knives are lined up nearby. Butcher knives, carving knives, even the pointed paring knife, all look too sharp and menacing for the job of cutting fruit. The cut fruit—a symbol of the vulnerable human body—also appears in *Nice Table with Apples and Pears and Details* (1993). *Nice Table with Parcheesi Board and Details* (1994) depicts the powerfully remembered game of Falk's childhood and its promise of paradise.

As in the Hedge and Clouds series, nature and culture mix it up with language. Sprinkled among the table-top still lifes are small three-dimensional versions of the word "NICE." (They look like little wooden carvings, something like a child's alphabet blocks.) "Nice" is a word, Falk says, that she was trying to rescue from the "trash can" into which "English-language zealots" had tossed it, scorning it as meaningless. But it is a particular and lovely word, she believes, a word whose alternate meaning she had encountered in the context of Amish-Mennonite needlework. Among the Amish, "for nice" can denote giving "beauty to the life of the people," enhancing the everyday with loveliness.[85] These paintings, of course, are enhanced with much more than loveliness; they encompass comfort and threat, immediacy and eternity, shadowy beauty and sunny enigma. The light in Nice Tables continues to shine with impossible brightness, through walls and screens and out of blank planes of impossible darkness. Little offerings, little miracles, continue to be enacted among the cut fruit and the coffee cups.

The next small series of paintings, Heads, represents a kind of blip in Falk's visual field, an imagistic obstacle she had to climb over, seeing no way around it. For over a year, she had been plagued by a vision of flower petals "like boulders running clear across the width of a canvas."[86] The surreal boulder-petals eventually resolved into whole blossoms, some simple, some complex, all big and monolithic and occupying the width of the painting. Their execution was a means for her to exor-

cise the demon of "flower painter," the deprecating designation she felt some members of the media and public had attached to her. Never mind that flowers were only one small entry in her expanding lexicon of images — Falk felt that she had to confront the notion of flower painter and dispose of it. She felt she had to paint flowers BIG TIME.

In 1994 and 1995, Falk produced a dozen canvases, each four feet square and each filled with an enormous blossom. (Formally, in their roundness and the way they occupy the canvas, they relate to her earlier moons and globes.) She painted two hydrangeas, two tulips, a clematis, two geraniums, a petunia, a magnolia and two tibouchinas — not necessarily her favourite flowers but possessing the shape and dignified presence she was looking for. (She also painted a bunch of paperwhites — little flowers with long stems — perhaps to confuse critics' attempts to generalize about the project.) Falk conceptualized each blossom, each "head," as a portrait, and not just any portrait, but a portrait of power, like that of a corporate head or a head of state. Each would be emblematic, she felt, of "civilized life."[87] She also conceived her flowers as sculptural presences, thus their monolithic aspect. As always, she had to invent a new way of painting a new subject. Paradoxically, given the sculptural aspect, she worked thin, not by applying thin washes of paint to her canvas but by laying on her paint thickly, then working back into it to lift it off the surface. She "scrubbed" at her medium with her brush to achieve a condition of luminous solidity. Inevitably, comparisons were made with Georgia O'Keeffe's flowers. As with O'Keeffe, Falk raises her floral subject to the status of an icon. Unlike O'Keeffe, however, Falk analogizes her flower paintings to liturgical music. "If I had written a piece of music instead of painting the pictures, the music would have been a Gloria," she has written,[88] suggesting that a force far greater than civilization is being praised.

After this intense period of representation, the pendulum of Falk's practice swung back — way back — to colour-field abstraction. She had been longing, even "des-perate," to return to Pieces of Water, which she'd left off painting thirteen years earlier. The premise was the same as that of the original series, to paint the surfaces or "skins" of cut-out chunks of sea water, and the subtitles, again, were drawn from news items playing on the radio as she painted. But the new Pieces of Water paintings are square rather than rectangular, and although her palette remained consistent, the skin has a different texture.

For health reasons, Falk had given up using the sticky and fast-drying dammar varnish she'd employed earlier. Instead, she diluted her paint simply with linseed oil. As a consequence, the 1995–96 Pieces of Water have an appearance that is at once more runny and more granular, more watery and more dry than the originals. (In these contrasts, the paintings are a little evocative of rain on a dusty windshield.) And the application of colour is no longer on the diagonal; rather, the scalloped ribbons and dots and dashes of colour move horizontally across the canvas, in dynamic opposition to the vertical drips.

From an extremity of abstraction, Falk returned, in 1996, to serial depictions of a familiar single motif — the apple. However, the single motif took on a few different aspects, according to how the fruit was cut. Literally. Playing variations on the theme of the cut melons, pears and apples in Nice Tables, she evolved a series of paintings in which whole apples are set in horizontal rows running upward from the bottom of the canvas; gradually, they are replaced by halves and quarters of cut apples, then by tiny wedges and triangular bits of the fruit. (The lower rows of apples are orderly; the upper rows, usually disorderly.) Renaissance perspective and illusionism are again tweaked through the placement of shadows and the use of graduating sizes, so that the top of the painting and the otherwise abstract ground appear to be tipping away from the viewer.

The format of rows of apple fragments, wedges, halves and wholes had been first fully developed in *Red Apples* (1994). As Falk's contribution to the exhibition

Survivors, In Search of a Voice, Red Apples spoke with eloquence and simplicity to the subject of breast cancer and surgery, to physical and emotional states of wholeness and loss. It spoke of mutilation and death but also, in its radiance, of hope and "redemptive beginnings of a new and richer life." Although Falk was loathe to "explain" her paintings (she compared the task of explaining to taking a "voyage into the unknown in a leaky boat with a blind navigator, half an oar, and a bag over my head"), she was also quite cognizant that the skin and flesh of the apple could symbolize the human body. As before, the meaning of the project into which she had entered intuitively and nonverbally emerged as she worked through it. "Groping in the dark, I occasionally find markers that suggest what my work may be about."[89]

In the Apples series, Falk worked mostly on four-foot square canvases, painting apples whose skins range in colour from crimson and gold to chartreuse and russet. The grounds on which the apples are laid also vary in shade, hue and opacity. Some are punctuated with flecks, bars and dashes of colour, and with the washy shadows cast by the apples. In a few works, such as *Apples 6*, the shadows and floating bars of colour resemble knife blades or knife handles, revisiting the menace of Nice Tables. In those paintings, in which golden-yellow apples are suspended upon grounds of deepest blue, she recalls her gridded paintings of moons and her constellations of light bulbs.

At the time Apples were first exhibited, in the spring of 1997, Falk spoke — unusually, given her stated antipathy to archetypes and collective symbols — about the cultural and religious meanings of the image, citing Adam and Eve in the Garden of Eden, the Song of Solomon and Greek mythology. In Western art and culture, the apple has symbolized immortality and wholeness, sin and salvation, death and wisdom, love and fertility. "Apples are something that people can dream about and find a great life force in. They've got blood and guts and flavour and juice," Falk added. She also extolled the apple's appearance: "The apple is just infinitely intricate and infinitely beautiful."[90]

Since the mid-1990s, Falk has worked on two series of paintings and drawings she has not yet chosen to exhibit. The first alternates portraits of friends with portraits of flowers, the flowers similar to those in Heads. The second series also portrays friends, this time enacting scenes of "blessings." In the summer of 1997, Falk fell again and badly broke her right arm. Friends rallied around her with support in the form of cooking, cleaning, shopping, physiotherapy, car maintenance and personal care. Nursing her right arm in its sling as if it were "a sick baby" and drawing and painting with her left hand — a new sensation for her and a fresh way of making marks — Falk chronicled the scenes in which her friends bestowed upon her their gifts of time and care. Each scene is watched over by angels or heavenly beings, expanding these anecdotes of human kindness to include the metaphor of divine aid. Each scene, too, is like a prayer of thanksgiving for that bestowal, that blessing. In the same summer of 1997, Falk was appointed a Member of the Order of Canada, another blessing of sorts, but of the institutional rather than heavenly variety. *(continued on page 126)*

Dress with Insects

by Bruce Grenville

The re-emergence of three-dimensional objects in Gathie Falk's work in 1998, after a twenty-year hiatus, took many by surprise, and yet their reappearance was as natural and as seamless as if she had never stopped making them. While she had strong doubts that the new dress sculptures would be widely embraced by her traditional audiences, they were immediately acquired by private collectors and public galleries across the country. Falk's long-standing interest in the human body and its representation is one that is clearly shared by her audiences. Paradoxically, it is rare that the actual physical body appears in her work. Instead, the body is replaced by a surrogate that is uncanny in its ability to convey a bodily presence. The earlier single right men's shoes were remarkable for this quality. But it is also there in the skin of the fruit, the leaves of the cabbage or the surface of the sidewalk. Falk's ability to convey an uncanny bodily presence while simultaneously avoiding a literal representation is no more successfully produced than in the six papier-mâché dresses that she created in 1997–98.

The dresses were originally envisaged as an integral component of the *Traces* installation produced in September 1998 for the Equinox Gallery in Vancouver. Together with the boxed shoes, the table of small articles, paintings, and prints of crossed ankles, they traced the presence of a body —unnamed, unknown. Like most of Falk's works, the idea of the sculptural dress came to her as a strong mental image that was refined through a long process of rumination and experimentation.

Falk had considered the possibility of producing the dresses in a variety of mediums, but most of these ideas were quickly rejected. A return to clay might have been conceivable, but the scale of the anticipated work would have made it too easily broken and very cumbersome to move. Sheet metal, Falk felt, was not fine enough and could not be made to convey the subtle manipulation of the surface that she wished to produce. Metal casting was too demanding, and again would have produced very cumbersome objects. Falk might have returned to the earlier technique of dipping existing clothing into enamel paint (as in *Home Environment*), but that would have restricted her to using real dresses of standard size. In the end, she settled on a laborious papier-mâché process that began, like sewing, with a rudimentary dress pattern cut from newspaper that was "stitched" together with short, thin strips of paper bound by liquid cellulose. Then layer upon layer of 3 x 15 cm strips of newspaper were melded to the surface to give the dress form and definition. The extremely time-consuming, repetitive process is typical of Falk's methodology. It is important to remember, however, that for her, the process itself is a means of scrutinizing the subject, giving it meaning through the making.

Falk deliberately used issues of the *Vancouver Sun* newspaper as the material for these works. In describing the process, she mentions that there are "a lot of people in those pieces," in reference to the photos that comprise the daily news. This reference to the quotidian world of

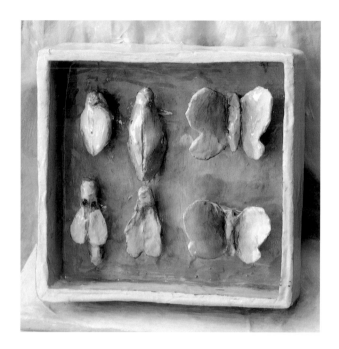

the daily news recalls the subtitles Falk gave to her 1981–82 Pieces of Water paintings (*Ronald Reagan*, *El Salvador*, *Bobbie Sands*, *Chief Dan George*, etc.), gleaned from the newspapers and newscasts during the time of their making.

Using paper as a medium also allowed Falk to give the surface variations that, in turn, give the dress its corporeal presence. The dress has the same surface character as a human body, with subtle undulations, irregular shapes and a translucent luminescence. In part, this effect is produced through a technique in which she paints the surface of the dress as if she were rendering a three-dimensional object. The paint is not simply applied as a uniformly decorative surface or as a protective cover for the paper, but as a representation of the surface of the dress. The shadows made by the folds are painted as shadows, and the highlights are tinted with white, giving the work a heightened physicality, or "super reality" as Falk calls it. This in turn enhances its uncanny character.

The surreality of the dress is also in part a product of its scale and design. The scale is slightly smaller than that of a life-size adult dress. It is possible to imagine it as the dress of a child or an adolescent, but the elusiveness of its style challenges this reading. Falk describes it as classic in style, something that might have been worn at any time between the 1930s and the present. Intentionally ambiguous in its design, it is the sort of dress that we would have seen somewhere but can't assign to a specific time or place. This is a strategy similar to the one she adopted when making the ceramic shoes and boots of the 1970s. There, she also chose styles, like the brogue shoe, that had been in production for decades and therefore could not be interpreted as an unmediated acceptance of contemporary fashion.

Falk has also intentionally given the dresses the volume of an actual body with a thick waist and small breasts. It is the plausible body of an adult, not the idealized body of a fashion model or the unformed body of a child. The position of the figure is relatively stable, suggesting animation but not movement.

The small object placed on the hem of the dress varies from work to work but consistently resists any sort of simple narrative that links the dress and the object. Falk is adamant that the two should not be put together to produce a meaning for the work, but rather that they are held apart in a meaningful tension. The insect box that sits on the hem of the *Dress with Insect* offers an uncanny juxtaposition of the very palpable, physical bodies of the moths held against the absent

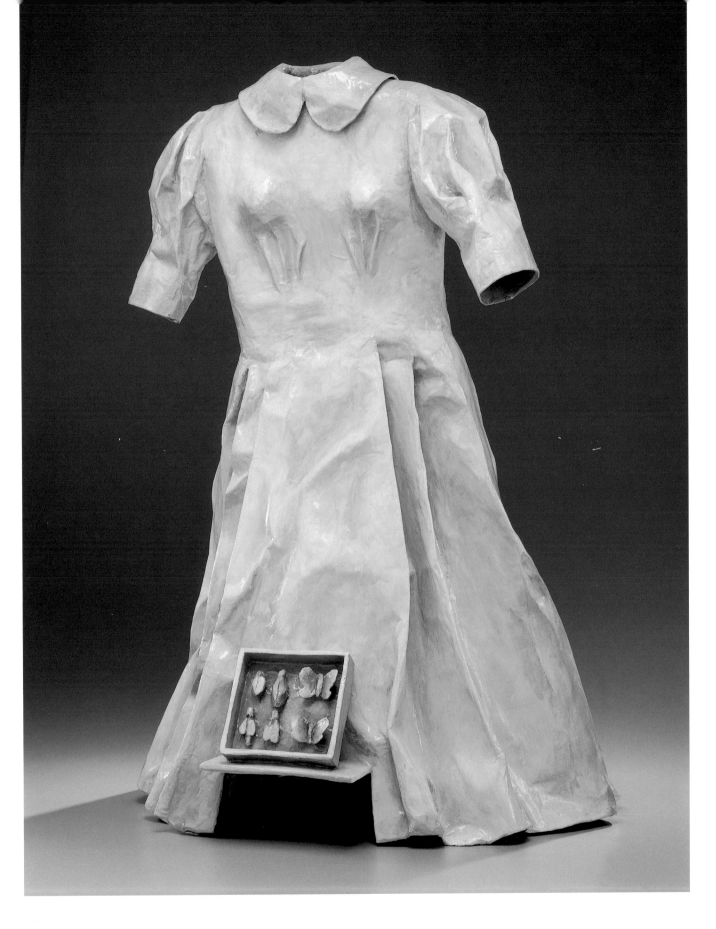

Above: *Dress with Insects* (detail, left), 1998, papier-mâché, acrylic paint and varnish, 90.0 x 60.0 x 60.0 cm,
Vancouver Art Gallery Acquisition Fund, 98.63. Photos by Teresa Healy, Vancouver Art Gallery

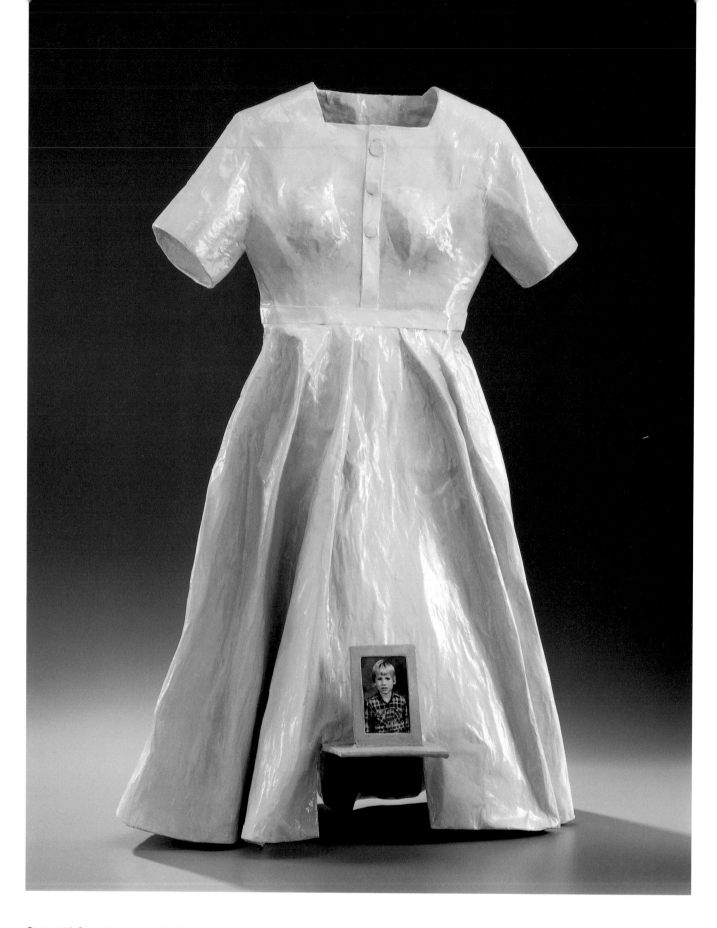

Dress with Boy, 1997, papier-mâché, acrylic paint and varnish, 83.8 x 63.5 x 45.7 cm,
collection of Mr. and Mrs. John C. Kerr. Photo by Teresa Healy, Vancouver Art Gallery

body of the dress. Neither can be said to explain the other, nor does their coincidence there have any likely literal meaning.

The reappearance of the insect box image/object in Falk's work is significant. It first appeared in the early 1970s, as part of a series of table settings that included clay birds, moth boxes (one real, the other made of clay) and other remarkable elements. The obvious references in these early ceramic works to mortality, ritual, order and appearance are repeated, more than twenty years later, throughout the *Traces* installation. Candles, photographs, souvenirs, uninhabited pieces of clothing, fragmentary images of the body—all speak directly, and indirectly, to the transformation and mortality of the body. Speaking of its presence in *Dress with Insects*, Falk described the insect box as an arrangement of "what has died to make it more palatable— a more lovely thing." Like it or not, mortality and appearance are inextricably linked in our culture. The mortal transformation of the body is largely defined by outward appearance, by the traces of change that are mapped across the surface of our bodies. *Dress with Insects* is not a cautionary tale, not a memento mori that reminds us that death comes to us all. Rather, it is a thoughtful reflection on mortality and the inexorable passage of time. It speaks of a life filled with liveliness, wonder, transformation and change.

As so often happens with Falk, the idea for her next body of work, an installation titled *Traces* which she completed in the fall of 1998, had been pressing on her mind for a few years. The vision she'd had was of sculpted women's dresses with little shelves built into their hems, and on those shelves, various articles of everyday womanhood and wonder. She was also thinking about religious sculpture, particularly the carved and painted wooden images of saints, angels and Virgins of folk and historic Québécois art. What especially drew her to those sculptures were the intricate and voluptuous folds of the skirts. Realizing that what she wanted to sculpt was too large to be executed in clay, Falk turned to papier-mâché, a medium so lowly in the fine-art hierarchy it does not even rank as "craft." Still, she converted the inglorious material into a medium of marvellous suppleness and plasticity, and also gave it a smooth, skin-like quality. She then painted the hardened papier-mâché, using it as a ground for subtle colour and fluid brushwork.

The idea of taking strips of newspaper, soaking them in liquid cellulose and turning the paper "back into wood," that is, something with the hardness and resilience of wood, deeply appealed to Falk. She also liked the concept of incorporating the histories and photographs of many individuals — the lives and experiences reported in the newspapers she used — into her sculptures. These unseen narratives conceptually reiterate the stories that she invented concerning the dresses themselves. Each of the six dresses, she says, was found in a closet in a different part of the country, not hanging flatly on a hanger but standing three-dimensionally on the floor. No dress is as fully rounded as it would be if being worn by a human body, but each bears the relief traces of a human body, the slightly collapsed protrusions of breasts, the contours of waist and hips.

In some of these fictions, the owner of the dress has died; in other instances, she has moved away, leaving the dress behind. Death, loss and abandonment are thus encoded within these garments, as they had once been encoded in empty armchairs and uninhabited men's shoes and clothing. The dresses have a classic, mid-century look to them, although each has a different style, colour and character, ranging from a chaste, white, high-necked dress with Peter Pan collar and long, box-pleated skirt to a slinky black dress with round neck, ruffled sleeves and short, clingy skirt. Each of the shelves, ingeniously cut and flipped up from the front hem of each dress, holds a different set of objects: four lighted candles; three toiletry items; a framed photo of a young boy; a row of five singing birds; a box of six insects, winged and unwinged; and a photo of a woman's shod feet with crossed ankles. Some of these images are new, but others have occurred before in Falk's work, as long ago as *Home Environment*.

A photo of crossed ankles — a discreet posture taught to generations of skirt-wearing schoolgirls in the middle decades of the twentieth century — also occurs in *Small Articles*, a table of papier-mâché cosmetics, folded nightgown and other small feminine items which are part of the overall installation. More significantly, the photographic image of crossed ankles is repeated in a huge grid of black-and-white silkscreen prints which cover an entire gallery wall. Produced on transparent vellum,[91] the prints overlap and hang loose at the bottom, so that they flutter in the occasional breeze and bear a metaphoric relationship to skirts. Opposite the grid of crossed ankles stand the six dresses, and beyond them hang three paintings, each juxtaposing female body parts with female adornments: bare feet and red sandals; bare backs with protruding shoulder blades and lavish corsages; bare midriffs and glittery belts. The naked body parts are not young and sexualized but appear to emerge from a slightly saggy and desexualized middle age. It seems significant that the corsages are juxtaposed with the awkward and seldom-noticed forms of shoulder blades and not with the socially and sexually loaded forms of breasts.

Traces is a meditation on femininity. Although in a visual sense Falk is deconstructing notions of gender conditioning, she is not critiquing the social or cultural

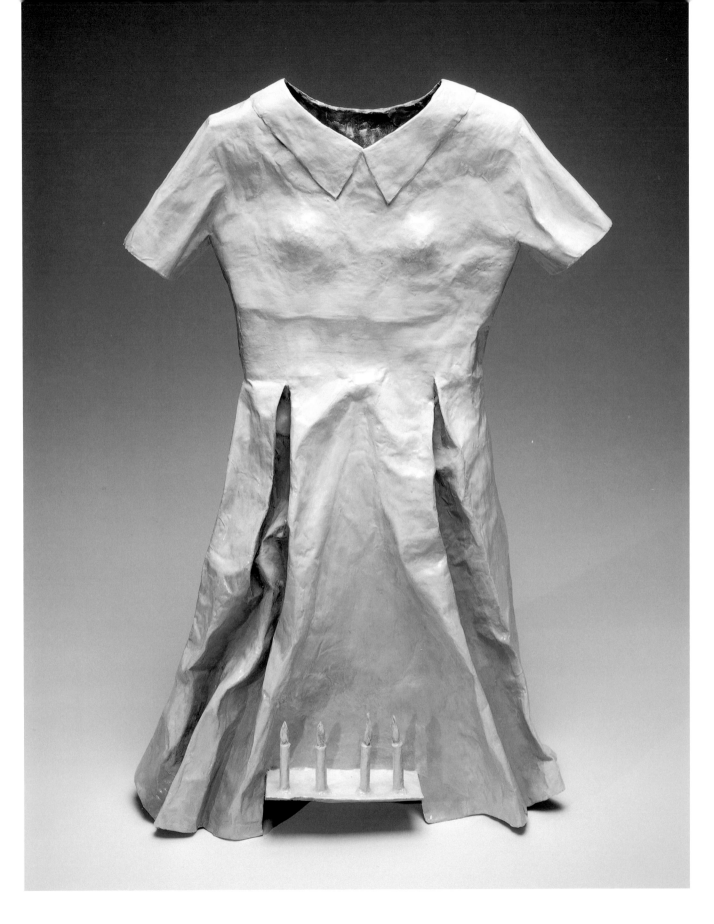

Dress with Candles, 1998, papier-mâché, acrylic paint and varnish, 88.9 x 60.9 x 30.4 cm,
National Gallery of Canada, Ottawa, 39892. Photo courtesy National Gallery of Canada

 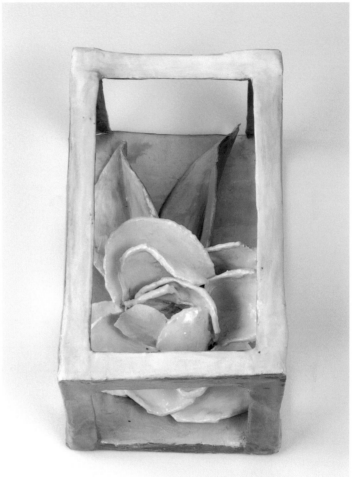

Left: *Small Articles* (two details, above), 1997–98, papier-mâché, acrylic paint, varnish and wooden table, 106.6 x 165.1 x 35.5 cm, collection of the artist. Photos by Teresa Healy, Vancouver Art Gallery

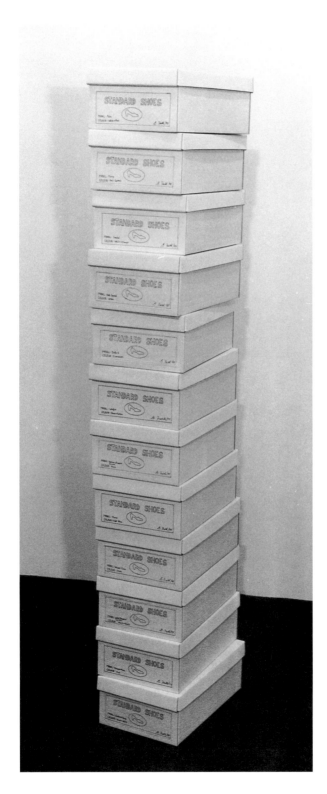

Installation view: *The Column* at the Equinox Gallery, Vancouver, 1998. Photo courtesy Equinox Gallery

production of the feminine. Instead, she is examining, with candour, affection and a little skepticism, aspects of her own life, her own feminine being and that of her friends. (In creating *Traces*, she took photographs of the crossed ankles of a number of her friends but won't say whose ankles she used in the installation.) The shift from her early interest in masculine apparel — shoes, suit coats, shirts and ties — to the clothing, shoes and cosmetics of the feminine realm represents, perhaps, the resolution of a long and absorbing grief. *Traces* sets aside the images and metaphors of absent father, unsuitable boyfriends and delinquent husband, replacing them with signs and symbols of her own singular yet highly socialized, late-adult condition. Within this condition, however, there are ongoing griefs and losses. The framed photo of the young child, the insects in various stages of metamorphosis, the candles burning like little prayers, all suggest quiet mourning over a condition of childlessness. Rightly or wrongly, the longing for a child is a star firmly fixed within the social constellation of the feminine.

While working on *Traces*, Falk began developing painted papier-mâché sculptures of women's shoes and placing them, in pairs wrapped in tissue paper, in white cardboard shoeboxes with hand-drawn labels. First was a series, Standard Shoes (1998), exhibited and sold as nine separate pairs. Second was *The Column* (1998–99), consisting of twelve pairs of shoes, also wrapped in tissue and placed in boxes, piled in a slightly wobbly stack and functioning as a single work. Although the viewer is welcome to open the boxes and peer inside, take out the shoes, perhaps even set the boxes and their contents down as a shoe clerk would, the exhibited form of *The Column* is just that — a column, a stack of boxes, no shoes visible.[92]

The idea of shoes within containers bears an obvious formal and thematic relationship to Single Right Men's Shoes of the early 1970s. But where the men's shoes have been worn, the women's shoes are new and imply a commercial or consumerist context rather than the everyday one of wear. Where the men's shoes are visible, displayed

in glass-fronted cabinets, the women's shoes are wrapped and enclosed, sealed off from casual view. And where the men's shoes are made of thick and durable-looking ceramic, the women's shoes are thin and fragile looking. (The paradox is that the ceramic is probably more fragile than the papier-mâché.) That is, the men's shoes suggest masculine qualities of strength, mobility and the assumption of a public life while the women's shoes suggest feminine notions of delicacy, seclusion and commodification.

The women's shoes are delightful things, wonderfully various in style and colour with their scalloped edges and ankle straps, their open toes and pointy toes, their stripes and dots and laces and gathers. But whether they are blood-red, spike-heeled pumps or mud-brown, low-heeled oxfords, young and sexualized or old and de-sexualized, they still have in common the closed expectations of gender. Again, Falk is not judging or critiquing gender conditioning; she observes it and represents its consequences in a way that is particularly hers. And within both conditions—masculinity and femininity—she conveys a condition of vulnerable humanity.

From shoes to shooting stars—in early 1999, Falk undertook an entirely new way of painting a grand and familiar subject. Her Heavenly Bodies are just that: night skies filled with suns and moons and five-pointed stars. Giotto's painted heavens continue to be a constant source of visual wonderment. More recent inspirations included the northern lights, the Hale-Bopp comet and two high, narrow walls in the little Anglican church Falk attends. She'd earlier been asked to paint a mural on the dome of the little church, but had refused, not so much out of Anabaptist iconoclasm as out of a practical apprehension of the "discord such work usually breeds." Still, while looking at the tall bare walls, ideas with their scale and dimension forced themselves into her head. These ideas were, she says, too good to ignore.

Falk conceived two tall paintings with sculptural and interactive aspects: cut-metal suns, moons and stars, with stems that slide into slits in the canvas, thus enabling them to be removed and dropped into a box below each painting. Because of the height of the project (eleven feet), she had to work on the floor on unstretched canvas. And because of her back condition, she had to invent ways of moving her medium around without excessive bending. She sketched in the background marks using a brush tied to a long ruler and laid down subsequent layers of paint with brooms, washing deep blue downward from the top of the canvas and raw sienna upward from the bottom to create immense, colour-field paintings, more closely related to action paintings than any she had yet undertaken.

The size and physical demands of the work again called Falk's friends into action. Elizabeth Klassen and Huyen Ha helped to wet, roll, lift and turn the canvas, cut slits in it and glue on pockets. Falk herself manipulated the paint on the canvas, cut out and coloured the aluminum suns and moons and the copper stars. More conspicuously than in Night Skies, she juggled different visual languages, different representational systems, different pictorial conventions. Upon *Heavenly Bodies, Suns* (1999), she placed eight different depictions of the sun, each with differently stylized rays. In *Heavenly Bodies, Stars and Moons* (1999), she made standard calendar depictions of five phases of the moon, and below them, four rows of five-pointed, storybook stars. Each work is charming and surprising, with something of the liveliness and spontaneity of Matisse's late-life cut-outs.

After tea, Falk offers a tour to and through her studio. Walking out the back door of the house, you step into a walled garden—the garden at the centre of the Parcheesi board, the garden in the neighbouring village—filled with flowers and bushes and fruit trees. Grapevines form a cool, green canopy over the back door, honeysuckle and clematis climb over a Giverney-inspired trellis and up the face of the studio. The camellia and viburnum have finished blooming, the Welsh poppies are up, the Constance Spry roses are out, the bee balm is in brilliant

Right: *Heavenly Bodies, Stars and Moons* (detail, above), 1999, acrylic on canvas, copper and aluminium, 327.0 x 152.0 cm, collection of the artist. Photos by Teresa Healy, Vancouver Art Gallery

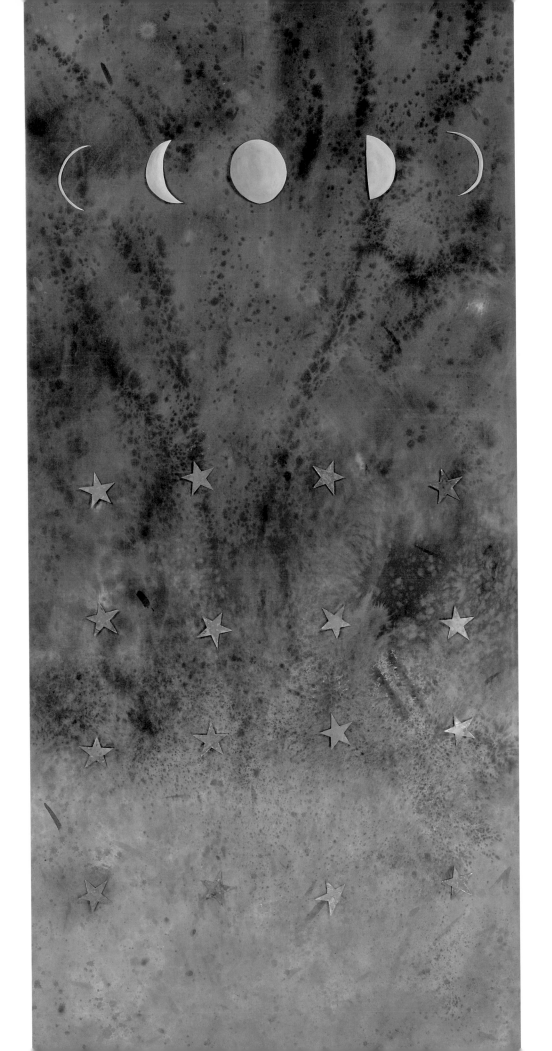

bud, and a thousand thousand stems and leaves and tendrils and blossoms crowd and jostle each other.

Inside the studio, Falk displays her works in progress, two papier-mâché dresses titled *Reclining Figure (after Henry Moore)*. One is subtitled *Alice*, the other *Stella*. The project is replete with cheerful ironies and inverted homages: where Moore's reclining figures are large-scale nudes — bodies without clothes — Falk's are life-size clothes without bodies; where Moore's figures are dense and fleshy, pressing their bulk earthward, Falk's figures are thin and hollow, as light as dried seed pods, arched and billowing upward.

Falk talks about how time-consuming the papier-mâché process is. And yet, papier-mâché is the medium that, at this moment, meets the need of the images that have gone "boing" in her head. It is the medium that, at this moment, expresses her heightened awareness of the everyday, an awareness that involves the heart and the soul as well as the senses. In its slow, repetitive and meditative process, building up layer upon tissue-thin layer, the medium is a metaphor for Falk's entire practice. Through her considered use of repetition, the acts and objects of everyday life become ritualized, invested with a character that both venerates the commonplaces of existence and transcends them. Falk's images, whether painted, sculpted or performed, are made as sacred as prayers, chants and mantras through repetition and reiteration. They are images that carry with them a weight of personal symbolism that draws upon her extraordinary life, upon her bank of experiences, emotions, beliefs and intuitions. But they are not simply personal: they convey social and cultural meanings, too, meanings that reverberate in our lives and times.

Gathie Falk's childhood was marked by profoundest tragedy, profoundest loss. The absence of her father can be seen as one of the defining conditions of her forming psyche, a greater deprivation than the material hardships she endured and the long road of hard work and premature responsibility, of high aspiration and deep disappointment, that she had to travel before arriving at the place of her artmaking, at this studio set in its blessed garden. Through the long shadows and large absences she depicts, Falk alerts us not only to a personal condition of her existence but also to the death that is twin to every lively aspect of all our experience. She alerts us not morbidly but meaningfully, because it is death that gives shape and definition to our lives, death that drives our artmaking impulses and our impulses to look at art, too. We seek out artists like Falk to give sense and shape to our jumbled sensations and experiences, our fears and joys and apprehensions. And to help us believe in ordinary miracles and everyday salvations. The evidence of physical damage, decay or suffering that occurs in Falk's art is always counteracted by her belief in rebirth, in transformation, in the everlasting life of the spirit.

On the way home, you pass a man's black boot leaning against a dumpster, a pair of brown brogues left under a park bench, leaves strewn across a sidewalk, a pile of glossy fruit at the corner store, a row of sparrows on a telephone wire, a patch of lawn, a flashing view of ocean. It is impossible, now, to look at these things without thinking about Gathie Falk and the awareness her art has bestowed upon your experience of them. Impossible to look, unmoved, at the clouds drifting across the night sky, the moon in its silvery nimbus, the clothes hanging in your closet, the small sink in your bathroom, the cabbage with curling leaves in your refrigerator, the wooden chairs at your kitchen table. By honouring such objects and sensations, Falk wakes us to their plainness and their beauty, their ordinariness and their extraordinariness, their particularity and their universality. And to all the conditions, glorious and mundane, loving and fearful, anguished and redemptive, that lie between the poles of our everyday lives.

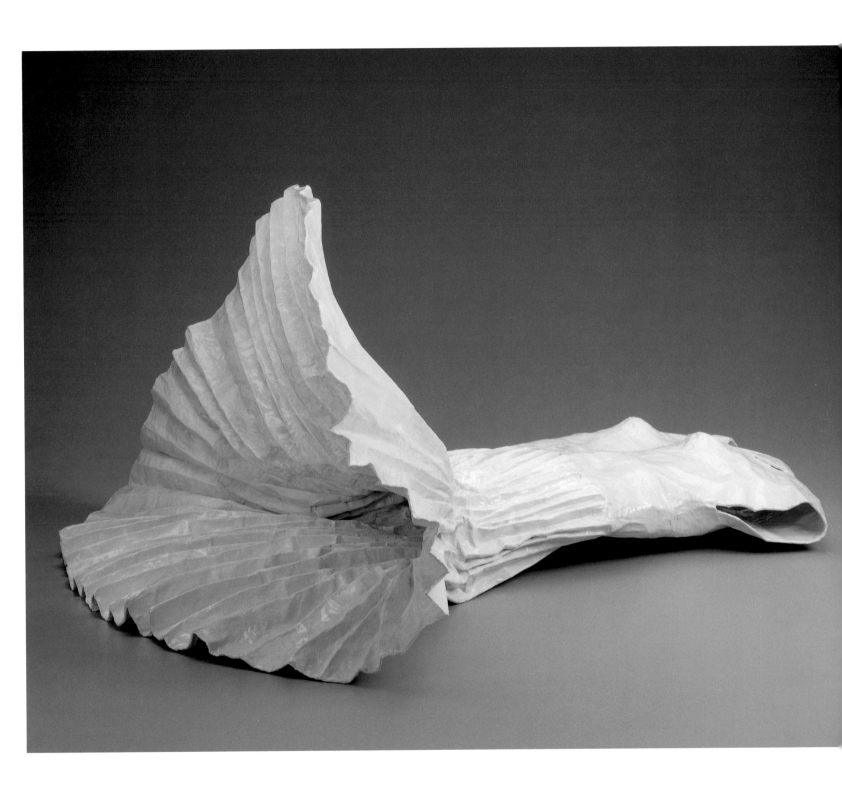

Reclining Figure (after Henry Moore): Stella, 1999, papier-mâché, acrylic paint and varnish, 47.6 x 88.9 x 100.9 cm, collection of the artist. Photo by Teresa Healy, Vancouver Art Gallery

[1] Gathie Falk, in an interview with the author, April 1999. Unless otherwise indicated, direct and paraphrased quotations are taken from a series of interviews, conducted between May 1996 and July 1999. Anecdotes, observations and biographical information have also been borrowed from the unpublished and unedited transcript of interviews between the artist and Jo-Anne Birnie Danzker, conducted in April 1985 and filed in the Vancouver Art Gallery library. This transcript is considerably longer than the version published as Falk's "Statements" in Jo-Anne Birnie Danzker et al., *Gathie Falk Retrospective*.

[2] Erwin Panofsky, *Meaning in the Visual Arts*, 26–39. Panofsky describes three "strata" of image interpretation in a work of art: primary, having to do with apparent meaning or simple identification of motifs; secondary or *iconographic*, having to do with cultural meaning or the stories and allegories told by images and motifs; and tertiary or *iconological*, having to do with intrinsic or symbolic meanings in the expanded context of the social and psychological conditions (as well as political and economic) within which the work of art was created and "often unknown to the artist himself."

[3] See Scott Watson's essay, "Gathie Falk's Sources and Rituals." See also Scott Watson and Sandra Martin, "Whimsical, Troubled and Bizarre: The Enigmatic Visions of Gathie Falk" and John Bentley Mays, "Christian Faith Permeates Work of Artangel Falk." In discussing Falk's work, few writers have noted that Mennonitism is a form of Dutch Anabaptism, which was opposed to the use of religious imagery.

[4] Mays, "Christian faith."

[5] Gathie Falk, "Some Thoughts on Christian Art (I Say No)," unpublished artist's statement, written for presentation to a Mennonite Bible college discussion on art, Winnipeg, 1974. (The talk was not delivered as written.)

[6] Among a number of articles and interviews, see especially Robert Enright's interview with Gathie Falk, "The Thing in the Head That's There."

[7] Ibid., 18.

[8] Gathie Falk, "Statements" in Danzker, *Gathie Falk Retrospective*, 11.

[9] Danzker, "Gathie Falk" in *Gathie Falk Retrospective*, 7.

[10] Falk, "Statements" in Danzker, *Gathie Falk Retrospective*, 14.

[11] Enright, "The Thing in the Head That's There," 19.

[12] David Watmough, "The Canvas Shack: Falk Art Strong in Human Focus."

[13] David Watmough, undated and unidentified review, probably having to do with the Flying Carpets series of 1966; in the Gathie Falk clipping file at the Vancouver Art Gallery.

[14] Donna Balma and Scott Watson, "Bernard Leach and His Vancouver Students," 102.

[15] Gareth Sirotnik, "Gathie Falk/Things That Go Bump in the Day," 8.

[16] Gathie Falk, undated artist's statement. Unless noted otherwise, undated statements are from Gathie Falk's personal archives.

[17] See Jonathon Fineberg, *Robert Arneson Self-Reflections*. See also "Robert Arneson" in *Voices and Images of California Art*.

[18] Falk, undated artist's statement.

[19] See particularly Joan Lowndes, "Glorious Fun-k Art of Gathie Falk." Lowndes admired Falk's "wit, invention and patient craftsmanship," the unsettling mix of found and handmade objects and the surrealistic touches. She also saw the influence of Claes Oldenburg, especially in Falk's "fake food."

[20] Ellen Johnson, *Modern Art and the Object*, 135. See also Lawrence Alloway, *American Pop Art*, concerning the mixed-media environments or tableaux produced by artists such as Robert Rauschenberg, Claes Oldenburg, Jim Dine and Tom Wesselmann.

[21] Falk remembers that Richard Simmins, an art critic and former director of the Vancouver Art Gallery, told her he thought the entire installation was about death. Poet Marguerite Pinney wrote about Falk's "preserved" home with its waxed, embalmed and mummified objects: "In Falk's tableau the parasitical undergrowth of materialism seems to have strangled humanity and beauty; and it lives on in its [sic] stead like the mummified remnants of a civilization." ("In the Galleries")

[22] Falk's own sense of this work is firmly secular, even though the combination of the fish with the throne and the spectral canopy lends itself to a Christian interpretation. The suggestions do exist for the Holy Trinity.

[23] In retrospect, Falk thought her living room environment was "too diffuse," containing too many works and failing to make a consolidating claim on the difficult space in which it was installed. Following the exhibition, less than half the original objects from *Home Environment* were preserved. (She had nowhere to store the furniture, and a few individual ceramic sculptures were sold.) In 1983, she restored the chair and canopy for exhibition at the Vancouver Art Gallery in *Vancouver: Art and Artists 1931–1983*. For her 1985 VAG retrospective, she restored and reassembled about a third of the objects from the original environment. This trimmed-down version was subsequently acquired by the gallery.

[24] Joan Lowndes, "The Spirit of the Sixties."

[25] Nancy Shaw, "Expanded Consciousness and Company Types: Collaboration Since Intermedia and the N.E. Thing Company."

[26] Falk was older than many of her fellow artists at Intermedia — but didn't look it. Her curiosity and creative sense of adventure accorded with her youthful appearance. Journalists made much of this, and of the girlish way in which she dressed, which included Mary Janes and mini-skirts. Falk remembers that during the 1960s, the only issue she'd argue about with her young counterculture friends was "their belief that after thirty, everything's over." Falk was forty when she exhibited *Living Room*.

[27] The work consisted of two square-sided towers, one composed of shredded paper or "excelsior" bound together with metal strapping and the other, of clear Plexiglas. As Falk

constructed the sculpture, strands of excelsior appeared to overflow in an arch from the top of the taller paper tower into the shorter Plexiglas tower, giving the work an active rather than static aspect. During the exhibition opening, visitors pulled all the excelsior out of the bale and strewed it around the gallery. Falk was appalled, but could not intervene.

28 If "was enrolled" sounds passive, that's because Falk initially resisted the idea of attending. She told Doug Christmas, a co-sponsor of the workshops along with the Vancouver Art Gallery and Intermedia, that she was not a dancer; he told her she didn't have to dance — but she did have to attend the workshops.

29 See A.A. Bronson and Peggy Gale, *Performance by Artists*. See also Robyn Brentano and Olivia Georgia, *Outside the Frame: Performance and the Object*.

30 Brentano and Georgia, *Outside the Frame*, 33. They also write that "From the turn of the century, the historical avant-garde considered the reintegration of art and life to be essential to the transformation of an ossified and morally corrupt society. Artists sought ways to remove art from its institutional confinement and to open up the creative process itself to influences from beyond the context of art."

31 Gathie Falk, "A Short History of Performance Art As It Influenced or Failed to Influence My Work," 13.

32 Falk, undated artist's statement.

33 Joan Lowndes, "But Whose Face Was the Egg On?"

34 Falk, "A Short History of Performance Art," 14.

35 The performance work was documented in 1982, in a special double issue of *The Capilano Review* vol. 1, no. 24/vol. 2, no. 25, written, edited and illustrated by Ann Rosenberg; and in a 1985 video, produced by Tom Graff, with camera work by Ken Blaine, Sara Diamond, Brian Dodd and Colin Griffiths, shown at the Vancouver Art Gallery in conjunction with Falk's 1985 retrospective.

36 The simplicity and seriality of the images — the ordinariness, again, of Falk's subjects — were critiqued in an editorial cartoon in the 19 April 1973 edition of the *Ottawa Citizen*. Falk reports, however, that the cleaning staff who watched her install the murals were delighted with them, and the construction workers on the site were impressed with how hard and efficiently the artist and her friends worked. No comments were forthcoming from the bureaucrats, who hadn't yet moved into the building.

37 Although the Fruit Piles never fell apart during firing, Falk did encounter a distressing technical problem. Almost a year's work had to be discarded and replaced when she discovered that a metallic element in her clay body was causing tiny explosions in the finished works, pitting the surface of the sculptures long after they'd been fired and glazed.

38 Falk, undated artist's statement.

39 Falk spent an entire Canada Council grant having the Plexiglas plinths custom-manufactured, but although the Fruit Piles sold very well, nobody wanted to buy the plinths which had been integral to their public presentation.

40 Ann Rosenberg, "Fruit Piles & Other Works" in "Gathie Falk Works," 9.

41 In a 1972 article about the tableau nature of Falk's art practice — an article which profiles the artist's house and its still-life arrangements as much as it does her ceramic sculpture and performance — Doris Shadbolt observed that Falk's "art is at the same time the context, the expression and the substance of her life." ("Tableau Is Her Form," 31)

42 Falk, undated artist's statement.

43 Joan Lowndes, "Schools Are Out for West Coast Artists."

44 Enright, "The Thing in the Head That's There," 20.

45 A humorous note about realism and surrealism in Falk's work: in 1972, she was invited to take part in a show titled *Realism: Emulsion and Omission*, organized by the Agnes Ether-

ington Art Centre in Kingston, Ontario; in 1976, her ceramic sculpture was included in a show of Canadian surrealism, titled *Other Realities*, also organized by the Agnes Etherington Art Centre. Her work, it seems, was both — and neither.

46 Falk, "Statements," 18.

47 Ibid. **48** Ibid.

49 Mayo Graham, "Introduction" in *Some Canadian Women Artists*, 9–24.

50 Falk, artist's statement, 1977.

51 Falk, "Statements," 19.

52 Eugenio Battisti, *Giotto*, 89ff.

53 Tom Graff, "Gathie Falk at Artcore," 6. See also Greg Bellerby, "Introduction" in *Gathie Falk Paintings 1978–1984*. Bellerby writes: "The paintings of Gathie Falk express her abilities as a colourist first and foremost."

54 Gathie Falk, artist's statement written for Mayo Graham, 1981.

55 Until the early 1960s, gardening had been Agatha Falk's pleasure and responsibility. Partly out of sorrow and partly out of a revulsion for worms (related to her snake phobia), Gathie herself did little in the garden after Agatha became incapacitated. Gradually, however, she overcame her fear of wiggly things and became a deft and inventive gardener.

56 Falk used the fast-drying dammar varnish for years until she realized the health risks it posed. At the time she did Night Skies, she was mixing her own paint using powdered pigment, linseed oil and beeswax.

57 Falk, artist's statement, 1980.

58 Russell Keziere, CBC Radio commentary, quoted in Alf Bogusky and Tom Graff, *Night Skies: Gathie Falk*.

59 Falk, undated artist's statement.

60 Bogusky and Graff, *Night Skies: Gathie Falk*.

61 Falk, artist's statement, 1982.

62 Ibid. **63** Ibid. **64** Ibid.

65 Gary Michael Dault, "The Alternate Eden" in *Visions: Contemporary Art in Canada*, Robert Bringhurst et al., 120.

66 Not all critics read Pieces of Water as benign. John Bentley Mays wrote that Falk's lawn and water paintings had a profoundly dark undertow beneath the mown or rippling surfaces that seem to speak so lovingly of nature. "[T]his bucolic romance is troubled by an upheaval which seems to be surging from the ground and depths, undoing the very molecules just below the surface." Nature in Falk's paintings, Mays writes, is "caving in at the metaphysical centre of itself, drawing the tentative, shining and tamed surfaces of civilization down into its dark core." ("The Snakes in the Garden" in Bringhurst, Visions, 189)

Scott Watson responded that it was not nature caving in at the centre of Falk's paintings, but culture. ("Gathie Falk's Sources and Rituals," 61)

67 Robert Louis Stevenson, "My Shadow," from A Child's Garden of Verses, 19.

68 Enright, "The Thing in the Head That's There," 23.

69 Bellerby, "Introduction," in Gathie Falk Paintings 1978–84.

70 Ibid., and Watson, "Gathie Falk's Sources and Rituals," 62.

71 Falk had originally conceived the installation with ceramic rather than actual bones. She'd been inspired by the large number of bones Maybe/Baby/Lady had been chewing on throughout the house and imagined the bones with small handles, like the ones she'd created for 150 Cabbages. However, the timeframe for creating the work was too short for that medium. Instead, Falk collected, boiled and cleaned hundreds of real bones. See Janet Lind, Gathie Falk, 17–19. Ceramic bones, Falk later reasoned, would probably have been impractically heavy.

72 Art Perry, "Billboard Celebration."

73 Watson, "Gathie Falk's Sources and Rituals."

74 Ibid.

75 Gathie Falk, "Soft Chairs."

76 Falk, undated artist's statement.

77 Ann Rosenberg, "Not a Pretty Picture of Dark Days to Come." Rosenberg's review is of the later Hedge and Clouds series, but she reflects on changes in Falk's manner of painting and particularly on the "enigmatic" imagery of Support Systems.

78 Art Perry, "Falk Wins $25,000 Prize."

79 Falk, undated artist's statement.

80 Falk, notes from working drawings for Development of the Plot II–V, c. 1991.

81 To me they look like the cross hairs of a rifle scope; to Ann Rosenberg, they connote "a surveillance instrument" or "a scientific grid." See Ann Rosenberg, "Swept Away by Shadbolt."

82 Gathie Falk, artist's statement, Artropolis 93: Public Art and Art about Public Issues.

83 Falk, undated artist's statement.

84 Ibid. 85 Ibid.

86 Falk, undated artist's statement.

87 Ibid. 88 Ibid.

89 Gathie Falk, "Gathie Falk / Artist" (artist's statement) in Barbara Amesbury, Survivors: In Search of a Voice, 19.

90 Robin Laurence, "Painter Eyes the Everyday Apple."

91 Falk's printer for the project was Terra Bonnieman, who had first worked with her thirty years earlier, on the serigraphs mounted in Home Environment. The surface of the transparent vellum was extremely difficult to print on — the ink did not want to adhere to the surface. Falk had chosen vellum because it resembled newsprint soaked with linseed oil, a ground with which she'd been experimenting.

92 There's a curious symmetry in The Column, with its interactive aspect, and the early Plexiglas and shredded paper sculpture Excelsior, with its two columnar forms — especially given Falk's horror at the interpretation of Excelsior as an interactive work when it hadn't been intended as such.

Selected Chronology

Bruce Grenville and Deanna Fergusson

Gathie Falk was born on January 31, 1928, in Alexander, Manitoba. During her early years, Falk's family moved several times between Manitoba, Saskatchewan and Ontario. In 1947 Falk and her mother, Agatha, moved to Vancouver, where Gathie completed teacher training, then taught for thirteen years. In the early 1950s, Falk saw a Jack Shadbolt exhibition at the Vancouver Art Gallery, Vancouver, and attended his artist talk. In 1957, she enrolled in summer school and night courses, studying design, drawing and painting with artists such as Bill West, Jim Macdonald, Ian McNairn, Lawren Harris Jr., Jacques de Tonnancour and Audrey Doray.

1960　Exhibits in *B.C. Annual*, Vancouver Art Gallery.

1961　Exhibits in *Northwest Annual*, Seattle Art Museum, Seattle.

1962　Works on Still Life Paintings series. First sees American abstract expressionism (Jasper Johns, Robert Rauschenberg) as well as the work of Picasso and other European artists at the Seattle World's Fair.

1964　Sees *The Nude in Art* at the Vancouver Art Gallery (includes work by Cézanne, Dürer, Mantegna, Renoir). Participates in *Spring Vernissage*, Burnaby Art Gallery, Burnaby.

1964–67　Studies ceramic modelling with Glenn Lewis at the University of British Columbia, Vancouver.

1965　Leaves teaching job in order to immerse herself in her art. Presents her first solo exhibition, *Paintings*, at The Canvas Shack, Vancouver. Participates in *B.C. Annual*, Vancouver Art Gallery.

"Gathie Falk, a young artist working in a rough approximation to German expressionism, is a painter for whom theme is a crucial factor.

"At least this is strongly suggested by the score or so oils in her first one-man show currently at the Canvas Shack.

"Whenever the human figure occupies a central place in Miss Falk's compositions, her canvases seem to spring to life — in a manner that her still lifes and domestic scenes rarely do, in spite of the vitality and raw energy of her palette." (David Watmough, "Falk Art Strong in Human Focus")

1966　Works on Landscapes, Boxes and Flying Carpets painting series. Begins to make pottery and ceramic sculpture. Sees Iain Baxter's *Bagged Place* at the Fine Arts Gallery, University of British Columbia, Vancouver. Participates in *Crossley/Falk/Shari*, Bau-Xi Gallery, Vancouver; *B.C. Annual*, Vancouver Art Gallery; *B.C. Society of Artists*, Vancouver Art Gallery.

1966–68　Works on *Living Room* (later retitled *Home Environment*) installation.

Left: Invitation: *Gathie Falk* at the Odalisque Gallery, Victoria, 1967. Right: Poster: *Living Room, Environmental Sculpture and Prints* at the Douglas Gallery, Vancouver, 1968.

1967 Gets to know potter Mick Henry and painter Michael Morris. Receives a Canada Council Short Term Grant and designs and builds a 50-cubic-foot gas kiln with potter Charmian Johnson. The Intermedia art group starts at the New Era Social Club. Becomes a member of Douglas Gallery, Vancouver. Sees *Rauschenberg: Booster and 7 Studios* at the Douglas Gallery, Vancouver, and *11 Pop Artists: The New Image* at the Fine Arts Gallery, University of British Columbia, Vancouver. Exhibits *Gathie Falk*, Odalisque Gallery, Victoria. Participates in pottery exhibition at The Canvas Shack, Vancouver; *B.C. Society of Artists*, Vancouver Art Gallery; *Canadian Group of Painters 67*, Montreal Museum of Fine Arts, Montreal; *Birth and Rebirth*, Fine Arts Gallery, University of British Columbia, Vancouver; *Little Funky Objects*, Simon Fraser University Art Gallery, Burnaby.

1967–70 Works on two sculpture series, Fruit Piles and Art School Teaching Aids.

1968 Works on Synopses A–F sculpture series. Gets to know artist/curator Glenn Allison and meets art critics Ann Rosenberg, Joan Lowndes and Marguerite Pinney. Workshop and performance with New York-based performance artist Deborah Hay. Goes to Los Angeles for opening of ACE Gallery (run by Douglas Christmas, owner of the Douglas Gallery, Vancouver). Sees *Los Angeles 6* at the Vancouver Art Gallery (includes work by Ed Kienholz, Jim McCracken and Larry Bell) and is strongly impressed. Sees *New British Painting and Sculpture* at the Vancouver Art Gallery (includes work by Anthony Caro, Nigel Hall and Bridget Riley). Exhibits *Living Room, Environmental Sculpture and Prints*, Douglas Gallery, Vancouver. Participates in *Younger Vancouver Sculptors*, Fine Arts Gallery, University of British Columbia, Vancouver; *Group Show*, Douglas Gallery, Vancouver; *Invitation I*, Canadian Guild of Potters, Toronto. Produces performance of *A Bird Is Known by His Feathers Alone* (first version) at Intermedia Performance, Vancouver Art Gallery.

Ballet for Bass-Baritone, performance documentation, Vancouver, 1984 (first performed at the Vancouver Art Gallery, 1971). Photo by Chick Rice

"Call it funky, surrealist, environmental, trompe l'œil, high camp — by any name Gathie Falk's current show at the Douglas Gallery is glorious fun.

"The entire gallery has been transformed into a mock middle-class living room, filled with treasures which Gathie Falk has spent months hunting down in welfare industry stores. Then with wit, invention and patient craftsmanship she has transformed them into art objects." (Joan Lowndes, "Glorious Fun-k Art of Gathie Falk")

1968–70　Works on Shirt Drawings series.

1969　New York-based performance artists Yvonne Rainer and Steve Paxton come to the Vancouver Art Gallery and to Intermedia. Falk takes part in Rainer's and Paxton's performances. Sees *New York 13* at the Vancouver Art Gallery (includes work by Jasper Johns, Donald Judd, Roy Lichtenstein, Claes Oldenberg and Andy Warhol). Participates in *Electrical Connections*, Intermedia Show, Vancouver Art Gallery (shows her *Woman Walking on Wall* installation and *Excelsior* sculpture); an exhibition, Douglas Gallery, Vancouver; *5th Burnaby Print Show*, Burnaby Art Gallery, Burnaby; *The New Art of Vancouver*, Newport Harbor Art Museum, Balboa, California, and University of California at Santa Barbara. Produces performances at Festival of the Arts, University of British Columbia; *Some Are Egger Than I*, New Era Social Club, Vancouver, and Arts Club, Vancouver; *69 Grapefruit*, Douglas Gallery, Vancouver.

1969–70　Works on Man Compositions sculpture series.

1970　Meets artist Tom Graff at a workshop at the University of British Columbia. Exhibits *29 Pieces* (with Glenn Lewis), Vancouver Art Gallery. Participates in *Survey/Sondage*, Musée des beaux-arts, Montréal; *Works Mostly on Paper*, Institute of Contemporary Art, Boston. Produces performances of *Crocheted Geodesic Dome with Sound by Buckminster Fuller*, Festival of the Arts, University of British Columbia; *Before & After* and *Cat Piece*, Domes Intermedia Show, Vancouver; *Drill*, Summer Performance, University of British Columbia.

1970–71　Teaches in new Faculty of Fine Arts, University of British Columbia, Vancouver.

1971　Commissioned to do two murals called *Veneration of the White Collar Worker #1* and *#2* for the Department of External Affairs Building, Ottawa. Receives Canada Council Arts Bursary. Participates in *Contact, The Northwest*, Seattle Center, Seattle; *Canadian West Coast Art*, Australia National Library, Canberra; *Northwest Annual*, Seattle Art Museum, Seattle; *Art from Canada's West Coast*, Vancouver Art Gallery. Produces performances of *Ballet for Bass-Baritone* and *And*

Others, a collaboration of pieces with Tom Graff, Vancouver Art Gallery; *Cross Campus Croquet*, a collaboration with Tom Graff, Festival of the Arts, University of British Columbia.

1971–73 Works on *Veneration of the White Collar Worker #1* and *#2* murals.

1972 Visits New York. Participates in *Realism: Emulsion and Omission*, Agnes Etherington Art Centre, Kingston, and University of Guelph, Guelph. Produces performances of *Orange Peel* and other pieces, Vancouver Art Gallery; *Vancouver–Halifax Exchange*, Nova Scotia College of Art and Design, Halifax. Also produces performances of *Gathie Falk and Tom Graff on Tour*, Confederation Art Centre, Charlottetown; Isaacs Gallery, Toronto; Fanshaw College Gallery, London, Ontario; Alberta College of Art, Calgary; Edmonton Art Gallery, Edmonton (with Elizabeth Klassen, Salmon Harris, Anna Gilbert and Janet Malmberg); then mounts performances (funded by Local Initiatives Programme) in Vancouver with this group (and with Nomi Kaplan, Lynne Polkinghorne and Pat Knox) at the Vancouver Art Gallery, the University of British Columbia, churches, schools and retirement homes.

"What makes Gathie Falk a particularly interesting artist of tableau is the wholeness of her creation —the degree to which her life and her art interpenetrate. For, as a visit to her house confirms, her art is at the same time the context, the expression and the substance of her life. It is not a case of the life-style artist where style equals art. Her art-creation is very conscious, very crafted, but her art-works, whether sculpture or theatre, are distinguished from the rest of her life only by their completeness and their definition. And there is also the personal character of her imagery, the sense in which she is psychically present and projected in all she does." (Doris Shadbolt, "Tableau Is Her Form: Gathie Falk")

1972–73 Works on Single Right Men's Shoes sculpture series.

1973 Installs *Veneration of the White Collar Worker #1* and *#2* murals in Ottawa with the help of Glenn Allison, Elizabeth Klassen and Tom Graff. Participates in *Ceramic Objects*, Art Gallery of Ontario, Toronto, and New York Cultural Center, New York; *Traces*, Burnaby Art Gallery, Burnaby; *Pacific Vibrations*, Vancouver Art Gallery; Librations, Art Gallery of Greater Victoria, Victoria.

1974 Spends a month in Paris. Exhibits *Single Right Men's Shoes* at the Canadian Cultural Centre, Paris. Participates in *Drawings*, Bau-Xi Gallery, Vancouver; *Contemporary Ceramic Sculpture/ from alberta saskatchewan british columbia and manitoba*, Fine Arts Gallery, University of British Columbia, Vancouver; *Fired Sculpture*, Art Gallery of Greater Victoria, Victoria.

1974–75 Works on *Herd One* and *Herd Two* installations, and Saddles sculpture series.

1975 Participates in *Some Canadian Women Artists*, National Gallery of Canada, Ottawa; *Current Energies, B.C.*, Saidye Bronfman Center, Montreal; *Chairs*, Art Gallery of Ontario, Toronto.

"Gathie Falk first constructed Theatre Art Works in 1968. These works had an historical-æsthetic bond with the 'Happenings' which began in New York and Los Angeles. The words Theatre Art

Installing *Veneration of the White Collar Worker #2* (Glenn Allison, Gathie Falk, Elizabeth Klassen) at the External Affairs Building, Ottawa, 1973. Photo by Tom Graff

Works were coined by Gathie Falk and another artist because the word 'Happening' was coming to mean an improvisational experiment. To the contrary, Falk's works are planned to the last detail as in a piece of music . . .

"These works are visual art works juxtaposed to movement in time and space. Therefore they are strictly what you see and hear, nothing else. Do not look for plot, dramatic development, or philosophical import in a theatre arts work. There may be extended use of tension, occasional surprise, or humour, but these are merely tools. The very private and poetic intermingling of time and space occur when the viewer allows the various elements of the work to play upon his perception." (Tom Graff, "Theatre Art Works")

"Falk has spoken about her art as being a 'personal vision of things already in the world.' It is personal, certainly, but it is linked to the experience of us all, because the objects we see and use, no matter how banal they seem, are attached by invisible threads to the lives we lead. Isolate those objects from the way we encounter them in our everyday lives, revise their appearance by representing them in changed materials, and they form a new context that challenges our conventions. In particular, their presentation as works of art in a gallery or museum setting gives them the character of precious objects or objects of celebration — as Falk has said, it is the 'veneration of the ordinary.'" (David Burnett, *Masterpieces of Canadian Art from the National Gallery of Canada*, 206)

Gathie Falk with a group of student friends at the University of British Columbia, c. 1977.

1975–76 Works on 39 Drawings series.

"Outside of Colette Whiten's large process sculptures, Vancouver's Gathie Falk commands the most praise as an inventive and important Canadian artist. Falk is whimsy where Whiten is disturbance. One enjoys Falk's Eighteen Pairs of Red Shoes with Roses, 1973, for its fantasy—close to, but detached from reality. Thirty-six shoes, hand sculptured in clay, and fired to a high red gloss, greet the viewer as the elevator door opens onto the fourth floor of the NGC. Most people chuckled, and one observer I remember went into hysterics (then reached a further uncontrollable state when he noticed the pink paper roses glued to each insole)." (Art Perry, "New Era for Women's Art")

1975–77 Teaches part-time in the Faculty of Fine Arts at the University of British Columbia. Beginning of The Group: Gloria Massé, Wendy Hamlin, John Clair Watts, Elizabeth Klassen, Gathie Falk.

1976 Exhibits *39 Drawings*, Bau-Xi Gallery, Vancouver; *Herd Two & Drawings*, National Gallery of Canada, Ottawa—touring to St. Catharines, Victoria, Halifax and Quebec City. Participates in *West Coast Waves*, Winnipeg Art Gallery, Winnipeg; *The Provincial Collection*, 1976 Olympic Exhibition, Montreal.

1976–77 Works on Picnics sculpture series.

"Gathie Falk's participation in *West Coast Waves* included six of her new series of 30 Picnics. They demonstrated the centrality of performance in her work, since they stemmed from a 1970 piece recalled through slides. In her ceramic extensions Falk set on a square of grass watermelons, cups or a cabbage in sublimations of the commonplace—her hallmark.

"But one piece was unlike anything she has ever done: *Picnic with Birthday Cake and Blue Sky*. There was a new element of excitement, a sense of splendid disaster as the wind whipped the candles into flaring orange flames. Using thick layers of acrylic and urethane, Falk imbued her always seductive surface with a gorgeous painterliness." (Joan Lowndes, "Western Triptych")

1977 Visits the Arena Chapel in Padua, Italy. Exhibits *Herd One*, Forest City Gallery, London, Ontario. Participates in *Four Places*, Vancouver Art Gallery; *From This Point of View*, Vancouver Art Gallery; *Works on Paper*, Harbourfront Gallery, Toronto; *Clay as Sculpture*, Alberta College of Art Gallery, Calgary; *For the Birds*, Fine Arts Gallery, University of British Columbia, Vancouver.

CLAY AS SCULPTURE

Invitation: *Clay as Sculpture* at the Alberta College of Art Gallery, Calgary, 1977.

"The Picnic series suggests that art may easily extend and fulfill the role of the imagination. One enjoys the visual rightness of a crown festooned with fish or of a grey dog, the archetypal hound of hell, benignly guarding a bouquet of pink camellias. It all seems so effortless. A perfect marriage of technical competence and visual force, the Picnics embody that concept of Sprezzatura (effortless grace) towards which Renaissance Italians strove. But the Picnics are more than graceful; they are also magic. The motif of flame unites them: sometimes it is bold and calligraphic as on the car doors; occasionally it rises triumphantly from teacups or consumes in cone-like ardour piles of leaves, heart-waffles, and the candles on cakes. It is a metaphysical device that Gathie borrowed from the world of hearsay and allowed to grow in her. A friend, apparently, covered a lighted birthday cake in order to take it outside — when she removed the foil the cake was destroyed by fire. In Gathie's current work this ordinary domestic crisis she heard described is the source of the supra-natural fire she brings to the work. The flame is present 'because she can't have stars.'" (Ann Rosenberg, "Vancouver: The Four Voices of Four Places")

1978 Works on paintings *East Border in Four Parts*, *West Border in Five Parts* and *Lawn in Three Parts*, as well as *150 Cabbages* installation. Commissioned to do *Beautiful British Columbia Multiple Purpose Thermal Blanket* for B.C. Credit Union Centre, Vancouver. Exhibits *Gathie Falk*, Edmonton Art Gallery, Edmonton; *Cabbage Environment and Borders*, Artcore, Vancouver. Participates in *Other Realities — The Legacy of Surrealism in Canadian Art*, Agnes Etherington Art Centre, Kingston; *Sculpture Today*, International Sculpture Symposium, Toronto.

"The theme of privacy or an inward vision combined with a proud and expansive hospitality is carried through in Falk's paintings, but, I think, less dramatically and less integrally, than in *Cabbage Environment*. That she is painting is significant. Before her relationship with sculpture and the mode she ultimately adopted, Falk would cite Gauguin, Bonnard and Blake as models: their works inspired her to become an artist. . . . It is interesting to note that these three have an emphasis on privacy in common: Gauguin was to retire to the hermitage of the south seas; Bonnard, very like Falk herself, consigned himself to the private world of his garden; and William Blake was the willing resident of his own visions. Falk would seem to be following through on the private-garden / public-space as a means to greater effectiveness by a treatment of private areas in large paintings." (Russell Keziere, "Gathie Falk: Cabbage Environment")

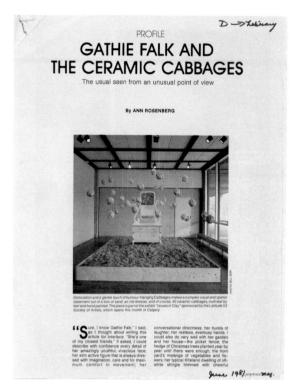

Left: Invitation: *Gathie Falk: Beautiful British Columbia Thermal Blanket Series* at the Equinox Gallery, Vancouver, 1981.
Right: Magazine article by Ann Rosenberg, "Gathie Falk and the Ceramic Cabbages," in *Interface*, June 1981.

1979 Installs *Beautiful British Columbia Multiple Purpose Thermal Blanket*, B.C. Credit Union Centre (now Credit Union Central of British Columbia), Vancouver. Participates in *Nationalism in Canadian Art*, Art Gallery of Greater Victoria, Victoria; *Compass 8*, Harbourfront Art Gallery, Toronto (shows five Night Skies paintings).

"For a year now, Gathie has composed border and lawn paintings of incisive colour, strong tonal command, and a precise balance of a rather cinematic repetition. The effect of parts 'remembered' from frame to frame unifies each series. It is exciting to see such vibrant paintings of large scale from a virtuoso ceramic artist. Falk's command of colour has always been her paramount achievement, and all other formal considerations are subject to it. All along Gathie has been *painting*. Sculpture after sculpture has been painted with either acrylic or oil as though it were either a still life painted in three dimensions or a painting which has suddenly gained gravity. And now she has rediscovered oil on canvas. The body of paintings in this exhibition sets forth this rediscovery in clear terms." (Tom Graff, "Gathie Falk at Artcore")

1979–80 Works on Night Skies painting series.

1979–81 Works on Beautiful British Columbia Thermal Blankets sculptured painting series.

1980 Exhibits *Night Skies*, Fine Arts Gallery, University of British Columbia, Vancouver—tour

GATHIE FALK WORKS
VOLUMES 1 AND 2

Journal cover: "Gathie Falk Works" in *The Capilano Review*, volume 1, number 24 / volume 2, number 25, 1982.

ing to Southern Alberta Art Gallery, Lethbridge, and Glenbow Museum, Calgary. Participates in *Aspects of Canadian Painting in the Seventies*, Glenbow Museum, Calgary; *On Canvas*, Simon Fraser University at Robson Square, Vancouver; *Art Bank Collection Show*, Algonquin College Gallery, Ottawa; *Celebrations*, Burnaby Art Gallery, Burnaby; *Retrospect Ceramics 80*, Potters Guild of British Columbia, Robson Square Media Centre, Vancouver.

1981 Exhibits *Beautiful British Columbia Thermal Blanket Series*, Equinox Gallery, Vancouver. Participates in *Issues in Clay*, University of Alberta Art Gallery, Edmonton; Alberta College of Art Gallery, Banff Centre, and Burnaby Art Gallery, Burnaby; *L'Art mis en boîte*, Musée d'art de Saint-Laurent, Québec.

"She has become a stargazer and the subject of this skyward vision is a series of paintings, Night Skies, begun in 1979. The images are ethereal—vaporous masses of clouds objectified by light; light itself, colour and space. They are grounded in a particular point of view that is humanistic, romantic, literary and most of all, urban. Falk's skies are illuminated by the artificial lights of a sprawling city. Hers is a city dweller's salutation to nature that moves easily between empirical observation and pure intellectual fantasy." (Nancy Tousley, "Gathie Falk")

1981–82 Works on Pieces of Water painting series.

1982 Ann Rosenberg produces the double-issue special edition of *The Capilano Review*, "Gathie Falk Works." Exhibits *Pieces of Water*, Equinox Gallery, Vancouver, and Isaacs Gallery, Toronto; *Herd One & Cement*, Equinox Gallery, Vancouver. Participates in *Curnoe/Ewen/Falk/Moppett*, Norman Mackenzie Art Gallery, Regina, and Nickle Art Museum, Calgary; *Group Show*, Downstairs Gallery, Edmonton; *Mere Morsels*, Vancouver Art Gallery—touring British Columbia.

"At the moment, Falk is starting a series that will probably be called Cement Sidewalks. Unlike Night Skies and Pieces of Water but like Borders, it is derived from snapshots of moments in the Kitsilano landscape when the shadows of trees and plants extend over pavement, when the cement blushes pink in the late afternoon, nudging borders of grass and flowers. Flesh pink, *shrimp pink*, like the enamel-hardened chair of *Home Environment*.

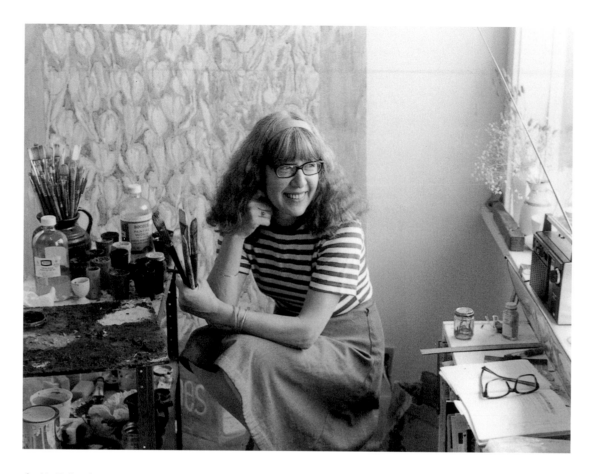

Gathie Falk in her studio, Vancouver, 1983. Photo by Tom Graff

"There is symmetry and continuum in all of Falk's art that is admirable . . . almost everything she had done — even work involving people as elements in a moveable still life — falls into place in a complex œuvre." (Ann Rosenberg, "Gathie Falk Works," 57)

1982–83 Works on Cement painting series.

1983 Works on Theatres in B/W and Colour painting series. Begins work on Vancouver Art Gallery retrospective with curator Jo-Anne Birnie Danzker. Works on *Two-Dimensional Rendering of a Large Number* painting. Exhibits *Theatre in B/W and Colour*, Equinox Gallery, Vancouver. Participates in *New Perceptions: Landscape*, Art Gallery at Harbourfront, Toronto; *Vancouver: Art and Artists 1931–1983*, Vancouver Art Gallery.

"Falk's new paintings surround the viewer with light, luminous colour, and a sense of controlled spontaneity not found in her paintings of the last few years. Falk's 1978 paintings at Art Core Consultants were weak in content and technique. They marked the artist's return to painting after a 12-year absence, and lacked the vigour and imagination of her sculptural installation of the same exhibit, *150 Hanging Cabbages*. Other ceramic exhibitions by Falk in Vancouver during the 70's evidence strength and professionalism. By contrast, her Night Skies paintings (1980) view the

Magazine cover: *Vanguard*, December 1985/January 1986.

artist's world without asserting strong purpose. The *Beautiful British Columbia Multiple Purpose Thermal Blanket II* of the 1979 series is interesting as a sculptural form, as a large quilt, more so than as a painting. The images of garden and home-life form a light impression, removed in their inwardness from any political and social realities." (Rosalie Staley, "Gathie Falk/Richard Prince")

"The paintings, with the overall title Pieces of Water, are large, rather impressionistic sheets of mainly watery blue and blue-green that look as if Falk 'took a long sharp knife and cut down into the ocean to lift out a piece . . . and painted the top surface of this piece of water.' The 'current' of the water is from the 'top left to the bottom right' of the picture plane (or the reverse) — that is to say, on the diagonal. Each of the paintings in the series has subtitle — a homely and everyday phrase which seems inexplicable in relation to the painting. There are, for example, paintings subtitled *President Sadat*, *Calgary Olympics*, *Constitutional Agreement* and *Surplus Cheese*. According to Falk, the subtitles come from radio broadcasts she heard while she was painting . . .

"It must be remembered, however, that these paintings are made of obliques. They are not horizontals of brimming sea stretching off into the archetypal. They are, rather, momentary and localized experiences, albeit cut from a matrix (of water) that runs through us all and under everything we do. Great, still oceans are horizontal. Prairies stretch off on either side till we must take their endlessness on faith. But Pieces of Water are angular shards of experience that enter our lives like facts, taking up local habitation — and given names." (Gary Michael Dault, "The Alternate Eden: A Primer of Canadian Abstraction" 119–20)

1984 Works on videotaping most of her performance work. Exhibits *Theatre in B/W and Colour*, Isaacs Gallery, Toronto. Participates in *Reflections: Contemporary Art since 1964*, National Gallery of Canada, Ottawa.

1984–85 Works on Chairs painting series.

1985 Works on *My Dog's Bones* installation. Exhibits *Gathie Falk Retrospective*, Vancouver Art Gallery; *Chairs*, Equinox Gallery, Vancouver; *Paintings 1978–1984*, Art Gallery of Greater Victoria, Victoria — touring to Art Gallery of Hamilton, Hamilton; Mount Saint Vincent University Art Gallery, Halifax; Agnes Etherington Art Centre, Kingston, and Mendel Art Gallery, Saskatoon.

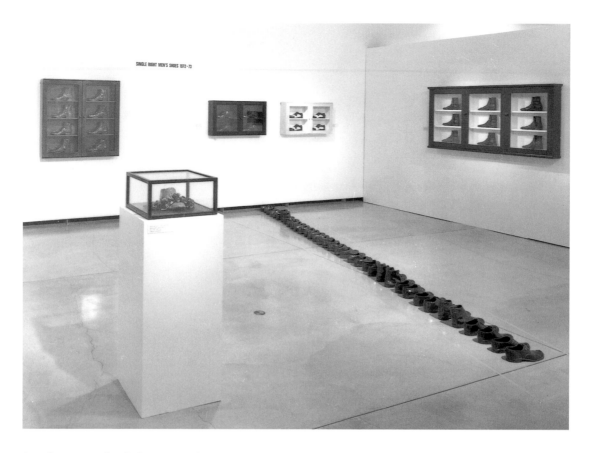

Installation view: Single Right Men's Shoes at the Vancouver Art Gallery, 1985.

Participates in *Aurora Borealis*, Centre international d'art contemporain de Montréal, Montréal; *Atmospheric Synthesis*, Art Gallery of Peterborough, Peterborough, Ontario; *Vancouver Now*, Walter Phillips Gallery, Banff—touring to London Regional Art Gallery, London, Ontario; Oboro, Montréal, and Winnipeg Art Gallery, Winnipeg.

"Try as you will . . . it is virtually impossible to settle down comfortably in Falk's yard. The lawns and sidewalks do not rest easy, but seem to rise toward the viewer, like the leaf-littered doors of storm cellars creaking open. Similarly, the night skies buzz with faint, neurotic electricity. And the 'pieces of water' depict the surface of water, not as a friendly seaside shimmer, but as a mineral slab of frozen light and physics. We cannot tell where we stand in relation to those oceans and lawns and sidewalks. Falk disorients us with odd, disconcerting shifts in perspective and with the jarring rhythm of punches, tiny jump-cuts and anxious silences in the paint surface itself.

"Yet, there is never the feeling that Falk has merely taken a prosaic visual subject and made it unnecessarily difficult or troubling. These are the gardens and lawns we may look at every day, but are actually *seeing* for the first time here, in these paintings. She has never made any extravagant claims about the revelatory power of her artistic practice. Yet viewed as the apocalypse of the ordinary, Falk's painting strategy begins to make sense." (John Bentley Mays, "Blending the Black Skies and Sunny Noons of Life")

GATHIE FALK RETROSPECTIVE

VANCOUVER ART GALLERY SEPTEMBER 7 TO NOVEMBER 11, 1985

GATHIE FALK
PAINTINGS
1978-1984

Left: Exhibition catalogue: *Gathie Falk Retrospective* at the Vancouver Art Gallery, 1985. Right: Exhibition catalogue: *Gathie Falk: Paintings, 1978–1984* at the Art Gallery of Greater Victoria, Victoria, 1985.

"There has been little attempt to interpret Falk's work in the light of her beliefs. Instead there is an image of Falk as a surrealist of good vibes — a funky, bizarre artist for whom play and the recreation of her childhood are her most serious concerns. Much of her popularity is based on the mistaken idea that she is a master of whimsy. The charm she gives to an image or an object have hidden from us a darker aspect to her work. The obsession with shiny, sticky surfaces — the chaos of many compositions and the emphasis on organic processes of decay and regeneration, as well as many metaphorical allusions to death, all point to ongoing thematic concerns which expands the 'veneration of the ordinary' into something with cultural and mythic implications." (Scott Watson, "Gathie Falk's Sources and Rituals," 58)

"Over and over, I have seen her frustrated at attempts to make her works into universal statements of moral, æsthetic or cosmic purpose. I feel similarly, but not quite as strongly. In working with her on *Tea*, this became clearest. She wanted simply to make a moment of pouring too many cups of tea and surrounding herself with them. I came into it when we realized that her impulse was not exactly enough to hold attention (or deserve it). But even after I added the idea of formal clothing and the covering of the chair, Falk still got most of her delight in simply giving the audience the slightly mad experience of seeing someone pour tea *ad infinitum*. I believe that my part is a foil for this basic need. Her movement embodies wit, slightly removed from anything real. Yet it is very real on the other hand, as when she hits eggs over and over in *Some Are Egger Than I*." (Tom Graff, "Notes, Anecdotes and Thoughts on Gathie Falk's Performance Art")

GATHIE FALK

Opening Saturday, March 7,
2 to 5 p.m.
– The artist will be present –
Until March 27, 1987

The Isaacs Gallery 179 John Street, Toronto M5T 1X4 595-0770

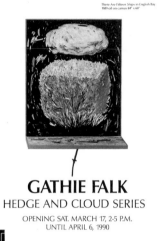

There Are Fifteen Ships in English Bay
1989 oil on canvas 84" x 60"

GATHIE FALK
HEDGE AND CLOUD SERIES

OPENING SAT. MARCH 17, 2-5 P.M.
UNTIL APRIL 6, 1990

THE ISAACS GALLERY 179 JOHN STREET TORONTO M5T 1X4 416-595-0770

Left: Invitation: *Gathie Falk* at the Isaacs Gallery, Toronto, 1987. Right: Invitation: Gathie Falk: *Hedge and Cloud Series* at the Isaacs Gallery, Toronto, 1990.

1986 Works on Soft Chairs painting series.

1987 Works on *Two Curves Celebrating* painting, commissioned by Manufacturers Life Insurance Company. Exhibits *Gathie Falk*, Equinox Gallery, Vancouver; *Gathie Falk*, Isaacs Gallery, Toronto; *Gathie Falk*, 49th Parallel Centre for Contemporary Canadian Art, New York. Participates in *Tables Turned, Aspects of Furniture as Visual Art*, Whyte Museum of the Canadian Rockies, Banff; *Waterworks*, London Regional Art Gallery, London, Ontario; *Painting the Town*, Toronto, Montreal, Vancouver.

1987–88 Works on Support Systems painting series. Designs her new house and studio in east Vancouver.

1988 Exhibits *Support Systems*, Equinox Gallery, Vancouver, and Isaacs Gallery, Toronto; *Working Through the Gray Scale*, Surrey Art Gallery, Surrey, B.C.

1988–89 Falk's new house and studio are built by Bob Falk and Garry Nikolychuck. Works on *Diary* mural, commissioned by architect Arthur Erickson for the Canadian Embassy in Washington, D.C., and on *Salute to the Lions of Vancouver*, commissioned by the Government of Canada for Canada Place in Vancouver.

1989 Designs and plants new garden at her home. Works on *Development of the Plot in Four Parts* mural, commissioned for Park & Tilford Cineplex Odeon, North Vancouver. Participates in *Artluminium*, an exhibition presented by Alcan and Lavalin, Montréal.

1989–90 Works on Hedge and Clouds painting series.

1990 Receives the Gershon Iskowitz Prize. Exhibits *Hedge and Cloud Series*, Isaacs Gallery, Toronto, and Equinox Gallery, Vancouver; *Ceramic Sculpture from the 60s and 70s*, Equinox Gallery,

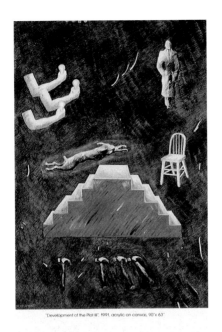

"Development of the Plot III", 1991, acrylic on canvas, 90" x 63".

Invitation: *Gathie Falk* at the Wynick/Tuck Gallery, Toronto, 1992.

Vancouver. Participates in *Artropolis*, Vancouver; *North of the Border*, Whatcom Museum, Bellingham, Washington.

"Coming as it did in the mid-1980s, the retrospective necessarily culminated with the paintings done in the early years of the decade, after Falk had stopped doing performances. Those vertiginous, semi-abstract night skies, expanses of water, lawns and sidewalks were in some ways the strongest works Falk had ever done; and they were also the most forlorn and empty of whimsy. But in turning her into a brooding existentialist painter — a tendency in reviews by this critic in the mid-1980s, incidentally — there was always the temptation to forget the fact of her Christian belief, and her commitment to being a Christian artist, even in the valley of shadows portrayed in the oils of the 1980s." (John Bentley Mays, "Christian Faith Permeates Work of Artangel Falk")

1990–91 Works on Venice Sinks with Postcards from Marco Polo painting series.

"Since 1978, after giving up ceramics, she's concentrated on working on canvas and produced many suites that feature sky, water and garden environments. These works sometimes contain unexpected combinations of motifs — fish piled up on chairs, light bulbs suspended from the sky. The paintings are rendered transparently in a style inspired, in part, by the impressionists and post-impressionists.

"In the last four years, Falk has consciously moved away from this approach to a style that is more briskly painted and to subjects that are less pleasant to view and think about. This change in mood had been deliberate, as well-considered as other choices she has made in her artistic life.

"What precipitated this recent change? After seeing her early paintings pulled out of the attic for a major retrospective at the VAG in 1985, Falk says she decided to work more expressionistically and to use unpleasant colours, unsettling subject matter and angry-looking brushwork in order to get back to the state of liberation she sensed was present in her work in the mid-'60s." (Ann Rosenberg, "Not a Pretty Picture of Dark Days to Come")

1991 Works on *June 1992, For a Wall* installation. Exhibits *Venice Sinks with Postcards from Marco Polo Series*, Equinox Gallery, Vancouver.

1991–92 Works on Development of the Plot painting series.

Magazine cover: *Border Crossings*, spring 1993.

1992 Surgery performed on Falk's back causes permanent impairment. Exhibits *Development of the Plot*, Wynick/Tuck Gallery, Toronto. Participates in *La Collection*, Musée d'art contemporain, Montréal.

1992–93 Works on Clean Cuts painting series and *150 Light Bulbs* installation.

1992–2000 Falk's garden redesigned and replanted by Elizabeth Klassen.

1993 Works on Constellations painting series. Exhibits *Clean Cuts*, Equinox Gallery, Vancouver. Participates in *Artropolis 93*, Vancouver; *Pop Art Plus*, Equinox Gallery, Vancouver; *Corpus I*, Mendel Art Gallery, Saskatoon—touring to Walter Phillips Gallery, Banff, and Oakville Galleries, Oakville.

"Falk likes art when it records the point of contact between two or more elements, when one thing enters into the space of another and in the process changes our view of both things. Often in her work something placed on or growing up from the ground will meet something hanging down from the ceiling—Christmas trees and dog bones, a dresser and cabbages, cabbages and ribbons, rose trees and light bulbs, disembodied arms clutching light bulbs in a disquieting space also populated by dogs, kitchen chairs and mysterious walking men. But despite the sometimes unsettling relationships the work suggests between objects, Falk's world is ultimately one of calming connections—the blue shadows cast from white kitchen chairs lined up in a neat rows and festooned with hand-picked flowers are a network of sustained linkages as elaborate in its intricate architecture as a Piranesi. But it's free of his labyrinthine claustrophobia. The artist talks about things 'floating around in her image bank,' a characteristically Falkian way of describing the imagination. What's clear is that the float is not a free fall; it's a buoyant world where things are encouraged to bump into one another, to nudge things into new orientations, to slip into one another's orbit. So we shouldn't be surprised that one of Gathie Falk's most recent bodies of work is a series of globes. She has pulled the earth out of the galaxy and made it just another element in her own personal, moving and fascinating cosmology." (Robert Enright, "The Thing in the Head That's There")

1993–94 Works on Nice Tables painting series.

GATHIE FALK
PIECES OF WATER
1995·1996

APRIL 11–MAY 4, 1996

EQUINOX GALLERY

2321 GRANVILLE STREET, VANCOUVER, CANADA V6H 3G3
TUESDAY–SATURDAY 10:00 AM–5:00 PM (604) 736-2405

GATHIE FALK
T R A C E S

AN INSTALLATION
SEPT 24 - OCT 24, 1998

EQUINOX GALLERY
2321 GRANVILLE STREET, VANCOUVER
TEL 604.736.2405 FAX 604.736.0464

PLEASE JOIN GATHIE FALK FOR HER OPENING ON
WEDNESDAY, SEPTEMBER 23, FROM 6:00 – 8:00 PM

Left: Invitation: *Gathie Falk: Pieces of Water, 1995–1996* at the Equinox Gallery, Vancouver, 1996. Right: Invitation: *Traces: An Installation* at the Equinox Gallery, Vancouver, 1998.

1994 Works on *The Moon Loosely Attached* serial painting in four parts. Exhibits *Nice Tables with Details*, Equinox Gallery, Vancouver; *Recent Works by Gathie Falk*, Art Gallery of S.W. Manitoba, Brandon. Participates in *Hidden Values: Contemporary Canadian Art in Corporate Collections*, Art Gallery of Nova Scotia, Halifax—touring to Edmonton Art Gallery, Edmonton; McMichael Canadian Art Collection, Kleinburg, and Musée d'art contemporarain, Montréal.

1994–95 Works on Heads painting series.

1995 Exhibits *Heads*, Equinox Gallery, Vancouver. Participates in *Survivors, In Search of a Voice: The Art of Courage*, Royal Ontario Museum, Toronto—touring to Halifax, Calgary, Winnipeg and Regina; *World Tea Party*, Presentation House Gallery, North Vancouver.

1995–96 Works on second Pieces of Water painting series.

1996 Exhibits *Pieces of Water: 1995–1996*, Equinox Gallery, Vancouver. Participates in *Great Work*, Atrium, Vancouver.

1996–97 Works on Apples painting series.

1997 Receives the Order of Canada. Exhibits *Apples*, Equinox Gallery, Vancouver.

1997–98 Works on *Traces* installation.

"Falk, a devout Mennonite and former schoolteacher, is well aware of the apple's biblical and classical connotations, yet there is something in her celebration of the apple that is a particularly hers, particularly here and now. It has to do with a heightened awareness of the everyday, an awareness that involves the senses as well as the spirit. It has to do with a veneration of the beauty that is found in ordinariness, a revering of the small tasks and unspectacular objects that comprise our daily rituals." (Robin Laurence, "Painter Eyes the Everyday Apple")

1998 Works on Standard Shoes sculpture series. Exhibits *Apples & Pieces of Water*, Galerie René Blouin, Montréal; *Traces: An Installation*, Equinox Gallery, Vancouver. Participates in *Making It New*, Glenbow Art Museum, Calgary, and Windsor Art Gallery, Windsor; *The Group: A Twentieth Anniversary Exhibition / Gathie Falk, Wendy Hamlin, Gloria Massé and John Clair Watts*, John Ramsay Gallery, Vancouver.

1998–99 Works on *The Column* sculpture.

1999 Works on Heavenly Bodies painting series and Reclining Figure (after Henry Moore) sculpture series. Exhibits *The Column*, Equinox Gallery, Vancouver.

2000 Retrospective exhibition *Gathie Falk*, Vancouver Art Gallery, touring to the Art Gallery of Nova Scotia, Halifax; MacKenzie Art Gallery, Regina; and National Gallery of Canada, Ottawa.

Selected Bibliography

ALLOWAY, Lawrence. *American Pop Art*. New York/London: Collier Books Macmillan with the Whitney Museum of American Art, 1974.

AYRE, Robert. *Canadian Group of Painters 67*. Montreal: The Montreal Museum of Fine Arts, 1967.

BALKIND, Alvin. *Four Places*. Vancouver: Vancouver Art Gallery, 1977.

BALKIND, Alvin. Unpublished interview with Gathie Falk, 4 January 1977, archived in the library of the Vancouver Art Gallery.

BALMA, Donna, and Scott Watson, "Bernard Leach and His Vancouver Students" in *Vancouver: Art and Artists 1931–1983*, Alvin Balkind et al. Vancouver: Vancouver Art Gallery, 1983.

BATTISTI, Eugenio. *Giotto*, trans. James Emmons. Lausanne: Skira, 1960.

BEHR, Shulamith. *Women Expressionists*. Oxford: Phaidon, 1988.

BELLERBY, Greg. *Gathie Falk: Paintings, 1978–1984*. Victoria: Art Gallery of Greater Victoria, 1985.

BIRNIE DANZKER, Jo-Anne, et al. *Gathie Falk Retrospective*. Vancouver: Vancouver Art Gallery, 1985.

BOGUSKY, Alf, and Tom Graff. *Night Skies: Gathie Falk*. Lethbridge: Southern Alberta Art Gallery, 1980.

BRENTANO, Robyn, and Olivia Georgia. *Outside the Frame: Performance and the Object*. Cleveland: Cleveland Center for Contemporary Art, 1994.

BRONSON, A.A., and Peggy Gale. *Performance by Artists*. Toronto: Art Metropole, 1979.

BURNETT, David. *Masterpieces of Canadian Art from the National Gallery of Canada*. Edmonton: Hurtig Publishers, 1990.

BURNETT, David. "Some Canadian Women Artists/The National Gallery of Canada." *artscanada* (winter 1975–76): 54–58.

BURNETT, David, and Marilyn Schiff.

Contemporary Canadian Art. Edmonton: Hurtig Publishers with The Art Gallery of Ontario, 1983.

CHADWICK, Whitney. *Women, Art, and Society*. London: Thames and Hudson, 1991.

DAULT, Gary Michael. "The Alternate Eden: A Primer of Canadian Abstraction" in *Visions: Contemporary Art in Canada*, Robert Bringhurst et al. Vancouver/Toronto: Douglas & McIntyre, 1983, 119–20.

DUBE, Wolf-Dieter. *Expressionism*, trans. Mary Whittall. New York/Toronto: Oxford University Press, 1979.

DYCK, Cornelius J. *An Introduction to Mennonite History*. Scottdale, Penn./Waterloo, Ont.: Herald Press, 1993.

ENRIGHT, Robert. "The Thing in the Head That's There." *Border Crossings* (May 1993): 12–23.

ERNSTROM, Adele M. "Stealing the Show: Seven Women Artists In Canadian Public Art." *Woman's Art Journal* (fall 1997/winter 1998): 53–55.

FALK, Gathie. Artist statement in *Artropolis 93: Public Art and Art about Public Issues*. Vancouver: Artropolis 93/A.T.Eight Artropolis Society, 1993, 33.

FALK, Gathie. "Chairs, 1985." Vancouver: Equinox Gallery, 1985.

FALK, Gathie. "Gathie Falk/Artist" (artist's statement) in *Survivors: In Search of a Voice*, Barbara Amesbury. Toronto: Woodlawn Arts Foundation, 1995, 19.

FALK, Gathie. "A Short History of Performance Art As It Influenced or Failed to Influence My Work." *artscanada* (March/April 1981): 12–14.

FALK, Gathie. "Soft Chairs" (artist's statement in catalogue-brochure for the 1987 exhibition *Gathie Falk*). New York: 49th Parallel Centre for Contemporary Canadian Art, 1987.

FALK, Gathie. "Statements" in *Gathie Falk Retrospective*, Jo-Anne Birnie Danzker et al. Vancouver: Vancouver Art Gallery, 1985.

FALK, Gathie. Undated and unpublished artist's statements, 1968–99. Gathie Falk's personal archives.

FERGUSON, George. *Signs & Symbols in Christian Art*. London/Oxford/New York: Oxford University Press, 1954.

FINEBERG, Jonathon. *Robert Arneson Self-Reflections*. San Francisco: San Francisco Museum of Modern Art, 1997.

GAMMAN, Lorraine, and Margaret Marshment, eds. *The Female Gaze: Women As Viewers of Popular Culture*. Seattle: Real Comet Press, 1989.

GARVER, Thomas H. *The New Art of Vancouver*. Balboa, Calif.: Newport Harbor Art Museum, 1969.

"Gathie Falk: Recent Work." *The Capilano Review*, no. 50 (June 1989): 136–41.

Gathie Falk Performance Art Retrospective. Produced by Tom Graff. Vancouver: Vancouver Art Gallery, 1985. Videocassette (3/4-inch VHS).

GAUTHIER, Serge, and Tamara Préand. *Ceramics of the 20th Century*. New York: Rizzoli, 1982.

GERSON, Erika, and Millie McKibbon. *Contemporary Ceramic Sculpture/from alberta saskatchewan british columbia and manitoba*. Vancouver: Fine Arts Gallery, University of British Columbia, 1974.

GINSBERG, Susan. "The New Art of Vancouver." *artscanada* (December 1969): 56–57.

GRAFF, Tom. "Gathie Falk at Artcore." *YVR Vancouver in Review*, no. 5 (December 1978/January 1979): 6–10.

GRAFF, Tom. "Notes, Anecdotes and Thoughts on Gathie Falk's Performance Art" in *Gathie Falk Retrospective*, Jo-Anne Birnie Danzker et al. Vancouver: Vancouver Art Gallery, 1985.

GRAFF, Tom. "Theatre Art Works" (program notes). Ottawa: National Gallery of Canada, 1975.

GRAHAM, Mayo. *Some Canadian Women Artists.* Ottawa: National Gallery of Canada, 1975.

GRAHAM, Mayo. "Some Canadian Women Artists." *Artmagazine* (December 1975): 13–14.

GRENVILLE, Bruce. *Corpus.* Saskatoon: Mendel Art Gallery, 1993.

GUSTAFSON, Paula. "Falk Distils Floral Essences." *Georgia Straight*, 28 April–5 May 1995, 51.

HARRINGTON, LaMar. *Ceramics in the Pacific Northwest: A History.* Seattle/London: University of Washington Press for the Henry Art Gallery, 1979.

JAMES, Geoffrey. "Grand Funk." *Time*, 23 April 1973, 8.

JOHNSON, Ellen. *Modern Art and the Object.* New York/Hagerstown/San Francisco/London: Harper & Row Icon Editions, 1976.

JOHNSON, Eve. "Artist They Once Called Funky Falk." *Vancouver Sun*, 12 October 1985, C4.

JOHNSON, Mia. "Gathie Falk: Apples." *Preview of the Visual Arts* (April/May 1997): 20.

JONES, Janet. "Ten Canadian Artists versus Canadian Museums." *Vanguard* (summer 1982): 22ff.

KELLEIN, Thomas. *Fluxus.* London: Thames and Hudson, 1995.

KEZIERE, Russell. "Gathie Falk: Cabbage Environment." *Vanguard* (December 1978/January 1979): 15.

KLUYVER-CLUYSENAER, Margreet. *Realism: Emulsion and Omission.* Kingston: Agnes Etherington Art Centre, 1972.

LAMBTON, Gunda. *Stealing the Show.* Montreal/Kingston: McGill University Press, 1994.

LAURENCE, Robin. "Falk Settles for Venice Sinks." *Georgia Straight*, 18–25 October 1991, 29.

LAURENCE, Robin. "Gathie Falk." *Georgia Straight*, 8–15 May 1997, 35.

LAURENCE, Robin. "Painter Eyes the Everyday Apple." *Georgia Straight*, 17–24 April 1997, 51.

LIND, Janet. *Gathie Falk.* Vancouver/Toronto: Douglas & McIntyre, 1989.

LOWNDES, Joan. "But Whose Face Was the Egg On?" *Vancouver Sun*, 9 February 1972.

LOWNDES, Joan. "Falk, Lewis Sculptures Keep Gallery in Touch." *Vancouver Sun*, 18 June 1970.

LOWNDES, Joan. "Four's an Art Crowd in Burnaby." *Vancouver Sun*, 29 April 1975, 39.

LOWNDES, Joan. "Gathie Falk's Drawings: Icons from the Commonplace." *Vancouver Sun*, 1 March 1976, 33.

LOWNDES, Joan. "Glorious Fun-k Art of Gathie Falk" in "Spotlight," *Vancouver Province*, 30 August 1968, 10–11.

LOWNDES, Joan. "Inter-media Must Not Forget to Be Inter-people." *Vancouver Province*, 18 April 1969.

LOWNDES, Joan. "Modalities of West Coast Sculpture." *artscanada* (autumn 1974): 68–73.

LOWNDES, Joan. "The New Art of Vancouver Is Getting Abroad." *Vancouver Province*, 6 June 1969.

LOWNDES, Joan. "Ottawa: Joan Lowndes Tells How Capital and Modern Sculpture Meet Head On." *Vancouver Sun*, 8 February 1974, 6A.

LOWNDES, Joan. "Schools Are Out for West Coast Artists." *Vancouver Sun*, 10 October 1973, 43.

LOWNDES, Joan. "The Spirit of the Sixties" in *Vancouver: Art and Artists 1931–1983*, Alvin Balkind et al. Vancouver: Vancouver Art Gallery, 1983, 142–44.

LOWNDES, Joan. "Vancouver Artist Asked to Do Cafeteria Murals." *Vancouver Sun*, 8 October 1971.

LOWNDES, Joan. "Western Triptych." *artscanada* (December 1976/January 1977): 47–48.

LOWNDES, Joan. "Who They Are: Joan Lowndes Takes a Look at Two of Our Fine Artists." *Vancouver Sun*, 3 July 1970.

LUCIE-SMITH, Edward. *Cultural Calendar of the 20th Century.* Oxford: Phaidon, 1979.

LUCIE-SMITH, Edward. *Late Modern: The Visual Arts Since 1945.* New York/Toronto: Oxford University Press, 1979.

LUCKYJ, Natalie. *Other Realities: The Legacy of Surrealism in Canada.* Kingston: Agnes Etherington Art Centre, 1978.

MARTIN, Elizabeth, and Vivian Meyer. *Female Gazes: Seventy-five Women Artists.* Toronto: Second Story Press, 1997.

MAYS, John Bentley. "Blending the Black Skies and Sunny Noons of Life." *Globe and Mail*, 20 July 1985, E5.

MAYS, John Bentley. "Christian Faith Permeates Work of Artangel Falk." *Globe and Mail*, 24 March 1990, C4.

MAYS, John Bentley. "The Snakes in the Garden" in *Visions: Contemporary Art in Canada*, Robert Bringhurst et al. Vancouver/Toronto: Douglas & McIntyre, 1983, 119–20.

MERTENS, Susan. "Celebration of the Joys of True Friendship." *Vancouver Sun*, 28 March 1981.

OUELLET, Raymond. *Gathie Falk.* Edmonton: Edmonton Art Gallery, 1978.

PAGONIS, Illyas. *Fired Sculpture.* Victoria: Art Gallery of Greater Victoria, 1974.

PANOFSKY, Erwin. *Meaning in the Visual Arts.* Garden City, N.Y.: Doubleday Anchor Books, 1955.

PERRY, Art. "Billboard Celebration." *Vancouver Province*, 26 October 1987, 38.

PERRY, Art. "Falk Fuses Poetry, Painting." *Vancouver Province*, 10 February 1980.

PERRY, Art. "Falk's Homey Drawings Enchanting." *Vancouver Province*, 3 March 1976.

PERRY, Art. "Falk Wins $25,000 Prize." *Vancouver Province*, 21 February 1990, 56.

PERRY, Art. "Gathie Falk: A Bronze Water-melon a Year." *Pacific Time* (spring 1976): 8–11.

PERRY, Art. "Gathie Falk Strikes Gold." *Vancouver Province*, 2 February 1988, 38.

PERRY, Art. "New Era for Women's Art." *Vancouver Province*, 9 January 1976, 27.

PERRY, Art. "A Taste of Honey." *Vancouver Province*, 22 March 1981, 6.

PINNEY, Marguerite. "In the Galleries." *artscanada* (October/November 1968): 37.

POLLACK, Jill. "City Captured As It Really Is." *Vancouver Courier*, 13 December 1989, 25.

POLLACK, Griselda. *Vision & Difference / Femininity, Feminism and the Histories of Art*. London/New York: Routledge, 1988.

REIMER, Priscilla. *Wind & Fire: Women Artists of Anabaptist Heritage*. Winnipeg: Mennonite Heritage Centre Gallery, 1996.

REIMER, Priscilla, et al. *Mennonite Artist / Insider As Outsider*. Winnipeg: Main Access Gallery, 1990.

ROSENBERG, Ann. "About Art . . ." *Vancouver Sun*, 23 August 1968, 14ff.

ROSENBERG, Ann. "Gathie Falk." *Gathie Falk: Beautiful British Columbia Thermal Blanket Series*. Vancouver: Elizabeth Nichol's Equinox Gallery, 1981.

ROSENBERG, Ann. "Gathie Falk Works." *The Capilano Review* vol. 1, no. 24/vol. 2, no. 25, double issue (1982).

ROSENBERG, Ann. "Getting the Hang of It." *Vancouver Sun*, 19 January 1991, D10.

ROSENBERG, Ann. "The Group: A Twentieth Anniversary Exhibition / Gathie Falk, Wendy Hamlin, Gloria Massé and John Clair Watts." Vancouver: John Ramsay Gallery, 1998.

ROSENBERG, Ann. "It's a Happening at Art Gallery." *Vancouver Sun*, 26 October 1968.

ROSENBERG, Ann. "Life Intimates Art for Fascinating Falk." *Vancouver Sun*, 5 October 1991, D12.

ROSENBERG, Ann. "Movement Art Works." *Vanguard* (November 1976): 9–10.

ROSENBERG, Ann. "Not a Pretty Picture of Dark Days to Come." *Vancouver Sun*, 15 September 1990, D10.

ROSENBERG, Ann. "Swept Away by Shadbolt." *Vancouver Sun*, 17 April 1993, C7.

ROSENBERG, Ann. "Vancouver: The Four Voices of Four Places." *Artmagazine* (May/June 1977): 21–22.

ROSSITER, Sean. "Hotrods and Cabbages: The Homely Surrealism of Gathie Falk." *Vanguard* (October 1983): 40–44.

SHADBOLT, Doris. "Tableau Is Her Form." *artscanada* (spring 1972): 30–34.

SHADBOLT, Doris. "The Vancouver Scene." *Canadian Art Today: A Studio International Publication*, no. 42 (1970): 61–64.

SHAW, Nancy. "Expanded Consciousness and Company Types: Collaboration Since Inter-media and the N.E. Thing Company" in *Vancouver Anthology: The Institutional Politics of Art*, edited by Stan Douglas. Vancouver: Talonbooks, 1991, 86.

SIMMINS, Richard. "Gathie Falk / Glenn Lewis." *artscanada* (June 1970): 34–35.

SIMMINS, Richard. "Glimpses of Remarkable Achievements." *Vancouver Province*, 30 June 1970, 11.

SIROTNIK, Gareth. "Gathie Falk: Things That Go Bump in the Day." *Vanguard* (February 1978): 8–10.

STALEY, Rosalie. "Gathie Falk / Richard Prince." *Vanguard* (May 1982): 37–38.

STEPHENSON, Wendy. "Central's Wall Mural Takes Shape." *Enterprise* (March/April 1979): 17–18.

STEPHENSON, Robert Louis. *A Child's Garden of Verses*. New York: Charles Scribner's Sons, n.d.

SWAIN, Robert. *Hidden Values: Contemporary Canadian Art in Corporate Collections*. Vancouver/Toronto: Douglas & McIntyre, 1994.

TIPPETT, Maria. *By a Lady: Celebrating Three Centuries of Art by Canadian Women*. Toronto/London: Viking Penguin, 1992.

TOUSLEY, Nancy. "Gathie Falk." *artscanada* (March/April 1981): 60.

Voices and Images of California Art. San Francisco: San Francisco Museum of Modern Art, 1997. CD ROM.

WATMOUGH, David. "The Canvas Shack: Falk Art Strong in Human Focus." *Vancouver Sun*, 9 September 1965, 43.

WATSON, Scott. "Gathie Falk: Paintings 1976–1984." *Canadian Art* (spring 1985): 89–90.

WATSON, Scott. "Gathie Falk's Rituals and Sources" in *Gathie Falk Retrospective*, Jo-Anne Birnie Danzker et al. Vancouver: Vancouver Art Gallery, 1985, 58–62.

WATSON, Scott, and Sandra Martin. "Whimsical, Troubled and Bizarre: The Enigmatic Visions of Gathie Falk." *Canadian Art* (fall 1985): 52–58.

WENGER, J.C. *What Mennonites Believe*. Revised edition. Scottdale/Waterloo: Herald Press, 1991.

List of Works in the Exhibition

All measurements are in centimetres; height precedes width precedes depth.

Home Environment, 1968
ceramic, paint, flock, varnish, polyester resin, silkscreen print, paper, Plexiglas and steel
244.0 x 305.0 x 305.0
Vancouver Art Gallery, 86.32

Performance Works, 1968–72
video documentation produced 1984, laserdisk, transferred from master videotape, courtesy of the artist

30 Apples, 1969–70
ceramic and Plexiglas stand
28.0 x 30.5 x 31.8
Collection of John and Elizabeth Nichol

55 Rotten Apples, 1969–70
ceramic and Plexiglas stand
30.5 x 43.8 x 47.0
Collection of Mr. and Mrs. John C. Kerr

196 Apples, 1969–70
ceramic and Plexiglas stand
40.6 x 88.3 x 66.7
Collection of the artist

30 Grapefruit, 1970
ceramic and Plexiglas stand
32.4 x 49.5 x 49.5
Vancouver Art Gallery, 70.112

26 Oranges, 1970
ceramic and Plexiglas stand
19.1 x 36.5 x 24.4
Vancouver Art Gallery, 70.111

14 Rotten Apples, 1970
ceramic and Plexiglas stand
19.1 x 28.0 x 25.0
Vancouver Art Gallery, 70.110

8 Oranges, 1970
ceramic and Plexiglas stand

17.0 x 17.0 x 26.0
Collection of Ron Longstaffe, on extended loan to the Vancouver Art Gallery

Single Right Men's Shoes: Bootcase with 1 Green Banker's Shoe, 1972
glazed ceramic, painted wood and glass
68.6 x 113.0 x 39.4
Private Collection

Single Right Men's Shoes: Bootcase with 6 Orange Brogues, 1973
glazed ceramic, painted wood and glass
70.2 x 94.9
Collection of the artist

Single Right Men's Shoes: Bootcase with 4 Patent Leather Shoes, 1973
painted ceramic, painted wood and glass
52.0 x 95.5 x 18.0
Collection of Ron and Jacqueline Longstaffe

Single Right Men's Shoes: Bootcase with 1 Shoe with Roses, 1973
glazed ceramic, painted wood, varnish and glass
20.4 x 41.1 x 41.2
Vancouver Art Gallery, 91.34.1

Single Right Men's Shoes: Eight Red Boots, 1973
glazed ceramic, glass and coloured varnish on wood
101.2 x 105.7 x 15.5
National Gallery of Canada, Ottawa, 18157

Single Right Men's Shoes: Blue Running Shoes, 1973
glazed ceramic, glass and coloured varnish on wood

101.5 x 105.4 x 16.1
Vancouver Art Gallery, 83.41 a–i

Single Right Men's Shoes: Bootcase with Single Right Men's Shoes, 1973
flocked ceramic, painted wood and glass
82.5 x 43.7 x 15.0
Private Collection

Single Right Men's Shoes: Bootcase with 9 Black Boots, c. 1973
earthenware painted with acrylic, painted wood and glass
88.9 x 192.4 x 17.2
Vancouver Art Gallery, 76.4 a–j

Picnic with Lemons, 1976
ceramic, acrylic paint and varnish
17.5 x 53.5 x 33.5
Collection of John and Elizabeth Nichol

Picnic with Clock and Bird, 1976
ceramic, acrylic paint and varnish
22.0 x 29.0 x 23.0
Collection of the artist

Picnic with Clock and Egg Cups, 1976
ceramic, acrylic paint and varnish
27.5 x 36.0 x 28.0
National Gallery of Canada, Ottawa, 18846

Picnic with Birthday Cake and Blue Sky, 1976
ceramic, acrylic paint, varnish and wood
63.6 x 63.4 x 59.7
National Gallery of Canada, Ottawa, 18872

Picnic with Dog and Potted Camellia, 1976–77
ceramic, acrylic paint and varnish
66.0 x 45.7 x 57.2

Collection of John and Sherry Keith-King

Picnic with Fish and Ribbon, 1977
ceramic, acrylic paint and varnish
20.0 x 33.7 x 27.8
National Gallery of Canada, Ottawa, 18845

Night Sky #2, 1979
oil on canvas
198.1 x 167.6
Private Collection

Night Sky #3, 1979
oil on canvas
198.1 x 167.6
Private Collection

Night Sky #7, 1979
oil on canvas
198.1 x 167.6
Memorial University Art Gallery, St. John's

Night Sky #22, 1979
oil on canvas
198.1 x 167.6
Collection of the artist

Beautiful British Columbia Multiple Purpose Thermal Blanket, 1979–80
oil on canvas
490.0 x 550.0
Credit Union Central of British Columbia, Vancouver

Piece of Water: Happy Ending, 1981
oil on canvas
198.1 x 167.6
Collection of Trans Mountain Pipe Line Co. Ltd., Vancouver

Piece of Water: President Reagan, 1981
oil on canvas
198.0 x 167.8
Vancouver Art Gallery, 81.7

Cement with Grass #1, 1982
oil on canvas
200.7 x 123.2
Collection of the artist

Cement with Grass #4, 1982
oil on canvas
198.5 x 121.9
Canada Council Art Bank, Ottawa

Cement with Black Shadow,
1983
oil on canvas
198.0 x 122.0
Collection of the artist

Cement for Grass, 1983
oil on canvas
198.5 x 122.0
Collection of the artist

*Theatre in B/W and Colour:
Bouquets in B/W*, 1983
oil on canvas
198.1 x 167.6
Vancouver Art Gallery, Gift
of J. Ron Longstaffe, 86.203

*Theatre in B/W and Colour:
Bouquets in Colour*, 1983
oil on canvas
198.2 x 167.4
Glenbow-Alberta Institute, Glen-
bow Museum, Calgary, 984.31

*Theatre in B/W and Colour:
Alberta Spruce & Streamers
in B/W*, 1984
oil on canvas
198.1 x 167.6
Vancouver Art Gallery
Acquisition Fund, 86.3

*Theatre in B/W and Colour:
Alberta Spruce & Streamers
in Colour*, 1984
oil on canvas
198.1 x 167.6
Vancouver Art Gallery
Acquisition Fund, 86.3

*Theatre in B/W and Colour:
Bushes with Fish in Colour*, 1984
oil on canvas
198.2 x 167.4
National Gallery of Canada,
Ottawa, 29516.2

*Theatre in B/W and Colour:
Bushes with Fish in B/W*, 1984
oil on canvas
198.2 x 167.4
National Gallery of Canada,
Ottawa, 29516.1

*Theatre in B/W and Colour:
The Kitchen Chairs*, 1984
oil on canvas
198.1 x 167.6
Collection of John and
Elizabeth Nichol

*Theatre in B/W and Colour:
My Dog's Bones*, 1984
oil on canvas
198.1 x 167.6
Musée d'art contemporain,
Montréal, A92 42 P1

*Theatre in B/W and Colour:
My Dog's Bones with Alberta
Spruce*, 1984
oil on canvas
198.1 x 167.6
Private Collection

My Dog's Bones, 1985
bones, cord, Cedar trees, enamel
paint and aluminum paint
309.0 x 109.0 x 109.0
Collection of the artist

Soft Chair with Black Dress, 1986
oil on canvas
122.0 x 106.6
Collection of Barbara and
Glenn McInnes

Soft Couch with Suit, 1986
oil on canvas

124.5 x 199.0
Private Collection

Soft Chair with White Dress, 1986
oil on canvas
122.0 x 106.6
Private Collection

*There Are 11 Ships and a Barge
in English Bay*, 1990
oil on canvas
213.4 x 152.4
Collection of the artist

*There Are 21 Ships and
3 Warships in English Bay*, 1990
oil on canvas
213.4 x 152.4
Collection of the artist

*There Are 9 Ships and a Warship
in English Bay*, 1990
oil on canvas
213.4 x 152.4
Collection of the artist

*Development of the Plot III:
#1 The Stage Is Set*, 1992
oil on canvas
228.6 x 160.0
Collection of the artist

*Development of the Plot III:
#2 Entrance*, 1992
oil on canvas
228.6 x 160.0
Collection of the artist

*Development of the Plot III:
#3 Development*, 1992
oil on canvas
228.6 x 160.0
Collection of the artist

*Development of the Plot III:
#4 Entrance from the Right*,
1992
oil on canvas
228.6 x 160.0
Collection of the artist

*Development of the Plot III:
#5 Climax*, 1992
oil on canvas
228.6 x 160.0
Collection of the artist

*Development of the Plot III:
#6 Diversion*, 1992
oil on canvas
228.6 x 160.0
Collection of the artist

*Development of the Plot III:
#7 Passing*, 1992
oil on canvas
228.6 x 160.0
Collection of the artist

*Development of the Plot III:
#8 Conclusion*, 1992
oil on canvas
228.6 x 160.0
Collection of the artist

*Development of the Plot III:
#9 Transformation*, 1992
oil on canvas
228.6 x 160.0
Collection of the artist

Development of the Plot IV, 1992
oil on canvas
27.3 x 19.3 each, nine panels
The Donovan Collection,
St. Michael's College, University
of Toronto, Toronto

*Nice Table with Bowl of Pears and
Details*, 1993
oil on canvas
122.5 x 122.0; 76.4 x 51.0;
76.4 x 51.0
Private Collection

Nice Table with Raspberries, 1993
oil on canvas
122.0 x 122.0; 51.0 x 76.0;
76.0 x 51.0
Collection of Ron and
Jacqueline Longstaffe

Dress with Cosmetics, 1997
papier-mâché, acrylic paint and
varnish
73.6 x 53.3 x 38.1
Private Collection

Dress with Boy, 1997
papier-mâché, acrylic paint and
varnish
83.8 x 63.5 x 45.7
Collection of Mr. and
Mrs. John C. Kerr

Dress with Singing Birds, 1997
papier-mâché, acrylic paint and
varnish
91.4 x 60.9 x 60.9
Kamloops Art Gallery,
Kamloops. Purchased with the
support of the Canada Council
for the Arts Acquisitions
Assistance Program

Crossed Ankles and Sandals, 1997
oil on canvas

129.5 x 129.5
Private Collection

Small Articles, 1997–98
papier-mâché, acrylic paint,
varnish and wooden table
106.6 x 165.1 x 35.5
Collection of the artist

Crossed Ankles, 1998
silkscreen prints, transparent
vellum
62.2 x 45.7 each; overall
dimensions variable
Equinox Gallery, Vancouver

Dress with Candles, 1998
papier-mâché, acrylic paint
and varnish
88.9 x 60.9 x 30.4
National Gallery of Canada,
Ottawa, 39892

Dress with Insects, 1998
papier-mâché, acrylic paint

and varnish
90.0 x 60.0 x 60.0
Vancouver Art Gallery
Acquisition Fund, 98.63

Dress with Crossed Ankles, 1998
papier-mâché, acrylic paint
and varnish
91.4 x 55.8 x 50.8
MacKenzie Art Gallery, Regina.
Purchased with the support
of the Canada Council for the
Arts Acquisitions Assistance
Program

*Shoulder Blades and
Gladiola Corsages*, 1998
oil on canvas
129.5 x 129.5
Equinox Gallery, Vancouver

Midriffs and Belts, 1998
oil on canvas
129.5 x 129.5
Equinox Gallery, Vancouver

*Reclining Figure (after
Henry Moore): Alice*, 1999
papier-mâché, acrylic paint
and varnish
48.0 x 69.0 x 95.1
Collection of the artist

*Reclining Figure (after
Henry Moore): Stella*, 1999
papier-mâché, acrylic paint
and varnish
47.6 x 88.9 x 100.9
Collection of the artist

*Heavenly Bodies, Stars
and Moons*, 1999
acrylic on canvas, copper
and aluminium
327.0 x 152.0
Collection of the artist

Heavenly Bodies, Suns, 1999
acrylic on canvas and aluminium
327.0 x 152.0
Collection of the artist

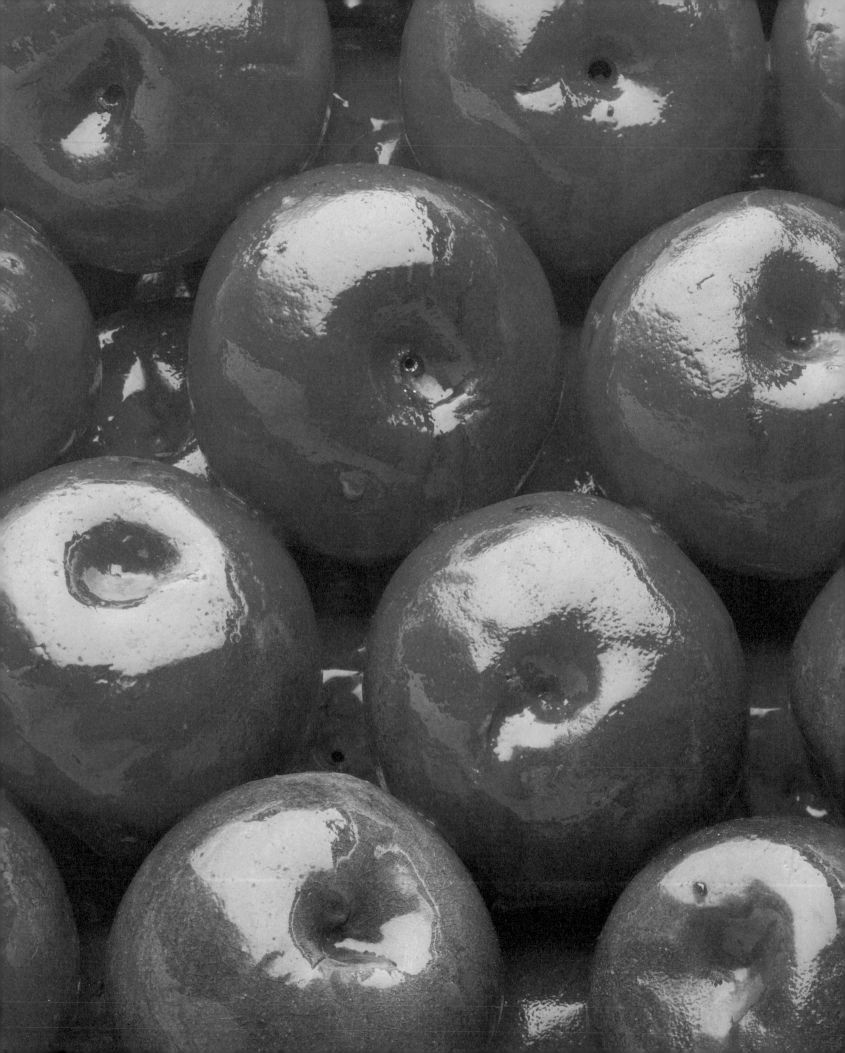